C000085340

The New York Schools of Music and Visual Arts

STUDIES IN CONTEMPORARY MUSIC AND CULTURE

Joseph Auner, *Series Editor*
 Associate Professor of Music
 The State University of New York at Stony Brook

Advisory Board
 Philip Brett, Susan McClary, Robert P. Morgan, Robert Walser

Messiaen's Language of Mystical Love
edited by Siglind Bruhn

Expression in Pop-Rock Music
A Collection of Critical and Analytical Essays
edited by Walter Everett

John Cage: Music, Philosophy, and Intention, 1933–1950
edited by David W. Patterson

Postmodern Music / Postmodern Thought
edited by Judy Lochhead and Joseph Auner

The New York Schools of Music and Visual Arts

John Cage Willem de Kooning

Morton Feldman Jasper Johns

Edgard Varèse Robert Rauschenberg

edited by Steven Johnson

Studies in Contemporary Music and Culture

Routledge
New York London

Published in 2002 by

Routledge
29 West 35th Street
New York, NY 10001

Published in Great Britain by

Routledge
11 New Fetter Lane
London EC4P 4EE

Routledge is an imprint of the Taylor & Francis Group.

Copyright © 2002 by Routledge

Printed in the United States of America on acid-free paper.

All rights reserved. No part of this book may be reprinted or reproduced or utilized in any form or by any electronic, mechanical, or other means, now known or hereafter invented, including photocopying and recording, or in any information storage or retrieval system, without permission in writing from the publisher.

A volume in the series Studies in Contemporary Music and Culture.

Library of Congress Cataloging-in-Publication Data

The New York schools of music and visual arts : John Cage,
Morton Feldman, Edgard Varèse, Willem de Kooning, Jasper Johns,
Robert Rauschenberg / edited by Steven Johnson.
 p. cm. — (Studies in contemporary music and culture; no. 5)
 Includes bibliographical references and index.
 ISBN 0-8153-3364-1 (acid-free paper) —
 ISBN 0-415-93694-2 (pbk. : acid-free paper)
 1. Art and music. 2. Music—New York (State)—New York—
20th century—History and criticism. 3. Avant-garde (Music)—
New York (State)—New York. 4. New York school of art.
5. Abstract expressionism—New York (State)—New York.
I. Johnson, Steven. II. Studies in contemporary music
and culture; v. 5.

ML3849 .N49 2001
700'.9747'1—dc21 2001048172

For Valerie, Kathryn, and Blair

[Contents]

[General Introduction]

Joseph Auner

A s we enter a new century, many of the established historical narratives of twentieth-century music are being questioned or reconfigured. New approaches from cultural studies and feminist theory, methodologies adapted from such disciplines as literary theory, philosophy, and anthropology, and debates about the canon, postmodernism, globalization, and multiculturalism are profoundly transforming our sense of both what the repertoire of twentieth-century music is and how it should be understood. The Studies in Contemporary Music and Culture series provides a forum for research into topics that have been neglected by existing scholarship, as well as for new critical approaches to well-known composers, movements, and styles.

Volumes in the series will include studies of popular and rock music; gender and sexuality; institutions; the audience and reception; performance and the media; music and technology; and cross-cultural music and the whole range of the crossover phenomenon. By presenting innovative and provocative musical scholarship concerning all aspects of culture and society, it is our aim to stimulate new ways to listen to, study, teach, and perform the music of our time.

[Introduction]

A Junction at Eighth Street

Steven Johnson

A t the beginning of the nineteenth century, when notions of original-
ity and personal expression became increasingly vital to artists, many
composers sought inspiration from other artistic disciplines to help
them create unique, individual styles. Ludwig van Beethoven's transfor-
mation of symphony and sonata into personal dramas of conflict and res-
olution, for example, involved the merger of purely musical concerns
with verbal ones, either implied (as in his Third or Fifth Symphonies) or
specified (as in his Sixth or Ninth Symphonies). Hector Berlioz turned
symphonies into stories, and Franz Liszt "recited" piano pieces and nar-
rated "symphonic poems." Felix Mendelssohn "painted" orchestral land-
scapes, Richard Wagner developed his notion of *Gesamtkunstwerk*, and
Gustav Mahler recast symphonies as *Buildungsromanen* or philosophical
arguments.

The quest for originality intensified at the turn of the century, when
long-held traditions of discourse in many artistic mediums began to dis-
solve. No longer satisfied with a singular voice created within the bound-
ary of a broader language, many composers began to invent new
languages, sometimes arriving at fresh, even revolutionary conceptions of
harmony, melody, instrumental color, and form. As in the nineteenth cen-
tury, inspiration from other artistic disciplines proved crucial. While
Claude Debussy and Igor Stravinsky drew some of their inspiration from
the art and music of non-European cultures, each also drew from the
ideas and methods of their European nonmusical contemporaries. A
principal source of Debussy's inspiration came from the poetry of
Stéphane Mallarmé, while theater, film, and especially analytical cubism
influenced Stravinsky.[1] Arnold Schoenberg formed a close relationship
with Wassily Kandinsky and several other painters as well, and he himself

painted a number of expressionist-style works. The composer who made perhaps the most radical break from tradition, however, was also the one who embraced other arts most enthusiastically. During his student years in Paris, Edgard Varèse cultivated friendships with many important painters, sculptors, and writers on art. Ultimately he grew to prefer the company of these artists to that of his fellow composers. As he explained years later, "It is many years now since painting freed itself from the constraints of pure representation and description and from academic rules. Painters responded to the world—the completely different world—in which they found themselves, while music was still fitting itself into arbitrary patterns called forms, and following obsolete rules."[2]

The exchange between musicians and other artists climaxed in the middle of the twentieth century, when a group of New York-based musicians, including John Cage, Morton Feldman, Earle Brown, and David Tudor, formed friendships with a group of painters. The latter group, now known collectively as either the New York School or the abstract expressionists, included Jackson Pollock, Willem de Kooning, Robert Motherwell, Mark Rothko, Barnett Newman, Clyfford Still, Franz Kline, Philip Guston, and William Baziotes. The group also included a younger generation of artists—particularly Robert Rauschenberg and Jasper Johns—that stood somewhat apart, both stylistically and aesthetically, from the abstract expressionists. During the late 1940s and 1950s, this group of painters created what is arguably the first significant American movement in the visual arts. Inspired by the artists, the New York School composers accomplished a similar feat. By the beginning of the 1960s, the New York Schools of art and music had assumed a position of leadership in the world of art.

The seminal exchange between New York School composers and artists was the product of complex events. The artists who forged a new language in New York in the later 1940s did so in the midst of great turbulence. In the 1930s these painters had faced not only political and economic turmoil but also a bewildering array of artistic languages. Several dominant European ideologies—the cubism of Pablo Picasso and Georges Braque or the surrealism of Salvador Dali and Joan Miró, for example—competed with a number of American styles, including the regionalism of Thomas Hart Benton and Grant Wood, the social realism of Ben Shahn and William Gropper, and American abstractionism, represented by such artists as Gertrude Green, Josef Albers, and Alexander Calder. An equally varied set of options confronted young American composers. The idiosyncratic, experimental amalgams of American vernacular and European art music created by Charles Ives and Henry Cowell in the first two decades of the

century offered one kind of model. Varèse, arriving in New York in 1915, offered a more experimental and abstract vision. Yet most young American composers emerging in the 1930s—Aaron Copland, Roy Harris, Virgil Thomson, Howard Hanson, Walter Piston, to name a few—held to more conservative styles, preferring to mix some American vernacular materials into music modeled otherwise on European neoclassicism. Indeed, the regionalism of Benton finds a direct counterpart in ballets of Copland and operas of Thomson, while the social realism of Shahn relates in spirit to politically charged work of Marc Blitzstein.

During and immediately after World War II, the American artists who would eventually make up the abstract expressionist movement began to regard these various ideological "isms" as unsatisfactory dead ends. Their goal—stated directly by many in the movement—was to clear the slate for a new kind of painting. Abstract expressionists wanted "to erase the past and invent an original culture. They hoped to achieve greatness by means of a revolutionary upheaval. . . . They were to be not the midwives of regenerated art but the first cause. They aimed to create something utterly unexampled, entirely their own, and yet completely American. If the spectator could not understand their canvases, Adolph Gottlieb and Rothko insisted, it was the artists' function 'to make the spectator see the world our way—not his way.'"[3] Ultimately, then, the Americans rejected traditional European notions of subject, style, and construction as they turned instead to themselves—and particularly, to their own interior psyches—as legitimate areas for exploration. Their interest in Native American images, the art of children, and psychic automatic techniques illustrates in part their search for a pure, primal new language.

The composers, of course, were largely sympathetic to these concerns. As is well known, anti-European, antiacademic, and anticonstructionist sentiments permeate Feldman's essays of the 1950s and 1960s. But Cage, too—though deeply influenced by the European Marcel Duchamp—expounded similar ideas. Statements made by Cage as early as 1937 describe "present methods of writing music" as "inadequate."[4] In his early writings, he consistently distinguished between American experimental music and a music that depended systemically on European models. In one statement, for example, Cage criticized a particular organization of composers (i.e., the League of Composers and the International Society for Contemporary Music, which had just recently merged) for their interest "in consolidating the acquisitions of Schoenberg and Stravinsky." For Cage, this was a "cautious" group, "refusing risk." He further complained that "they maintain conventions and accepted values. The young study

with NEO-CLASSICISTS, so that the spirit of the avant-garde, infecting them, induces a certain dodecaphony." For Cage, the New York School offered a cleansing new path: "In this social darkness, therefore, the work of Earle Brown, Morton Feldman, and Christian Wolff continues to present a brilliant light, for the reason that at the several points of notation, performance, and audition, action is provocative."[5] Cage humorously summarized his position in a typical anecdote, which links him in spirit with many of his abstract expressionist contemporaries. He wrote, "Once in Amsterdam, a Dutch musician said to me, 'It must be very difficult for you in America to write music, for you are so far away from the centers of tradition.' I had to say, 'It must be very difficult for you in Europe to write music, for you are so close to the centers of tradition.' "[6]

Despite such sentiments, the painters and composers of this time were far more allied with European modernism than they would have liked to think. In the case of the painters, for example, "There is no doubt that this very American form [of abstract expressionism], related in its improvisational characteristics to jazz (another quintessentially American contribution), was in its alienation, experimentation, and hermeticism more closely tied to the European *Zeitgeist* of the 1940s and 1950s than other American pictorial art of its time. One has only to recollect the alienation expressed by such writers as Albert Camus and Samuel Beckett, the Existentialism of Jean-Paul Sartre, the Theater of the Absurd, the *nouvelle vague* experimentation in the novel led by Alain Robbe-Grillet and Nathalie Sarraute to realize that the estrangement felt by the Abstract Expressionists was closer to French sensibilities than to the prewar imperatives that other schools of American art continued to explore."[7]

The presence of so many émigrés during the late 1930s and 1940s undoubtedly strengthened the connection with Europe even as it simultaneously prompted the Americans to develop their own aesthetic. By 1942, as Barbara Haskell has pointed out, émigré artists "had achieved critical mass" in New York.[8] Yet the activities of one early émigré figure, Hans Hofmann, proved to be crucial. Before arriving in the United States in 1930, Hofmann had managed to assimilate the main elements of most of the important European artistic movements of his time, including fauvism, expressionism, cubism, abstraction, and surrealist automatism. After moving to the United States, he opened a school for modern art in New York in 1934 and thus began a career as "the most important teacher of modern art in America."[9] His own work embraced spontaneous improvisation—he adopted the technique of pouring paint three years before Pollock—and the employment of color as a primary determinant of form.

Serving simultaneously, then, as one of abstract expressionism's earliest painters and one of the movement's most significant teachers, Hofmann helped connect the new American painters with European modernism.

A similar condition applied to the musical culture. Among European émigré musicians, Varèse provided an important point of departure for the New York composers. In a short 1958 article about Varèse, Cage argued that, even though Varèse was in most respects "an artist of the past," he nevertheless "more clearly and actively than anyone else of his generation . . . established the present nature of music." According to Cage, this was due to the fact that Varèse "fathered forth noise"—that is, he accepted "all audible phenomena as material proper to music."[10] Indeed, Cage's own definition of music as "organized sound" parallels the one offered by Varèse.[11] In contrast, Feldman praised Varèse wholeheartedly: "What would my life have been without Varèse? For in my most secret and devious self I am an imitator. . . . I would go to the concert hall to hear one of his compositions, or telephone to make an appointment to see him, feeling not unlike those who make a pilgrimage to Lourdes hoping for a cure." For Feldman, Varèse's worth lay in his avoidance of Old World thinking: "Instead of inventing a system like Schoenberg, Varèse invented a music that speaks to us with its incredible tenacity rather than its methodology."[12]

Another émigré composer, largely neglected in his own time, also influenced Feldman. The career of Stefan Wolpe (1902–1972) parallels that of Hans Hofmann. The Berlin-born composer was early on bred by European modernism. He attended lectures at the Bauhaus in the early 1920s, forming acquaintances with the painter Paul Klee and several other artists. He studied with Anton Webern for a year in the mid-1930s before fleeing Europe for Palestine. He finally settled in New York in 1938, where he established himself as an important teacher. When during his early years in New York Wolpe began associating with such abstract expressionists as de Kooning, Pollock, and Kline, his music began to embrace some of the movement's new principles. Indeed, Wolpe became a catalyst for the younger New York School musicians. In 1946, fresh out of high school, Feldman began several years of study with Wolpe. In interviews given years later, Feldman has discussed several aspects of his relationship with Wolpe. It was through Wolpe, for instance, that Feldman met Varèse, Tudor, and several of the New York painters. In strictly compositional terms, he credited Wolpe with showing him how to focus on the piece at hand (instead of on some predetermined, artificial methodology). Wolpe also forced Feldman to deal with principles of shape and opposition, even though Feldman would not subsequently embrace these in any direct way. Perhaps most

appreciated by Feldman, however, was the fact that Wolpe met his and Cage's new modes of thinking with openness rather than hostility.

For his part, Wolpe seems to have considered himself a proper member of the emerging New York School, and was disappointed when the younger men excluded him from their concerts. As Feldman once recollected, "To show you his identification with the avant garde, he *once balled me out, very strongly*, for never playing him in our concerts in the early fifties. The *Cage concerts.* He balled me out. He was *sore.* [This shows that] he *did* identify with the younger people, which certainly most of his students didn't. Ralph [Shapey] didn't, none of his students around him. I don't know what they identified with. They identified not with Wolpe so much, but the tradition which Wolpe came out of. They never identified with his attitudes, and his intellectual openness, and his involvement . . . with literature, painting. They heard the German tradition. They heard certain types of processes."[13]

In his essay "Give My Regards to Eighth Street" Feldman captured the spirit of the exchange between painters and musicians in New York in the 1950s. In an interview given just a few months before he died, Feldman reviewed the scene one last time, describing it as a place of almost magical serendipity, where the "intellectual weather was just right." Everybody that needed to came together, giving one another permission to think, see, and hear in new ways. The artists and musicians were conscious of their position on the periphery, relished it, and they went about their work free of the hype and "show business" sensibility that in later years eventually polluted the scene.[14] But how and where did the interaction between artists and musicians take place? What were the venues of transmission?

The exchange between the New York Schools often, if not exclusively, occurred in several official and unofficial gathering places in lower Manhattan, on or around Eighth Street.[15] During the War the painters had developed the habit of meeting in the Waldorf Cafeteria, located on Sixth Avenue just off of Eighth Street. Because the management of the Cafeteria sometimes treated the painters coldly, they began searching for a more comfortable place to congregate. They moved in late 1949 to another location on Eighth Street, where they formed an organization called The Club. There were two other similar organizations between 1948 and 1950—the Subjects of the Artist School and Studio 35—but these soon folded, leaving The Club as the primary official organization for abstract expressionist artists. The Club required only minimal dues and met fairly regularly, usually on Wednesday and Friday nights. It continued until 1962, even though many of the members from the early 1950s stopped coming by the middle of the decade.

In its heyday of the early 1950s, The Club presented panels, roundtable discussions, symposiums, lectures, and concerts. Philip Pavia acted as The Club's treasurer and arranged the programs. His papers that survive from this time—a collection of notebooks, announcement cards, membership lists, and the treasury records from 1948 to 1955—name many of the people who participated in these gatherings, including: artists such as Motherwell, Baziotes, Kline, Guston Ad Reinhardt, Elaine and Willem de Kooning, and Jack Tworkov; the critics Thomas Hess, Clement Greenberg, and Robert Goldwater; the philosopher Hannah Arendt; the mythologist Joseph Campbell; and the poet Frank O'Hara. In addition, the names of five musicians appear frequently on Pavia's lists: Edgard Varèse, Stefan Wolpe, John Cage, Morton Feldman, and David Tudor. Varèse, Wolpe, Cage, and Feldman all gave lectures at The Club during the early 1950s. In return, the painters often provided audiences for the composers. Years later, Feldman would recall that "[i]n The Club there was a kind of formalized talking. There were panels: Existentialist One, Existentialist Two. The talk in The Club was, more often than not, planned lectures on themes. I gave my first talk about my own music at The Club [which was] very responsive."[16]

Looking back, this mixed environment now seems like a wonderfully rarefied greenhouse, one that induced the cultivation of one of the most original movements in twentieth-century music. Yet while it is fairly clear that new and distinctly American forms of art and music emerged just after the war and that the composers generally followed the painters in the creation of a new aesthetic, the nature of the transmission is anything but clear. Did the composers embrace principles of abstract expressionism consistently and systematically? Did they produce as defined an aesthetic as the painters? As one might expect, the sources of inspiration for the major figures of the New York School—Cage, Brown, and Feldman— were anything but tidy and systematic. In fact, all three differed considerably in their reactions to visual art.

Although many consider John Cage the leader of the New York School composers, his relationship to abstract expressionist painters may be the most problematic. He once admitted that, for a time, he "felt very attracted to abstract expressionism."[17] While in Seattle in the late 1930s, Cage had developed an interest in the paintings of Mark Tobey. Tobey had left New York City in 1922 for the American Northwest and was therefore disconnected—if only physically—from the city's artistic community. Yet his pictorial language was consonant enough with other abstract expressionist painters that Harold Rosenberg and Samuel Kootz included his work in a 1949 show called *The Intrasubjectives*, which they organized in

order to identify common aesthetic principles linking painters such as Tobey, Motherwell, Hofmann, Rothko, and de Kooning.[18] For his part, Cage specifically enjoyed Tobey's "all-over" surfaces, a feature shared by many abstract expressionist paintings. Many of the paintings Cage saw later in New York featured this same all-over surface, which, he has written, holds "no center of interest," but rather seemed as though it "could continue beyond the frame." [19]

When Cage met Marcel Duchamp in 1941, however (soon after arriving in New York), the latter's influence seemed to neutralize—if not actually undermine—Cage's attraction to abstract expressionism. Duchamp earlier had adopted an attitude of indifference toward artistic beauty, and had created a series of "readymades"—among them urinals and bicycle seats with wheels attached to them—that stood as commentaries on artistic craft, individuality, and taste. He thus reacted in a predictably negative way to abstract expressionist painters, who in his view concerned themselves too much, as Irving Sandler explains, with "the manipulation of paint as an end in itself, that is, for purely visual or, as he put it, 'retinal' purposes. Since [Duchamp] considered art that appealed solely to the eye a thing of the past, he had little regard for Abstract Expressionism, which he denigrated as the epitome of this optical approach."[20] Cage, then, gradually came to share Duchamp's hostility. He would have found particularly distasteful the abstract expressionist painters' preoccupation with autobiographical self-expression, their view of themselves as existential heros, their overly serious regard for subject matter, and their desire to create artistic masterpieces.

Cage later noted that "Critics who in general link my activities with Dada are not mistaken." In a clarifying footnote, he added, "Now, if I were obliged to choose between Surrealism and Dada, I would naturally choose Dada. And if I had to prefer one Dadaist above all others, I would keep Duchamp."[21] Feldman ended up with a different view of Cage's aesthetic, noting that "the Surrealists paved the way for Cage, insofar as automatic writing is concerned. He's not out of Dada, he's out of Surrealism. I feel he's a combination of being Schoenberg's student and Surrealism. . . . He's proto-Abstract-Expressionist; he's not Abstract-Expressionist."[22]

Earle Brown's connection to abstract expressionism was close but hardly exclusive. In a group of pieces known collectively as *Folio* (1952–53), Brown began a landmark series of explorations in graphic notation. The work entitled *1953* features a kind of "time notation" in which the physical length of the noteheads correspond to their intended durations in musical time. While pointing to no specific style of visual art, the notation never-

theless demonstrates Brown's interest in merging sight with sound. Another piece in the *Folio* set, *December 1952*, takes a far more radical step in this direction. The score consists solely of straight horizontal and vertical lines, drawn with slightly different thicknesses, which Brown distributes randomly onto a single page. Lacking traditional musical nomenclature of any kind, the performers must rely instead on their imagination to translate these abstract marks into sound. The improvisational component of *December*, of course, connects this music directly to a number of abstract expressionist painters who embraced freedom, spontaneity, and accident in their work. Visually, however, the score itself most strongly resembles early paintings by Piet Mondrian that feature similarly abstract arrangements of vertical and horizontal lines (e.g., *Color Planes in an Oval*, 1913–14; *Composition No. 10*, 1915; and *Composition in Black and White*, 1917).

Perhaps the strongest connection between visual art and Brown's music involves his work in so-called mobile form. The pages of his *Available Forms I* (1961), for example, contain discrete modules of precomposed music, arranged in boxes that are numbered and separated by heavy lines. Using hand signals to indicate the segment to be played, the conductor presents her own version of the piece by choosing, in the midst of the performance, which module should follow another. The process of the performance replicates in spirit the improvisational, kinetic methods of such "action painters" as de Kooning and Pollock. By inviting performers to connect artistic intuition with their subconscious, the spontaneity of the process connects it with the surrealist principle of psychic automatism that so influenced the abstraction expressionists.

Brown himself reinforces this comparison when, in the preface to another "mobile form" work, *String Quartet* (1965), he explains what he hopes to achieve by such a method: "I would like to think that an intensified sense of human and sonic presence and intuitive performance contact can be extended beyond the 'normal' precision-goal of most chamber music performing, into an area of immediacy of action, reaction, and flexibility, while maintaining the basic shape and character of the work."[23]

Yet, as with Cage, abstract expressionism gave Brown only part of his inspiration. During this time he also became interested in the mobile sculptures of Alexander Calder.[24] Early in the 1930s Calder had developed into one of the leaders of an American abstractionist movement (though he never joined the actual organization, which met under the official title American Abstract Artists, or AAA). His mature work, a blend of Mondrian's austere geometry and Joan Miró's biomorphic abstraction, often

used open wire to connect flat shapes of steel painted black, white, or one of the primary colors. The parts of the pieces would then be set—or hung—in a way that would allow them to shift in the air. The lean, hard-edged character of his sculpture—emotionally cool in spirit if sometimes whimsical—seems far removed from the sensuous, painterly world of the abstract expressionists.

Brown confirmed the influence of Calder and abstract expressionism on his work when he wrote, "My first thoughts about making musical works in what I call a condition of mobility, and what is now called open form, were influenced by the mobiles of the American sculptor Alexander Calder. At approximately the same time, around 1948, the paintings and working methods of Jackson Pollock began to be widely publicized in America. A correlation that I made—rightly or wrongly—between these two artists and their technical and aesthetic points of view has been my rather obsessive primary motivation as an artist and composer since that time."[25]

Morton Feldman was the composer of this group most closely tied to abstract expressionism. His connection, which was methodological as well as personal and philosophical, is also the one most clearly documented. In the 1950s and 1960s Feldman published a number of essays—among them "The Anxiety of Art," "Give My Regards to Eighth Street," "Autobiography," and "After Modernism"[26]—that stressed in sometimes polemic terms the crucial role played by painters (rather than composers) in the formation of his musical aesthetic. "The new painting," he explains, "made me desirous of a sound world more direct, more immediate, more physical than anything that had existed heretofore. Varèse had elements of this. But he was too 'Varèse.' Webern had glimpses of it, but he was too involved with the disciplines of the twelve-tone system."[27] Feldman's lifelong habit of naming his compositions after abstract expressionist painters—*For Franz Kline* (1962), *de Kooning* (1963), *Rothko Chapel* (1971), and *For Philip Guston* (1984), to name a few—strongly reinforced his debt to them.

Indeed, from the outset, Feldman's life and work wove intricately around those of the painters. Beginning in 1950 he began, through Cage, to meet many figures of the New York art world who were either well established or on the verge of being so. At parties given by Cage, at meetings of The Club, or in conversations at the Cedar Tavern, the young composer encountered the surrealist painter Max Ernst, the composers Henry Cowell and Virgil Thomson, the sculptor David Hare, the painters Robert Rauschenberg and Joan Mitchell, the writer Frank O'Hara, and the critic Clement Greenberg.[28] During this time, he also met Jackson Pollock, who invited Feldman to write music for a film being made about the artist.

Feldman's music for the project, dated May 1951 but never published, features a quick tempo and a wide variety of dynamic levels, elements uncharacteristic of Feldman but appropriate for Pollock's energetic methods.[29] Later the composer reflected on the ways in which his working method connected with those of the painter, writing, "I realize now how much the musical ideas I had in 1951 paralleled his mode of working. Pollock placed his canvas on the ground and painted as he walked around it. I put sheets of graph paper on the wall; each sheet framed the same time duration and was, in effect, a visual rhythmic structure. What resembled Pollock was my 'all-over' approach to the time-canvas."[30]

Feldman's allegiance to abstract expressionism was hardly exclusive, let alone fanatically ideological. He greatly admired the paintings of Mondrian, for example, and later in his career drew inspiration from such seemingly disparate sources as Johns and Turkish carpets. Nevertheless, abstract expressionism formed the core of his artistic being. In the 1950s he developed especially close friendships with Rothko and Guston, two painters with aesthetic sensibilities that matched his own. Feldman frequently visited Rothko's studio and the two also regularly went to museums together. When Rothko killed himself in 1970, it was Feldman who was asked to write music for the dedication of the Rothko Chapel, the painter's last major project. The music turned out to be one of the most sensuous, emotive, and autobiographical pieces Feldman ever composed.[31] Guston was Feldman's closest friend among the painters and the one that he talked to most extensively.[32] Guston's quiet, nearly inert pictures of the 1950s and early 1960s seem more closely related in spirit to Feldman's music than the work of anyone else, yet at the same time it's hard to pinpoint specific, concrete links between the two. Feldman himself attempted to do so in two essays in particular—"After Modernism" and "Essay"—but the nature of the expression is anything but concrete.

Feldman once wrote about how proud Cage was of the New York painters,[33] but it was Feldman himself who harbored the deepest reverence for them. The possessive tone of one of Feldman's following reminiscences, in which the composer refers to an evening he once spent with several colleagues talking about the old days, confirms his strong self-identification with the artists. He writes, "I left the gathering quite late with Pierre Boulez, and we walked over to the Cedar Tavern. We closed the bar that night. Closed it, in fact, for good—the building was being demolished. We talked about American literature, very little about music. There was nobody there I knew; the older crowd had stopped going some time back. Somehow it didn't seem right that I should spend that last evening

with Boulez, who is everything I don't want art to be. It is Boulez, more than any composer today who has given system a new prestige—Boulez, who once said in an essay that he is not interested in how a piece sounds, only in how it is made. No painter would talk that way."[34]

The eight essays in this volume examine the interaction between the New York musicians and visual artists from a variety of angles. David Nicholl's "Getting Rid of the Glue: The Music of the New York School" serves as a general introduction to the subject. Nicholls, dwelling mostly on the four major figures of the New York School, explains how Cage, Feldman, Brown, and Wolff came together as a group and how they differed from one another in their compositional aesthetic. He tells us who came late to the group, who remained relatively indifferent to the work of the painters, and why the group finally disbanded. He also provides a brief but useful historical context, showing that many of the ideas now credited to the New York School were explored at least embryonically in the music of earlier Americans such as Charles Ives, Henry Cowell, and Lou Harrison. Nicholls's principal theme, however, is the way in which the experimental methods of notation developed by Cage, Feldman, Brown, and Wolff originated in the first place from their wish to liberate individual sounds from compositional rhetoric, and second from their experience with the new American painting.

The following seven essays focus more sharply on different aspects of the subject. In "The Physical and the Abstract: Varèse and the New York School," Olivia Mattis tells how an emerging group of New York School painters came to be drawn to Varèse's music and how he in turn grew interested in their work and, through them, in jazz improvisation. In "Stefan Wolpe and Abstract Expression," Austin Clarkson demonstrates the connections among Wolpe, Varèse, and early European modernism in the visual arts. He then proceeds to show how Wolpe's interaction with abstract expressionist painters in the late 1940s and early 1950s transformed his own compositional aesthetic and transformed him into mentor to young American composers, such as David Tudor and Morton Feldman.

David Bernstein's "John Cage and the 'Aesthetic of Indifference'" examines the connection between abstract expressionism and that composer's other aesthetic, political, and philosophical ideas. In his "A Question of Order: Cage, Wolpe, and the Principle of Plurality," Thomas DeLio examines two musical compositions to show how Cage and Wolpe were part of broader movement of artists—Robert Rauschenberg, Jasper Johns, and Merce Cunningham, for example—who came of age just after the heyday

of abstract expressionism and who tended to practice a new kind of multiplicity with respect to methods and materials. But DeLio chooses to focus on two artists of an even later generation—Robert Smithson and Carl Andre—to make his comparisons between art and music.

The final three essays in the volume dwell mainly on Morton Feldman. The chief objective of John Holzaepfel's "Painting by Numbers: The *Intersections* of Morton Feldman and David Tudor" is to explore the way in which Tudor went about creating performance versions of Feldman's early indeterminately notated scores. In the process, he also demonstrates the connections among the composer's music, the performer's realization, and one of abstract expressionism's most important methodolgies: the practice of "action painting." In "Feldman's Painters," Jonathan Bernard makes perhaps the most systematic reading yet attempted of Feldman's many utterances about art and music. Bernard discovers core aesthetic principles that Feldman gleaned from his abstract expressionist contemporaries and gives examples of how the composer applied these to the composition of music. The editor's essay, "Jasper Johns and Morton Feldman: What Patterns?" explores the relationship between Feldman and the visual arts at the very end of his career. During the late 1970s, when many of his painter friends were dead and when the abstract expressionist movement had long since faded into history, Feldman began turning his attention to different kinds of visual art. Predictably, his music changed, too, revealing once again how important the visual world was to this musician.

Notes

1. The influence exerted on Stravinsky by artists from other disciplines is discussed in great detail in Glenn Watkins, *Pyramids at the Louvre* (Cambridge, Mass.: The Belknap Press of Harvard University Press, 1994). See especially his chapter "Stravinsky and the Cubists," 229–74.

2. Edgard Varèse, "Edgard Varèse on Music and Art: A Conversation between Varèse and Alcopley," *Leonardo* 1 (1968): 189; quoted in Jonathan W. Bernard, *The Music of Edgard Varèse* (New Haven: Yale University Press, 1987), 1. The first chapter of Bernard's book, "Varèse's Aesthetic Background," provides an excellent study of the connection between Varèse and the important movements in visual art in the early twentieth century.

3. David Shapiro and Cecile Shapiro, *Abstract Expressionism: A Critical Record* (Cambridge: Cambridge University Press, 1990), 9. The literature on abstract expressionism is far too extensive to survey here. Works that have particularly helped this writer include William C. Seitz, *Abstract Expressionist Painting in America* (Cambridge, Mass.: Harvard University Press for the National Gallery of Art, Washington, D.C., 1983); Stephen Polcari, *Abstract Expressionism and the Modern Experience* (Cambridge: Cambridge University

Press, 1991); and Michael Leja, *Reframing Abstract Expressionism: Subjectivity and Painting in the 1940's* (New Haven: Yale University Press, 1993).

4. John Cage, "The Future of Music: Credo," in *Silence: Lectures and Writings by John Cage* (Middletown, Conn.: Wesleyan University Press, 1961), 5.

5. John Cage, "Composition as Process," in *Silence: Lectures and Writings by John Cage* (Middletown, Conn.: Wesleyan University Press, 1961), 52.

6. John Cage, "The History of Experimental Music in the United States," in *Silence: Lectures and Writings by John Cage* (Middletown, Conn.: Wesleyan University Press, 1961), 73.

7. Shapiro and Shapiro, *Abstract Expressionism*, 5–6.

8. Barbara Haskell, *The American Century: Art and Culture 1900–1950* (New York: Whitney Museum of American Art and W. W. Norton, 1999), 327.

9. Irving Sandler, *The Triumph of American Painting: A History of Abstract Expressionism* (New York: Praeger, 1970), 20; see also 138–42.

10. John Cage, "Edgard Varèse," in *Silence: Lectures and Writings by John Cage* (Middletown, Conn.: Wesleyan University Press, 1961), 83-84.

11. James Pritchett, *The Music of John Cage* (Cambridge: Cambridge University Press, 1993), 11.

12. Morton Feldman, "In Memoriam: Edgard Varèse," in *Morton Feldman Essays*, ed. Walter Zimmermann (Kerpen, West Germany: Beginner Press, 1985), 54.

13. Morton Feldman, "An Interview with Austin Clarkson," Buffalo, N.Y., November 13, 1980, unpublished.

14. Morton Feldman, "Captain Cook's Virst Voyage: An Interview with Morton Feldman," with R. Wood Massi, *Cum Notis Variorum* 131 (April 1989): 7–12.

15. The information about these gathering places comes from Irving Sandler, "The Club," in *Abstract Expressionism: A Critical Record*, ed. David Shapiro and Cecile Shapiro (Cambridge: Cambridge University Press, 1990), 48–58. Sandler served as an officer in The Club from 1956 until 1962.

16. Feldman, "Captain Cook's First Voyage," 9.

17. John Cage, *For the Birds: John Cage in Conversation with Daniel Charles* (Boston: Marion Boyars, 1981), 222.

18. Sandler, *The Triumph of American Painting*, 216.

19. Quoted in Irving Sandler, *The New York School: The Painters and Sculptors of the Fifties* (New York: Harper and Row, 1978), 163–64.

20. Sandler, *The New York School*, 163.

21. Cage, *For the Birds*, 222.

22. Feldman, "Captain Cook's First Voyage," 10.

23. Quoted in Bryan R. Simms, *Music of the Twentieth Century: Style and Structure* (New York: Schirmir Books, 1986), 367.

24. The term *mobile* was first applied by Marcel Duchamp to Calder's moving sculptures.

25. Earle Brown, "Notation und Ausführung neuer Musik," lecture presented at Darmstadt, 1964; *Darmstaedter Betraege zur neuen Musik* 9 (1965): 64–86. Quoted in John P. Welsh, "Open Form and Earle Brown's *Modules I* and *II* (1967)," *Perspectives of New Music* 32, no. 1 (Winter 1994): 261

26. The reader will find these and many other writings in Walter Zimmermann, ed., *Morton Feldman Essays* (Kerpen, West Germany: Beginner Press, 1985).

27. Morton Feldman, "Autobiography," in *Morton Feldman Essays*, ed. Walter Zimmermann (Kerpen, West Germany: Beginner Press, 1985), 38.

28. Morton Feldman, "Give My Regards to Eighth Street," in *Morton Feldman Essays*, ed. Walter Zimmermann (Kerpen, West Germany: Beginner Press, 1985), 71–78.

29. Olivia Mattis, "Morton Feldman (1926–1987): Music for the film *Jackson Pollock* by Hans Namuth and Paul Falkenberg," in *Settling New Scores: Music Manuscripts from the Paul Sacher Collection*, ed. Felix Meyer (New York: Pierpont Morgan Library, 1998).

30. Morton Feldman, "Crippled Symmetry," in *Morton Feldman Essays*, ed. Walter Zimmermann (Kerpen, West Germany: Beginner Press, 1985), 136.

31. See Steven Johnson, "*Rothko Chapel* and Rothko's Chapel," in *Perspectives of New Music* 32, no. 2 (summer 1994): 6–53.

32. Feldman, "Captain Cook's First Voyage," 7.

33. Feldman, "Give My Regards to Eighth Street," 74.

34. Morton Feldman, "Predeterminate/Indeterminate," in *Morton Feldman Essays*, ed. Walter Zimmermann (Kerpen, West Germany: Beginner Press, 1985), 47.

[1]

Getting Rid of the Glue

The Music of the New York School

David Nicholls

I

The term *New York School* is usually applied to a number of American visual artists working in and around Manhattan from the early 1940s to the late 1950s. The group included abstract expressionists, abstract impressionists, and action painters; among its leading lights were Mark Rothko (1903–1970), Willem de Kooning (1904–1997), Franz Kline (1910–1962), Jackson Pollock (1912–1956) and Philip Guston (1913–1980). The typical features of New York School art were innovative individual expression and a rejection of past tradition. The sum of the school's activity was a characteristically American radical approach that had much influence internationally: indeed, it has been said that "Abstract Expressionist painting . . . made New York the center of the postwar international art world."[1] Within the school, though, there was no single group style, but rather a number of independent styles: "On the one hand there were painters whose work was wholly or mainly based on gestural drawing: not only [d]e Kooning and Jackson Pollock, but Robert Motherwell [1915–1991] too . . . On the other hand, Clyfford Still [1904–1980], Mark Rothko, and Barnett Newman [1905–1970] relied on large fields of colour to produce solemn and elevated effects."[2] Apart from these artists—who might be thought of as the New York School's first generation—there was also to some extent a second generation, including most pertinently Robert Rauschenberg (1925–) and Jasper Johns (1930–). Although Johns and Rauschenberg have been viewed primarily as important precursors of the pop art that emerged in the late 1950s, "A desire to assimilate but also transcend the lessons of Abstract Expressionism was a strong motivating force in Rauschenberg's early work."[3] The same could be said of Johns.

However, *New York School* has also been used as a term to describe the composers John Cage (1912–1992), Morton Feldman (1926–1987), Earle Brown (1926–) and Christian Wolff (1934–), together with the pianist/composer David Tudor (1926–1996). The group worked together principally during the early 1950s, at times intensively so. Like their colleagues in the visual arts, they rejected past traditions and cultivated innovative, personal expression; equally, there is no single style that identifies them. But their work—individually and collectively—has had a profound influence on contemporary music, particularly in America and Europe.

The primary focus of this chapter is the work of the New York composers; but the use by critics and commentators of an identical term to describe two supposedly separate groups of artists working in different media is no mere coincidence. Rather, it is indicative of the surprising number of links—both personal and professional—that exist between the two groups. Significantly, the music of Cage and his colleagues was in its early years more appreciated by visual artists than by musicians, and several of the composers cite their relationships with painters as a strong influence on their development. Cage was a member in the late 1940s and early 1950s of the Artists Club, which "became the primary arbiter of what would be called abstract expressionism."[4] On three occasions, he was invited to speak to The Club on subjects of his own choosing; these lectures were "Indian Sand Painting or The Picture that is Valid for One Day" (1949), "Lecture on Nothing" (1950), and "Lecture on Something" (1951).[5] He was also an invited contributor to periodicals produced by other Club members, including *The Tiger's Eye* and *Possibilities*. As Caroline A. Jones has noted, "the club was nonetheless ambivalent in its relation to Cage, and he to it."[6] But while there was particular antipathy between Cage and Jackson Pollock—Cage, uncharacteristically, once quite bluntly stated that he "couldn't stand the man"[7]—both for a time shared similar aesthetic views, as the title of Cage's 1949 lecture suggests. Pollock's work was influenced by that of Navaho sand painters, an art form Cage referred to in both his Artists Club talk and a contemporaneous article for *The Tiger's Eye*, entitled "Forerunners of Modern Music."[8]

Cage became particularly associated with another (similarly disaffected) member of The Club, Robert Rauschenberg. Cage's well-known silent piece, 4'33" (1952) was in part inspired by the example of Rauschenberg's all-white and all-black canvasses. Although Cage had imagined as early as 1948, in the context of his autobiographical talk "A Composer's Confessions,"[9] a work he called "Silent Prayer," it only became a reality in 1952 once he had experienced Rauschenberg's work. "I was afraid," said

Cage, "that my making a piece that had no sounds in it would appear as if I were making a joke. In fact, I probably worked longer on my 'silent' piece than I worked on any other. . . . what pushed me into it was not guts but the example of Robert Rauschenberg. His white paintings. . . . When I saw those, I said, 'Oh yes, I must; otherwise I'm lagging, otherwise music is lagging.' "[10] Or, put more succinctly, "The white paintings came first; my silent piece came later."[11]

The twenty-five-year retrospective concert of Cage's music, held in New York's Town Hall in May 1958, was only made possible through the financial support of Rauschenberg and Johns. (Johns had met Cage, probably in 1954, at a party "after one of two concerts of contemporary American and European music that [Cage] had arranged, somewhere on 57th Street."[12]) Although the work of neither Johns nor Rauschenberg had at this stage begun to sell, since 1955—as "Matson Jones"—they had jointly undertaken creating commercial window displays, mainly for Bonwit Teller and Tiffany.[13] In association with entrepreneur Emile de Antonio (who was also middleman in Cage's burgeoning mushroom supply service[14]), Rauschenberg and Johns supported the Cage retrospective both directly, and through the organization of a complementary exhibition at the Stable Gallery; Rauschenberg's work was displayed downstairs, while pages from Cage's music manuscripts were shown upstairs. (It is worth noting that the scores produced by the New York composers are often more akin to visual art than to conventional music notation. The most obvious examples include Cage's *Concert for Piano and Orchestra* of 1957–58, which received its premiere at the Town Hall concert, Earle Brown's *December 1952*, and some of the graphed pieces of Morton Feldman.) The Cage scores shown at the Stable Gallery—several of which were sold—"caused a considerable stir in art circles. The exhibition caught the fancy of the art press; the flavor of the reviews [was] captured in *Art News*' opening observation that 'John Cage exhibits scores in autograph of his own compositions as works of visual art. And they are.' "[15]

Feldman—in an autobiographical essay of 1962—described Philip Guston as his "closest friend who has contributed so much to my life in art."[16] (Feldman had first met Guston, probably in 1950, in Cage's Monroe Street apartment, part of the so-called Bozza Mansion in which Feldman himself subsequently became a tenant.) Feldman's essays are peppered with stories about Guston and other artists, and the importance of artistic concepts to his work is apparent from a number of quotations appearing later in this chapter. It might also be noted that (on the recommendation of Cage) Feldman provided the soundtrack for a 1951 documentary film

about Jackson Pollock,[17] and that a number of Feldman's works—including *For Franz Kline* (1962), *De Kooning* (1963), *Rothko Chapel* (1971), and *For Philip Guston* (1984)—are either dedicated to New York School artists or refer to them in their titles. Earle Brown, too, has been profoundly influenced in his music by the work of visual artists, especially Jackson Pollock and sculptor Alexander Calder (1898–1976).

The New York School composers came together rather serendipitously, as Feldman has explained: "My first meeting with John Cage was at Carnegie Hall when Mitropoulos conducted the Webern Symphony [on January 26, 1950]. The audience reaction to the piece was so antagonistic and disturbing that I left immediately afterwards. I was more or less catching my breath in the empty lobby when John came out. I recognized him, though we had never met, walked over and, as though I had known him all my life, said, 'Wasn't that beautiful?' . . . We immediately made arrangements for me to visit him."[18] Cage was by this time well established as a leading figure in the American avant garde and was beginning to receive recognition in Europe. He had achieved some notoriety for his percussion music (a 1943 concert at the Museum of Modern Art had been covered in detail by *Life* magazine) and for his development of the prepared piano (a concert grand whose sound is fundamentally changed through the insertion between its strings of various objects, including pieces of metal and rubber). In January 1949, his large-scale prepared piano piece *Sonatas and Interludes* (1946–48) had been well received at its Carnegie Hall premiere, performed by Maro Ajemian. Feldman, in complete contrast, was an unknown student of the composers Wallingford Riegger (1885–1961) and Stefan Wolpe (1902–1972).

Feldman noted that he had already become friends with David Tudor while studying with Wolpe, and that it was he who introduced Tudor to Cage.[19] Shortly afterwards, in April 1950, Christian Wolff—a high-school student wishing to study composition with Cage—joined the group as a result of contacts through another pianist, Grete Sultan.[20] Earle Brown's initiation took place only two years later, in 1952; he and his wife moved east from Denver in response to an invitation from Cage and his partner, choreographer Merce Cunningham (1919–). Carolyn Brown was to dance in Cunningham's company, while Brown himself was to participate in Cage's "Project for Music for Magnetic Tape." This project was funded by Paul Williams (dedicatee of the 1953 *Williams Mix*), who—like Robert Rauschenberg—was a former student of Black Mountain College, which Cage and Cunningham had first visited in the summer of 1948.[21]

Feldman's memory of subsequent events, chronological inaccuracies notwithstanding, gives some indication of their intensity and sense of

excitement: "Between 1950 and 1951 four composers—John Cage, Earle Brown, Christian Wolff and myself—became friends, saw each other constantly—and something happened."[22]

||

In his article "History of Experimental Music in the United States," Cage writes, "[Henry] Cowell remarked at the New School before a concert of works by Christian Wolff, Earle Brown, Morton Feldman, and myself, that here were four composers who were getting rid of glue. That is: where people had felt the necessity to stick sounds together to make a continuity, we four felt the opposite necessity to get rid of the glue so that sounds would be themselves."[23] If, in the abstract expressionist painting of the late 1940s, "[t]he composition [had] dissolved into a seething field of fragments dispersed with almost equal intensity throughout the picture,"[24] then the main way in which the New York composers managed to "get rid of the glue" was through a radical redefinition of the relationship between notation and performance. By the early 1950s, in both Europe and America, composers were making extreme demands on performers: this is demonstrated by the opening pages of two of the twentieth century's most notorious works, Cage's 1951 *Music of Changes* and the first book of *Structures* by the French composer Pierre Boulez (1925–), written in the following year. A brief description of these pieces will make clear the problems they present.

In Boulez's *Structures*, Schoenbergian serialism is applied not just to pitch but also to dynamics, attack, register, tempo, and density. The skills required by its two pianists include extraordinary rhythmic precision, both individually and collectively, combined with an ability to throw the hands about the keyboard in an untraditional manner; and an acute sense of dynamic range and contrast. Cage's *Music of Changes*, written for a single pianist, is not dissimilar in its demands, though here the performer has additionally to decipher the notational difficulties associated with the concurrent use of an overall rhythmic structure combined with changing tempi, and of a space-time notation where a quarter note equals 2½ centimeters (see figure 1.1). Thus, in the first three measures, the tempo accelerates rapidly from quarter note = 69 to quarter note = 176; during the next five measures, it decelerates more gradually to quarter note = 100, where it temporarily stabilizes. A number of notes in this passage carry fractional qualifiers indicating nonstandard durations; furthermore, pedaling is

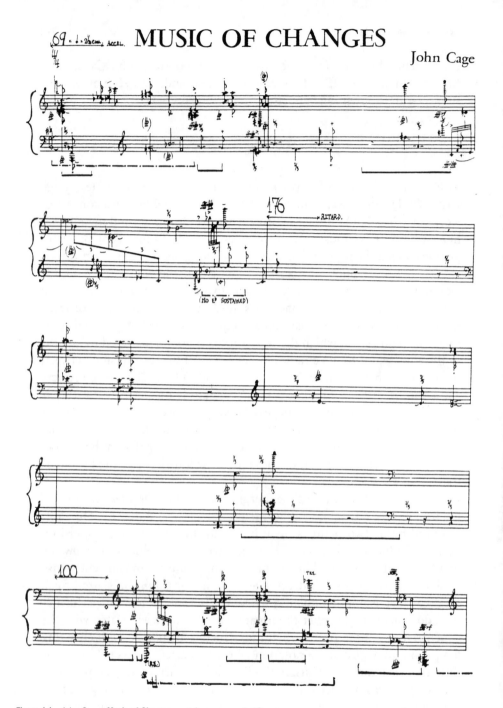

Figure 1.1 John Cage, *Music of Changes*, part 1, measures 1–10. © 1961 by Henmar Press Inc., New York. Reproduced by permission of Peters Edition Limited, London.

detailed to a fine point (for instance in measures 1 and 9–10) and the piece includes tone clusters (end of measure 10), unsounded notes (start of measure 1), and extraneous sounds. The dynamics, like those in *Structures*, range from *pppp* to *ffff*.[25]

These complexities were discussed by Cage in an interview, who noted, "If you look at the *Music of Changes* you see that every few measures, at every structural point, things were speeding up or slowing down or remaining constant. How much these things varied was chance-determined. David Tudor learned a form of mathematics which he didn't know in order to translate those tempo indications into actual time. It was a very difficult process and very confusing for him."[26]

Cage completed *Music of Changes* in December 1951, less than a month before Tudor gave its first performance at New York's Cherry Lane Theater. Yet if its notation (and, for that matter, sound) are compared with those of *Music for Piano 4-19* (March 1953) finished approximately fifteen months later, it is clear that a dramatic change has come about. The notation in Figure 1.2 no longer shows the obsessive precision of that for *Music of Changes*. It again suggests a space-time format in which duration is understood in terms of the relative positions of the notes on the stave. But here, no exact rhythms are associated with the pitches—all notes being rendered as neutral whole notes—and the velocity of the music is uncontrolled: the score simply includes the instruction "tempo (or changing tempi) free," in stark contrast to the exact tempi—static, accelerating, or decelerating—of the earlier piece. The durations of the notes are therefore determined not by the composer but by the performer (who chooses the dynamics and placement points of the attacks) and by the sustaining power of the instrument being played. Thus the score—unlike that of *Music of Changes*—is to an extent indeterminate of its performance. All that Cage specifies in absolute terms are the pitches, their associated timbres (open, muted, or plucked), and the resonant sound that results from the pedal being depressed throughout.

It is perhaps surprising to realize, then, that both *Music of Changes* and *Music for Piano 4-19* were written using the same compositional tool, the *I Ching*, or *Book of Changes*, which Cage had discovered through Christian Wolff. Wolff, in exchange for his composition lessons, brought Cage books published by his father, Kurt.[27] Wolff senior was founder of the Pantheon Press, which had published an English translation of the *I Ching* in 1950. Cage was immediately struck on opening the *I Ching* by the correlation between its contents and the charts he had already been using as a compositional tool in works like "the *Sixteen Dances* and the Concerto for Pre-

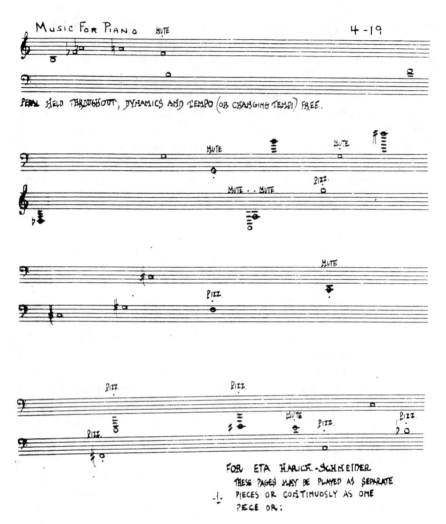

Figure 1.2 John Cage, *Music for Piano 4-19*, page 1. © 1960 by Henmar Press Inc., New York. Reproduced by permission of Peters Edition Limited, London.

pared Piano and Chamber Orchestra [both 1950–51]. Both of those use a chart like the Magic Square . . . Instead of having numbers, as the Magic Square would, the chart of course had single sounds, intervals, and aggregates. . . . It was while I was doing such work that Christian Wolff brought me a copy of the *I Ching*. . . . I immediately saw that the [*I Ching*'s 64-hexagram] chart was better than the Magic Square.[28] . . . right then and there I sketched out the whole procedure for my *Music of Changes*, which took its title from the book.

I ran over to show the plan to Morty Feldman, who had taken a studio in the same building, and I can still remember him saying, 'You've hit it!' "[29] Such was the impact of the book that to the end of his life, Cage composed using chance methods analogous to those employed when consulting the *I Ching.*

As well as their use of the same compositional tool, *Music of Changes* and *Music for Piano 4-19* also share the same ideological viewpoint: that music should be released from intention, and that the sounds should be allowed to be free. What changed in the interim was Cage's basic attitude to what should—and should not—be specified by the composer, and to the performer's role in interpreting the work.

III

The crucial notational and ideological changes in Cage's work of the early 1950s came about as a result of his meetings with Feldman, Wolff, and Tudor. Only nine days before the Carnegie Hall concert at which he met Feldman, Cage had written to Boulez, "The great trouble with our life here is the absence of an intellectual life. No one has an idea. And should one by accident get one, no one would have the time to consider it."[30] Yet within months, that had changed: "Things were really popping all the time. Ideas just flew back and forth between us, and in a sense we gave each other permission for the new music we were discovering."[31] Wolff and Feldman have supported this view. Wolff relates: "The people we were writing for were basically each other . . . what you would do [with your work would be to] show it to Cage or Feldman or [later on] Brown, and they would say, "Yes, it's great, it's wonderful. Look what I've been doing." It was that kind of interactive situation. . . . until Earle [Brown] came along, [Feldman and I] were the two composers that [Cage] was the most interested in, because we were doing stuff that he had never seen before and that he happened to like. And there were new ideas floating around . . ."[32] Feldman notes that "each of us in his own way contributed to a concept of music in which various elements (rhythm, pitch, dynamics, etc.) were de-controlled. Because this music was not 'fixed,' it could not be notated in the old way. Each new thought, each new idea within this thought, suggested its own notation."[33]

The relationships among the members of the group were clearly very intense at this stage, but also somewhat haphazard. As Wolff recollects, "I'd come down [to Monroe Street] around lunch time and bring some-

thing to eat. Then [Cage and I would] have lunch and then go to work . . . when all three of us [Cage, Feldman, Wolff] were together, we would mostly go out for meals, or I would go to Cage for a lesson or a visit, and then on our way out we'd stop by—Feldman was like two floors down—and see if he was in. And if he was in, he'd show us what he was doing. So I would see him mostly with Cage."[34]

Inevitably, given the age gap between Wolff and the others, he spent less time at this stage with Cage than did Feldman and Tudor: "Cage had a whole life of his own, and I was a kid, so that it wasn't as though I suddenly jumped into his personal life; he and I talked mostly about music . . . We didn't talk a whole lot, I think, about nonmusical ideas and such."[35] With Feldman, however, the situation was quite different: "There was very little talk about music with John. Things were moving too fast even to talk about. But there was an incredible amount of talk about painting. John and I would drop in at the Cedar Bar at six in the afternoon and talk until it closed."[36]

For Feldman, "the new painting made me desirous of a sound world more direct, more immediate, more physical than anything that had existed heretofore. Varèse had elements of this. But he was too 'Varèse.' Webern had glimpses of it, but his work was too involved with the disciplines of the twelve-tone system. The new structure required a concentration more demanding than if the technique were that of still photography, which for me is what precise notation had come to imply."[37] Indeed, so visually oriented did Feldman's compositional aesthetic become that he "used to work by putting his manuscripts on the wall so that he could step back and look at them the way an artist looks at a picture. I'm not sure about this, but I have a feeling sometimes he might have thought of something to do 'down here,' and then go back 'up here.' It was really like a canvas rather than a linear, narrative structure."[38]

In fact, it was Feldman rather than Cage who made the decisive move away from traditional notation and toward graphic representation: "Feldman left the room one evening, in the midst of a long conversation, and returned later with a composition on graph paper."[39] The work in question was *Projection 1*; remarkably, it was completed in 1950, before Cage had even commenced—let alone finished—the precisely notated and therefore "photographically still" *Music of Changes*.[40]

Projection 1 (the opening of which is shown in figure 1.3) allows only indeterminacies of pitch. The instrumentation, for solo cello, is specified. The signs ◊, P, and A refer to three kinds of timbral production, respectively harmonic, pizzicato, and arco. Within each of these timbral systems, *relative* pitch (high, medium, and low range)—but not specific pitch—is

PROJECTION 1 *Morton Feldman*

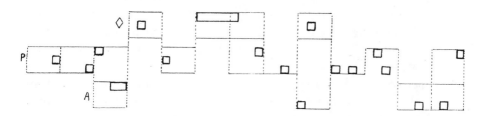

Figure 1.3 Morton Feldman, **Projection 1**, page 1. © 1962 by C. F. Peters Corporation, New York. Reproduced by permission of Peters Edition Limited, London.

shown. Feldman states in the score that "any tone within the ranges indicated may be sounded. The limits of these ranges may be freely chosen by the player." Although the score appears to suggest space-time notation, relative duration is in fact given: each dotted box is described as being equivalent, potentially, to four pulses at a tempo of about 72 beats per minute. Although no dynamics are indicated, it can be safely assumed that—as is normal with Feldman—they are of a low level and that silence is used as an important structural and gestural device.

Graphs similar to that of *Projection 1* were used in five more pieces over the next few months: *Projection 2*, for flute, trumpet, violin, cello, and piano (January 3, 1951); *Projection 3*, for two pianos (January 5, 1951); *Projection 4*, for violin and piano (January 16, 1951; the published score is written in Cage's hand, rather than Feldman's); *Projection 5*, for three flutes, trumpet, three cellos, and two pianos (1951); and *Intersection 1*, for orchestra (February 1951). Unsurprisingly, given his enthusiasm for painting and his aesthetic asceticism, Feldman habitually exhibited the same tendency toward abstract nomenclature as did many of the New York School artists. Extreme examples of the latter would include Jackson Pollock's *Untitled* (1946) and *Number 32* (1950), Clyfford Still's *1947-Y* (1947), Franz Kline's *Painting Number 7* (1952), and Mark Rothko's *Ochre and Red on Red* (1954).

There are a few refinements to *Projection 1*'s notational norms found in these new graphs: the inclusion of numbers within boxes indicates the number of sounds to be played simultaneously by the instrument in question; and the writing for piano tends to be presented on two staves,

one for sounded pitches, the other for silently depressed harmonic pitches (which give off sympathetic resonance). In *Projection 5*, the three cellists are allotted only one stave each, but ◊ (harmonic), A (arco), P (now indicating ponticello), and Pz (pizzicato) signs are employed to vary their timbres. The cellos and trumpet are muted; the latter plays into the belly of one of the pianos, adding further sympathetic resonance to the texture.

Intersection 1, dedicated "to John Cage," is in many respects the most radical of the early graphs. The score is notated on only four staves, one each for winds, brass, violins plus violas, and cellos plus basses. The details of the instrumentation, and the numbers of pitches in each chord, are unspecified and as a consequence indeterminate. The brass and strings are all muted and the score requests that "a minimum of vibrato should be used throughout by all instruments." Unusually, the dynamics "are also freely chosen by all players," allowing the possibility of amplitudes other than the customary "very low," though "once established, [a dynamic level] must be sustained at the same level to the end of the given time duration." Finally, in another major change to his previous practice, Feldman indicates that "the performer may make his entrance on *or within* each given time duration" (my emphasis), which frees up the rhythmic aspect of the work considerably.

It might be added that both visually and aurally, many of these early graph pieces are suggestive of the work of Barnett Newman and particularly Mark Rothko. When Robert Hughes writes, "This format enabled him to eliminate nearly everything from his work except the spatial suggestions and emotive power of his colour, and the breathing intensity of the surfaces, which he built up in a most concentrated way" he could as well be describing Feldman's compositions as Rothko's contemporary canvases.[41]

For the remainder of 1951 and the whole of 1952, Feldman returned mainly to the use of conventional notation; of a total of nine pieces, only two—*Marginal Intersection*, for orchestra (completed July 7, 1951) and *Intersection 2*, for piano (dedicated to David Tudor and finished in August 1951)—use graphs. Furthermore, the graphs employed show an increased attempt on Feldman's part to control the sounds made. *Marginal Intersection* is far more specific in its instrumentation than *Intersection 1* had been. Here, there are six staves: the first is for winds, the second for brass, and the third for six percussionists playing a large selection of wood, glass, and metal objects. The fourth stave is for amplified guitar, piano, and a sound effects record of riveting; the fifth is for two oscillators (one high fre-

quency, the other low); and the sixth is for strings. Each of the staves is subdivided: as in the earliest graphs, winds, brass, and strings have three pitch ranges: high, medium, and low. The percussion stave is divided threefold, allowing one "range" for each of its timbral families. (Feldman specifies that the wood group should include a xylophone and the metal group a vibraphone; each is encouraged to vary its mallets whenever possible and to choose sounds from any register.) The fourth stave is again divided threefold, each instrument occupying one "range": the piano and guitar, like the keyboard percussion, have free choice of register. The fifth stave has two "ranges," one for each oscillator.

In its reliance on short sounds (and in its colorful instrumentation) *Marginal Intersection* reminds us of the early pointillist atonal music of Anton Webern; in its leaning toward the "noise" of percussion and nonorchestral sounds (the riveting record and the oscillators) it evokes the Edgard Varèse of *Ecuatorial* (1934) and the Cage of *Imaginary Landscape No. 1* (1939). But while *Marginal Intersection* in some respects grows naturally out of its graphed predecessors (and especially *Intersection 1*), in other ways it is quite different. As the piece progresses, the instrumentation is increasingly determined by Feldman: from page 9 of the score, there are specified "solos" for bass clarinet, flute, trumpet, bassoon, horn, piccolo, trombone, contra bassoon, and alto saxophone. From page 5, the signs X / X+ and V / V+ indicate whether the xylophone and vibraphone are to play by themselves, or in combination with other wood or metal instruments; and on page 10, Feldman instructs that the vibraphone pedal be depressed. Similarly, despite the initial instruction that dynamics are "freely chosen by the players," from the approximate mid-point of the piece the signs S (soft) and L (loud) are increasingly used in boxes to specify the relative amplitude. In the piano piece *Intersection 2*, meanwhile, the elaborate use of numbers to show the quantity of pitches to be played at any given time is indicative of the virtuosity of its dedicatee, as is the use of extended techniques ("elbow" on page 9, "flat of hand" on page 11). Additionally, boxes are no longer subdivided into four pulses; rather, each box itself becomes a pulse.

During 1953 Feldman wrote both conventional scores—*Extensions 4*, for three pianos (late summer 1952–April 1953), and *Eleven Instruments* (December 1953)—and graphs: *Intersection 3*, for piano (April 1953), and *Intersection 4* for cello (November 22, 1953). The graphed pieces are similar to those of 1952; but there is also one example—completely isolated in Feldman's output and possibly prompted by Earle Brown, who by now had joined the group—of a mobile score. *Intermission 6*, for one or two

pianos (1953), consists of fifteen isolated musical elements distributed over a single page: some events contain one note, others more; the largest chord has but four pitches. The "composition begins with any one sound and proceeds to any other"; there should be "a minimum of attack . . . each sound [being held] until barely audible." *Intermission 6* is thus indeterminate in both its duration(s) and in the order of its pitched events.

Perhaps surprisingly, no more notational experiments occurred until 1957. After this time, the number of graphs in the earlier style is relatively small (for example *Ixion*, August 1958); instead, Feldman adopts a new system in which pitch is specified but rhythm and duration (either collectively or individually) are not. This can lead to two results. In the case of works like *Piece for 4 Pianos* (1957), several performers play the same material simultaneously, but each chooses his own durations for the pitches or chords: the effect is thus heterophonic. With *Piano (Three Hands)* (December 1, 1957), vertical coordination between the performers is specified; but the durations of the chords they play are not.

Cage once attempted to explain Feldman's veering between conventional and experimental notation in these years by stating that "Feldman's conventionally notated music is himself playing his graph music."[42] In fact, nothing could be further from the truth, the two types being quite distinct. The graph pieces—especially the earlier ones—tend toward a pulsed rhythmic stasis. The notated pieces, meanwhile, are rhythmically precise, often introducing subdivisions of the basic pulse. Interestingly, several also appear to be based in numerology (for want of a better word), at least in part. For instance, the first of the *Two Intermissions*, for piano (1950), consists of ninety-six eighth notes at a pulse of 69 eighths per minute; *Piece for Violin and Piano* (December 17, 1950) contains forty-eight measures at a pulse of eighth note = 84. Similarly, *Structures*, for string quartet, was written in March 1951 and consists of 951 eighth notes. Whatever Feldman's intentions may have been in these works, they contain a statistically unlikely level of numerological coincidence and consistency; in other words, the same numbers keep turning up. (Whether this relates obliquely to Cage's numerological practices, including square-root form, I have been unable to discern.) *Structures* also contains several extended passages remarkable for their use of a feature almost never encountered in the graphs, but very prophetic of Feldman's late music: the (Webernesque or Cagean?) repetition of tiny ostinati, either exactly (as in figure 1.4) or in minute variation.

The *real* explanation of Feldman's various notational U-turns of this period, as well as of his increasing tendency toward specificity in the

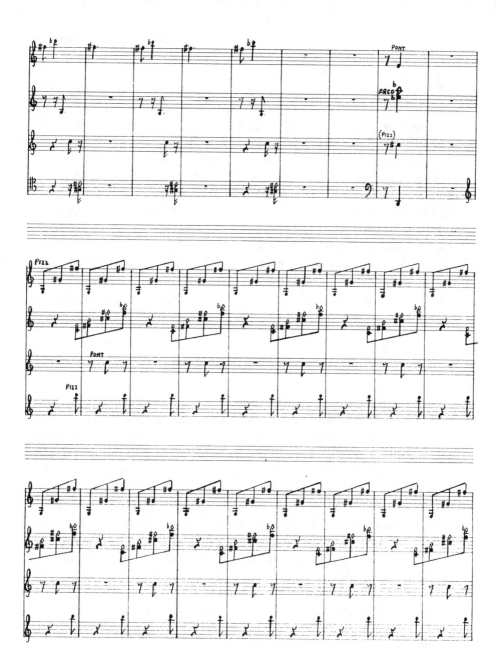

Figure 1.4 Morton Feldman, *Structures*, page 5. © 1962 by C. F. Peters Corporation, New York. Reproduced by permission of Peters Edition Limited, London.

graphed pieces, lies in the shared desire of the New York School composers to "unfix" music's traditional parameters (rhythm, pitch, dynamics, etc.) in such a way that the sounds could exist as themselves, rather than as "symbols, or memories which were memories of other music to begin with."[43] But in Feldman's own music, there is the additional wish that both freedom and control operate together. Thus he found the graphs flawed because "I was not only allowing the sounds to be free—I was also liberating the performer. I had never thought of the graph as an art of improvisation, but more as a totally abstract sonic adventure."[44] Precise notation, however, was equally limiting: "It was too one-dimensional. It was like painting a picture where at some place there is always a horizon. Working precisely, one always had to *'generate'* the movement—there was still not enough plasticity for me."[45] Only in the "free durations" pieces from 1957 onward did Feldman begin to find acceptable solutions to the problems he perceived.

IV

In direct opposition to Feldman, for Earle Brown the freeing of the performer was precisely what attracted him to the new graphic notations that he encountered when he joined the group in 1952. Brown has stated, "It is my responsibility to create and produce sound material, and by verbal and graphic means, making a strong impression on the performer. If I do my job well, I get back varying versions, all acceptable to me."[46] Thus *December 1952*, taken from Brown's collection entitled *Folio* (1952–53), is open to widely and wildly differing interpretations. The score (shown in figure 1.5) consists of a single sheet of card stock (sized approximately 12 x 16 inches), on which are drawn a variety of lines and rectangles of different thicknesses and lengths. In total there are thirty of these symbols, twenty lying horizontally and the remainder vertically in relation to Brown's signature, which appears in the bottom right hand corner of the score. However, the sheet may be placed on any of its four sides, and thus "read" in four basic ways.

December 1952 is a truly graphic score in that nothing is specified; rather, everything is to be interpreted along the lines suggested in Brown's accompanying note. His intention was "to have elements exist in space, space [being] an infinitude of directions from an infinitude of points in space . . . to work (compositionally and in performance) to right, left, back, forward, up, down, and all points between . . . the score [being] a

Figure 1.5 Earle Brown, *December 1952*. Copyright © 1961 (renewed) by Associated Music Publishers, Inc. (BMI). Reproduced by permission.

picture of this space at one instant, which must always be considered as unreal and / or transitory . . . a performer must set this all in motion (time), which is to say, realize that it is in motion and step into it . . . either sit and let it move or move through it at all speeds."[47]

Thus the composition can be played by one or more instruments and/or sound-producing media, and may be performed in any direction from any point in the defined space for any length of time. This does not, of course, give the performers permission to do anything they like; but the flexibility of the notation *does* allow them a remarkable degree of freedom in the way they interpret the piece.

As I've already noted, Brown's work during this period was greatly influenced by contemporary visual art. Although such influence inevitably intensified following Brown's arrival in New York, it had existed previously.

Of particular interest was the work of Jackson Pollock; Brown felt that the "dynamic and 'free' look of the work and the artistic and philosophical implications of Pollock's work and working processes seemed completely right and inevitable. In a sense it *looked* like what I wanted to *hear* as sound and seemed to be related to the 'objective' compositional potential of Schoenberg's twelve equal tones related only to one another and Schillinger's mathematical way of generating materials and structures, even though the painting technique was extremely spontaneous and subjective."[48] Before 1952, Brown had both studied and taught the Schillinger method, as well as being a performer, on trumpet, of both art music and jazz. His early music shows a clear knowledge of both Joseph Schillinger and Arnold Schoenberg.

However, the principal artistic influence on Brown lay elsewhere, in the work of sculptor Alexander Calder. Indeed, Brown's language in describing *December 1952*, quoted earlier, is already suggestive of the experience of watching mobile sculpture. Brown has written of Calder's idea "of making 'two or more objects find actual relation in space.' This was the first feature of his new approach: the organization of contrasting movements and changing relations of form in space. It seemed to me that it might be possible to bring about a similar 'mobility' of sound-objects in time."[49]

Brown himself has admitted, however, that "[t]he extremely high degree of notational ambiguity and notational freedom in *December 1952* seemed to be as far as I could go in that direction and the notational and performance process discoveries were applied to [later] works in a far more normal compositional way, in both closed and open-form works."[50] Certainly, *December 1952* is the most notationally adventurous of the pieces in *Folio*, the remainder of which rely more or less on conventional forms of notation. Of the two earlier works in the collection, *October 1952*, for piano—despite the apparent absence of clefs—is unusual only in its lack of rests. In Brown's words, "The total time-duration of the piece and the implied metrical-time relationships between events are to be determined by the performer. The absence of rests produces an intentional ambiguity and is intended to eliminate the possibility of a metrically rational performance."[51] *November 1952* ("Synergy"), for piano(s) and/or other instruments or sound-producing media, takes things a little further: conventional pitch/rhythm/dynamic notations are placed on a (necessarily clefless) fifty-line stave. Brown's note employs similar language to that of *December 1952*; and although the score looks one-dimensional, the work is in fact "To be performed in any direction from any point in the defined space for any length of time." The tempo is fluid—"as fast as possible to as

slow as possible . . . inclusive"—and "the frequency range will be relative to that of each instrument performing the work."[52]

After the graphic extremes of *December 1952*, the next two items in *Folio* are conventionally notated; *MM-87* and *MM-135* (both March 1953) "were composed very rapidly and spontaneously and are in that sense performances rather than compositions."[53] However, while each is for solo piano, Brown allows for the possibility of the two pieces being performed simultaneously by two pianos. *Music for "Trio for Five Dancers"* (June 1953), meanwhile, is written for piano and/or other instruments. Here Brown transcribes a floor plan of "spatial patterns of a dance by Carolyn Brown" into "a 'literal' and indigenous sound-event in comparable time."[54] The resulting score bears an interesting resemblance to those of Cage's *Music for Piano* series (begun six months earlier in December 1952), in which the "transcriptions" had been of imperfections in the paper being written on. In *Four Systems* (January 1954)—which was published in tandem with *Folio*—Brown returns to many of *December 1952*'s conventions, the score being in some ways redolent of a roll for player piano.

One senses that Brown, like Feldman, was striving to find ways in which his control over the material could be balanced against a new freedom on the performers' parts. This he achieved in two ways, each of which seems to relate in some degree to his background in jazz. First, in *Folio*'s final item—*March 1953*, for piano—Brown arrived at the basis of a notational system that served him well for a number of years. This system appears in *March 1953*, as well as in the work for which it was a study—*Twenty-five Pages*, for one to twenty-five pianos (1953)—and several others, including *Music for Cello and Piano* (1954–55). Generally speaking, in Brown's "time-notation" (as he termed it), pitch and dynamics are specified precisely, but durations (both successive and simultaneous) only loosely. In *March 1953* and *Twenty-five Pages*, there are additional flexibilities, in that "each page may be performed either side up [and] events within each two-line system may be read as either treble or bass clef" (which leads to the use of some novel dynamic signs).[55] But—as figure 1.6 shows—in *Music for Cello and Piano*, the score is conventional, except in its independence from a strict pulse or metric system. Relative durations are thus suggested by the physical lengths of the pitches on the page. (Again, the score in some ways resembles a player piano roll, albeit one superimposed on a series of conventional five-line staves.) With the general proviso that "Each system is to be played in a *maximum* of 15 seconds," Brown states, "The durations are extended visibly through their complete time-space of sounding and are precise relative to the space-time of the score. It is expected that the per-

8

AMP-96123-12

Figure 1.6 Earle Brown, *Music for Cello and Piano*, page 8. Copyright © 1961 (renewed) by Associated Music Publishers, Inc. (BMI).

Reproduced by permission.

former will observe as closely as possible the 'apparent' relationships of sound and silence but act without hesitation on the basis of [his] perceptions. It must be understood that the performance is not expected to be a *precise* translation of the spatial relationships but a *relative* and more spontaneous realization through the involvement of the performer's subtly changing perceptions of the spatial relationships. The resulting flexibility and natural deviations from the precise indications in the score are acceptable and in fact integral to the nature of the work."[56]

The second way in which Brown balanced control and freedom was in the development of "open forms" that are clearly connected to the mobiles of Alexander Calder. "Open form" is most typically found in two pieces from the early 1960s: *Available Forms 1* (1961) for chamber ensemble, and *Available Forms 2* (1962) for large orchestra with two conductors. The score of the former work consists of six unbound pages, each containing four or five events. Brown states, "The conductor may begin a performance with any event on any page and may proceed from any page to any other page at any time, with or without repetitions or omissions of pages or events, remaining on any page or event as long as he wishes."[57] In addition, the conductor has *general* control over the loudness and speed with which events are performed. Thus his function is "analogous to that of a painter who has a canvas (time) and colors (timbre) and the possibility of working with the medium."[58] Individual performers also have certain freedoms: while pitch is for the most part specified exactly, duration—as with the "time-notation" pieces—is not. Overall, Brown notes, "there is a high degree of 'plasticity' inherent in the work, and this plasticity is an indispensable element which engages the performers, the conductor, and myself in the immediacy and life of the work."[59] To what degree such procedures are truly analogous to those of the visual arts is, however, a moot point: painters and sculptors, after all, are able to communicate directly with the public rather than through such intermediaries as performers and conductors.

V

Although Christian Wolff had been a member of the New York School since its earliest days, joining in April 1950, he was always to some extent an outsider. First, he was significantly younger than the other members of the group. Second, and relatedly, his financial and social position was quite different from theirs: Cage, Feldman, Tudor, and—later—Brown

had to struggle to earn a living, while Wolff's passage through high school and college was financed by his parents. Third, his attitude to contemporary visual art was more distanced than that of his colleagues. As he has said in an interview, "I had an awareness of modern art in a general sense, but I never made a big deal out of it, partly because I didn't feel I had to. I thought that that was sort of taken care of. I've met these artists, and I loved their work. I still do. But I've never written about it or tried to do anything like that.... (Incidentally, if there was one artist I was interested in just as I was starting to compose, it was [Paul] Klee [1879–1940].)"[60]

Indeed, the closeness of the group in its early years notwithstanding, such was the perceived difference between Wolff and Feldman that the latter could state, in 1989, "I can't figure out what [Wolff's] concerns are—never could figure it out . . . I never had any conversations with Christian.... An early string quartet of his [*Summer*, 1961] is dedicated to me for no reason whatsoever."[61] There was a similar lack of comprehension on Wolff's part, as he notes that "it never crossed my mind to use the ideas of Feldman. Feldman, arguably, has no ideas. In a way, he's just Feldman. He's very hard to appropriate."[62]

When he first visited Cage, Wolff's compositions "were most affected by the Viennese School, sort of Schoenberg and Webern. But the other thing that I got into doing, which was unlike even that, was very dense, highly dissonant counterpoint—so dense that it would be, in effect, like a moving cluster."[63] Cage's initial reaction was very positive: "He said, 'I like this, I like that' . . . 'Okay, I'll take you on. I won't charge you anything,' without even asking if I could pay or anything. I think it was on the principle that Schönberg had taken him on without pay that he decided to do that."[64] Wolff's tuition was in stages: "We had, I think, basically three projects. He wanted me to do counterpoint exercises—species, sixteenth-century counterpoint. . . . Then he wanted me to analyze the Webern Symphony. . . . and then the last project was essentially composition."[65]

In a sense, Wolff learned at two levels with Cage. First, there was the indirect learning that came about through association generally with the other New York School composers and specifically with Cage: "[A]t the time, Cage must have been working on the Concerto for Prepared Piano and [Chamber] Orchestra—that and then the *Sixteen Dances*. I also remember being down there when he was working on the *Music of Changes*. So those are the three pieces I kind of lived through."[66] Second, Wolff was given specific composition projects by his teacher: "What Cage thought I needed to learn about was structure, and so he taught me about

his 'rhythmic structure' technique and gave me exercises to do . . . sort of very short pieces . . . like a one minute piece using only one melodic line with just five or six notes in a given rhythmic structure."[67] The composition exercises involving restricted materials gelled with various other influences to produce a sparse style not dissimilar to those encountered in—for instance—Cage's *String Quartet in Four Parts* (1949–50) and Feldman's *Structures* (March 1951). Yet, although Wolff continued to rely on conventional notation for much of the 1950s, he was still able to let sounds be themselves—and to give the sounds of his own works a most distinctive character—through the extraordinary concentration in each of his compositions on limited groups of pitches.

Typical of Wolff's earliest music is *Trio I* (January 1951), composed for a Feldmanesque ensemble of flute, trumpet, and cello and dedicated to Cage. As may be gleaned from figure 1.7, only four pitches—G3, A4, A♭5, and C6—are used during the work's approximate six-minute duration; the rhythms (again suggesting links with Feldman and Cage) are almost all eighth notes or eighth-note multiples; and each of the three instrumental lines contains many rests. Yet despite the casual, cool surface appearance of the music, both pitch and structure are organized very tightly. As Wolff notes, "I decided that if you have [three pitches] and you play them each in succession, those are three discrete sounds. However, if you play pitch[es] one and two simultaneously, that makes a new sound. . . . if you work out all the possible combinations, you end up with, as it happens, twelve different sounds generated by three notes on two instruments. I'd schematize them and then make what almost amounted to tone rows, but they would be, as it were, monophonic, melodic tone rows, but made up of complexes that required in this case, two instruments. I went up to nine instruments in my last work of this type [*Nine*, 1951]."[68]

In *Trio I*, four pitches are permutated by three instruments. However, the pitch permutations—and also dynamics—articulate a durational structure derived from the square-root form that Cage had employed in his works since 1939. Wolff notes, "In John's system, once you set up your rhythmic structure—it's in 2–4–1, let's say—you then repeated it over and over again. . . . You do 2–4–1 twice, then you do it four times, you do it once, but you're always doing 2–4–1. And I found that tiresome, so instead of doing 2–4–1 twice, I simply multiplied the whole line by two and got 4–8–2, and so forth."[69]

In the specific case of *Trio I*, the basic duration formula is 2–1–1½–4–1; each element is multiplied by each of the other elements and itself to give the durations (and, as a consequence, internal proportions) of the work's

To John Cage

TRIO I
for
Flute, Trumpet and Violoncello

CHRISTIAN WOLFF

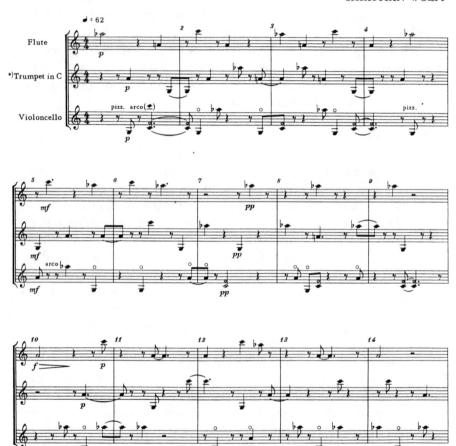

*) the part for the player is printed for Trumpet in B♭

Figure 1.7 Christian Wolff, *Trio I*, page 1. © 1963 by C. F. Peters Corporation, New York. Reproduced by permission of Peters Edition Limited, London.

five sections. Thus, in figure 1.7, the basic formula is multiplied by its first element—2—to generate the sequence 4–2–3–8–2. This internal structure is articulated by pitch patterns and dynamics: measures 1–4 are *piano* throughout, with each of the three instruments restricted to three of the four available pitches. In measures 5–6 the dynamic is raised to *mf* and the pitch patterns change; for the next three measures (mm. 7–9) the dynamic drops to *pp* and the patterns change again. The subsequent eight-measure subsection (starting in m. 10) is heralded by a dynamic outburst on the flute; and so on.

The importance of these durational structurings to Wolff's work cannot be overemphasized: "I used them for the next fifteen or twenty years. It seems to me the one single technical thing that I learned from John that was completely useful in every possible way. It really helped me a lot working with these scaffoldings."[70] As with Earle Brown's graphs, though, there was a limit to how far Wolff's reductionism could go: "I could have become a minimalist in my time. I'm sort of the protominimalist with those early pieces. But I decided that I had done it, and I needed to move on, and Boulez gave me a little shove."[71] The "little shove" came during the summer of 1951, when—as a high school graduation present—Wolff's parents took him to Europe. In Paris, with Cage's encouragement and introduction, Wolff spent approximately a week with Boulez: "I showed him these pieces with just these few notes, and he said, 'Well, this is very nice, this is all very well, but you know there are a lot more notes out there.' He couldn't see it. So as a kind of response to that, the next piano piece I wrote I made a point of using all eighty-eight keys. I sort of blew the whole thing up."[72] (In fact, Wolff's *next* piano piece—*For Piano I* (February 1952)—still used a restricted pitch palette; the piece "using all eighty-eight keys" was actually its immediate successor, *For Piano II*, completed over a year later in March 1953.)

This marked the beginning of Wolff's second style, in which the existing durational structures were filled with "a lot of notes, very complex . . ."[73] But it was only in 1957, with "the sudden discovery that all this incredibly complex, intricate stuff wasn't really necessary"[74] that Wolff finally started to use graphic notations that were quite different in their physical appearance from those of his New York School colleagues. Wolff's concerns in these notations—to achieve a balance between controlled and free elements—were not dissimilar to those of his colleagues earlier in the decade; but by this time, the group had in effect disbanded.[75]

VI

As I have noted, Feldman's adoption of graphs in late 1950 predated by over a year Cage's move away from conventional notational means. Although Cage was undoubtedly "getting rid of [the] glue . . . so that [the] sounds would be themselves" through his use of the *I Ching*, the norm in his pieces through 1952 was a notational system not dissimilar to that used in *Music of Changes*. This can be seen in a selection of the works which—like *Music of Changes*—were composed using a combination of durational structures and charts of materials: *Imaginary Landscape No. 4*, for twelve radios (1951); *Seven Haiku*, for piano (1951–52); *Two Pastorales*, for prepared piano (1951–52); *Waiting*, for piano (1952); and *For MC and DT*, for piano (1952).

During 1952, Cage—like Feldman—veered notationally between the conventional and the unconventional. His first graph, written in January 1952 for a dance by Jean Erdman, was *Imaginary Landscape No. 5*, for any forty-two phonograph records; the score is remarkably similar in its layout to many of Feldman's earlier graphs. Nine months later, in *Music for Carillon No. 1* (October 1952), Cage out-graphed Feldman (and even Brown) in providing a kind of blueprint for a piece, as figure 1.8 shows. As Cage notes in the score, "Each page has two systems of 10 seconds each (except the final system [on page 12] which is 9 seconds), space representing time horizontally, relative pitch vertically within 3 large squares of the graph."[76] (The "middle line" of each seven-square page is redundant; the two systems consist in the top three and bottom three lines of squares.) The score can either be played verbatim, or transcribed into semiconventional notation. Cage himself took up the latter possibility in the published space-time versions for two-octave and three-octave carillons; but the score notes that "other [transcriptions] can be made from this material."[77]

The compositional process employed in making the graph for *Music for Carillon No. 1* "consisted of plotting points onto [the] graph by means of templates, [which were] made by arbitrarily folding pieces of paper and then making holes at the intersections of the folds. Once these stencils were made, Cage superimposed them on his graph-paper score—placing them at points determined by an overall duration structure—and drew through the holes."[78] By December 1952—when Cage commenced the *Music for Piano* series—the process was even simpler: the "point-drawing system," as James Pritchett terms it, consisted solely in "observing and marking minute imperfections in the manuscript paper."[79]

Figure 1.8 John Cage, *Music for Carillon No. 1*, page 1. © 1961 by Henmar Press Inc., New York. Reproduced by permission of Peters Edition Limited, London.

The most extreme example of Cage's notational innovations in the early 1950s is found in *Water Music* (Spring 1952). Here, the score (shown in much reduced form in Figure 1.9) consists of a large (55 x 34-inch) sheet of musical and textual notations, suspended or otherwise positioned in view not just of its performer but also the audience. In addition to his (partly prepared) piano, the player requires a variety of other objects including whistles, playing cards, and water. *Water Music* is a hybrid in at least two ways: first, although it still makes use of the earlier chart techniques, metrical time is replaced by clock time. Second, the piece is as much theatrical as purely musical: "The *Water Music* wishes to be a piece of music, but to introduce visual elements in such a way that it can be experienced as theater. . . . The first thing that could be theatrical is what the pianist is looking at—the score. Normally nobody sees it but him, [but I made] it large enough so that the audience can see it. . . . [Secondly, I] put into the chart things that would produce not only sounds but actions that were interesting to see. I had gotten somewhere the notion

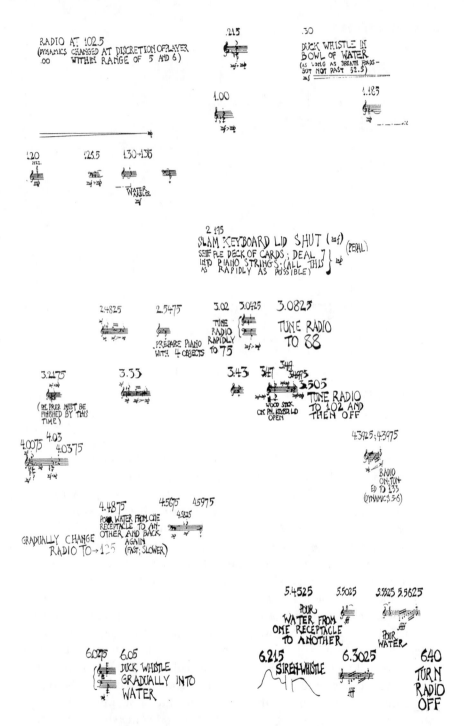

Figure 1.9 John Cage, *Water Music*. © 1960 by Henmar Press Inc., New York. Reproduced by permission of Peters Edition Limited, London.

that the world is made up of water, earth, fire, etc., and I thought that water was a useful thing to concentrate on."[80]

It is hard to avoid drawing parallels between *Water Music* and the contemporaneous work of Robert Rauschenberg, with which Cage was well acquainted, and which was similarly challenging the supposed boundaries of its medium. In the summer of 1950, Rauschenberg and his then wife, Sue Weil, experimented "with blueprint paper, placing various objects on sheets of it and exposing them to sunlight."[81] His work during the winter of 1950–51 was "abstract with figurative signs and symbols, such as black arrows and hands and flowerlike sequences of forms. . . . Only one picture from this period has survived—a painting consisting entirely of numbers penciled into a white ground."[82] Subsequently, "Rauschenberg's pictures started to go black—'night plants,' as he has described them—with forms emerging mysteriously from darkness. He rubbed dirt into white pigment to make rough-textured grays, and he used some red lead, but no other colors. . . . These somewhat somber experiments led directly to the extraordinary series of [all-white and all-black] paintings that he did in the summer of 1952 at Black Mountain College."[83] A year later, following a sojourn in North Africa, Rauschenberg commenced a line of development that would ultimately lead to such dramatic and radical "combines" as *Rebus* (1955), *Bed* (ca. 1955), *Odalisk* (1955–58) and *Monogram* (1955–59), the infamous "goat in the tyre."[84]

A second—and less circumstantial—link with painting explains Cage's use, from 1952, of the apparently independent compositional systems described earlier:

> Using the *I Ching* required an enormous amount of time . . . and extreme precision. . . . One day . . . the telephone rang, and a dancer [probably JoAnne Melcher, the dedicatee of *Music for Piano 1*] asked me to write some music for her immediately, for a performance . . . I had to find a way to work which would be quick, and not, as was most often the case, exaggeratedly slow any more. Certainly I intended to continue working . . . by consulting the *I Ching* as usual. But I also wanted to have a very rapid manner of writing a piece of music. Painters, for example, work slowly with oil and rapidly with water colors . . . I looked at my paper, and I found my "water colors": suddenly I saw that the music, all the music, was already there.[85]

For Feldman, the alternation between conventional and unconventional forms of notation had reflected his attempts to find a way of balancing the

freedom and control he desired in his scores. But for Cage, the alternation resulted from the fundamental changes in his underlying compositional practices. As was noted earlier in this essay, Cage had, since 1939, written music using rhythmic (or durational) structures based on the square root, by which the composition at the macrocosmic level was divided into a series of large proportions. For instance, in the case of the *First Construction (in Metal)* (1939), the macrocosmic proportions are 4–3–2–3–4. Each of these large sections is then divided up into the same proportions, the microcosmic figures denoting the number of measures played. Thus, *First Construction*'s total duration is 16^2 measures, to which is appended a nine-measure coda. By the early 1950s, Cage was already filling his durational structures with materials that were arrived at via decontrolled processes: the magic squares of the Concerto for Prepared Piano and the charts of the *I Ching*-based pieces. But the implication of chance-determined procedures was twofold: first, that durational structuring was no longer necessary; and second, that conventional notational practices could be sidestepped, with a variety of unconventional practices being substituted in their place. Hence the increasing appearance not only of Feldman-like graphs, but also of more experimental notations.

The compositions from 1953 onward show Cage responding to the challenges of the new notational possibilities, but within the context of his adoption of chance as a basic compositional tool. Not surprisingly, the resulting works are far more radical than those of his colleagues, even to the extent that many can be performed either separately or simultaneously, as is the case with "The Ten Thousand Things," "a series of pieces whose rather unwieldy titles are their durations (e.g. *26' 1.1499" for a String Player* [1955])."[86]

But the most remarkable of Cage's works from the later 1950s is the *Concert for Piano and Orchestra* (1957–58), which was dedicated to Elaine de Kooning. Here an astonishing variety of notations is provided for a pianist and thirteen other instrumentalists, all of whom have an unprecedented degree of control over what (and how) they perform:

> My intention in this piece was to hold together extreme disparities, much as one finds them held together in the natural world, as, for instance in a forest, or on a city street. The conductor, by his gestures, represents a chronometer of variable speed. Harmonious fusion of sound is not an objective. For audible and visual clarity the players are separated in space as far as is convenient in a concert hall. The pianist's part is a "book" [of sixty-three pages] containing 84 different kinds of

composition, some, varieties of the same species, others, altogether different. The pianist is free to play any elements of his choice, wholly or in part and in any sequence. The orchestral accompaniment may involve any number of [the thirteen] players on more or fewer instruments, and a given performance may be extended or shorter in length.[87]

Cage's intention in all of these works—including, somewhat ironically, the obsessively determinate *Music of Changes*—was to free the sounds from the composer's grasp, and let them be themselves. But from the performer's point of view, the ramifications of these primarily notational developments are huge: the traditional performer-interpreter becomes instead a performer-creator, who has to make fundamental decisions regarding the music's public appearance. These affect not just the tempo, dynamics, rhythms, and timbres, but also at times the duration of the piece, the instruments it is for, the pitches played, and the aesthetic world so defined. It requires a very special kind of performer—a David Tudor, for instance—to take on such responsibilities; and this is certainly one reason why traditionally trained musicians, used to being told what to do, have been so inimical to the music of the New York School composers. As Cage once remarked, "[The] giving of freedom . . . to a musician like David Tudor . . . provided results that were extraordinarily beautiful. [But] . . . given to people who are not disciplined . . . people with particular likes and dislikes, then, of course, the giving of freedom is of no interest whatsoever."[88]

VII

It has been claimed that the works of the New York School painters "undeniably became the first American visual art to attain international status and influence," that "Abstract Expressionism . . . transformed the fundamentals of painting and sculpture in the mid–20th century, and its influence in terms of style and aesthetics extended over a vast spectrum of subsequent art."[89] Arguably, a similar claim could be made for the music of the New York School composers, for theirs was the first indigenous (as opposed to Eurocentric) American music to have a major international impact. Initially, and as a result of the increasing number of transatlantic contacts made between avant-garde musicians from the late 1940s onwards, some of the ripples created by the New York School's notational innovations spread across the pond to Europe. The two most prominent composers to get their feet wet were Pierre Boulez and Karlheinz Stockhausen (1928–).

The relationship between Boulez and Cage has become reasonably well documented. They first met in 1949 while Cage was living in Paris; Boulez subsequently visited New York in the late fall of 1952. The pair corresponded intensively during the intervening period, and each gave consistent support to the other's work during the early 1950s.[90] The problem that came between them is best summed up in a remark Boulez purportedly made to Feldman: "I love John's mind, but I don't like what it thinks."[91] Boulez had reacted with increasing hostility to Cage's use of chance to determine musical *detail*, as is ultimately made clear in his 1957 article "Aléa."[92] Yet from 1956 onwards, Boulez was himself prepared to see performers choose individual pathways through given material. Thus in his Third Piano Sonata (1956–57) there are five movements that can be arranged by the player in eight different ways, while each movement contains its own smaller-scale mobilities. One of the movements, "Trope," is divided into four sections that are played cyclically, but the performer chooses which section to start with. Two of "Trope"'s sections—"Commentaire" and "Parenthèse"—contain both compulsory and optional structures: each of the latter can be played or omitted at the performer's discretion. And so on. Such a plan—in which the score effectively becomes indeterminate of its performance, and where the pianist creates as well as interprets—would have been unthinkable without the example of Cage and his colleagues. The existence of David Tudor, as a virtuoso performer of the piano music of all these composers, including Boulez, is also very important in this respect.

Stockhausen first met Cage and Tudor in October 1954, when they gave a concert in Cologne. In Stockhausen's case, it is again the role of the performer that is redefined as a result of his contact with the New York School. Witness, for instance, his *Klavierstück XI* (1956), which—like Boulez's "Miroir" from the Third Piano Sonata—consists of a large number of unequal musical fragments distributed over a single large sheet. (It is worth recalling, in this context, Feldman's similarly structured *Intermission 6* (1953)—discussed earlier—that Stockhausen, if not Boulez, knew of through Tudor.[93]) In the Stockhausen, the order in which the fragments are played is determined by the performer alone, who selects them at random, depending on where his or her eye falls. Each fragment contains at its conclusion details of tempo, dynamic, and touch, which are then applied to the *next* randomly selected fragment. *Klavierstück XI* was given its premiere in New York in April 1957 by David Tudor as part of a recital organized by Cage of recent European music. Tudor played the piece twice; the two versions were apparently of quite different lengths.[94]

It should be obvious that the indeterminacy and loosening of the musical structure found in these works is dependent on the fact that their notation has also been loosened. And it is here that the real impact of the New York School lies: in other works of Stockhausen from the 1950s and beyond, there is clear use of experimental notational devices. A good example is *Klavierstück VI*, written in 1955 and dedicated to Tudor, which bears a striking physical resemblance to one of Cage's "Ten Thousand Things" series, *31' 57.9864"*, for a pianist, of the previous year. Yet in its varying tempi, notated graphically above the staff, *Klavierstück VI* refers to both *31' 57.9864"* and the earlier *Music of Changes* (which Stockhausen again knew via Tudor). Elsewhere, the variable structure of *Momente* (1961–69) is clearly related to those of Brown's *Available Forms 1* (1961) and *Available Forms 2* (1962), while the use of a movable plastic transparency in the score of *Refrain* (1959) follows on from Cage's use of similar materials in *Variations I* and *Fontana Mix* (both 1958).

The links between Europe and America go even further than the New York School's influence on Boulez and Stockhausen, however, as has been suggested (in characteristically bold terms) by Feldman, who wrote, "I find Earle [Brown] was a kind of bridge between Europe and America. And I think that as a tangible influence, Brown, by his notation and by his plastic forms, has influenced Europe more than the rest of us. In an obvious way, I feel that [Luciano] Berio [1924–] in the notation of, say, *Circles* [1960], comes out of Earle Brown. The loops of [Witold] Lutoslawski [1913–1994] are out of Brown. I think he's been ripped off more than any of us, in an overt way. The rip-off of Cage is, to some degree, disguised. And the rip-off of myself to some degree gets into the world of a philosophical approach that might influence somebody, rather than the music itself."[95] In this context, it is worth noting that Brown visited Europe in 1956 and 1958, and that his *Pentathis* (1957) and the two *Available Forms* pieces were all first performed there.

However, the flow of ideas was not necessarily one-way. As Christian Wolff has stated,

> The European music at that time affected us a lot. I think Boulez had considerable influence on Cage, for instance. The *Music of Changes* [1951] owes a lot to the Second Piano Sonata of Boulez [composed 1947–48, and given its American premiere, at Cage's behest, by David Tudor in December 1950], even to the point where the pitch choices that John makes involve using up all twelve tones of the chromatic scale. And the density and complexity, that came from Europe, essentially. We were

affected by that. And then there was a certain element of violence in that music. That has some Zen relationship; you knock the student on the head occasionally. And also that aesthetic of Boulez's, a very pure, violent quality in the music.[96]

There is also a broader context into which the American and European innovations of the 1950s should be placed: that of the earlier tradition of American experimentalism. For instance, in his book *New Musical Resources* (first published in 1930, though written over a decade earlier) [97] Henry Cowell (1897–1965) had proposed the ordering of tempi via the use of ratios derived from the overtone series. This clearly anticipates by over thirty years the techniques employed in Cage's *31' 57.9864"* and Stockhausen's *Klavierstück VI*.[98] Indeed, many of the New York School's innovations were already implicit in earlier American music. Simple graphic notations are employed by Charles Ives (1874–1954) and Henry Cowell, the former in *In Re Con Moto Et Al* (1913), and the latter in (for example) *A Composition* (1925, L406). Elsewhere, performers are encouraged (or required) to make decisions of creation as well as interpretation: in Cowell's *Mosaic Quartet* (1935, L518), the five movements may be played in any order, repetitions not being precluded. In the same composer's *Amerind Suite* (1939, L564), each of the three movements is in five versions of increasing difficulty; but the score allows for the simultaneous performance on two or three pianos of different versions of the same movement. And Ives, of course, is famous for his flexible scorings and pragmatic performance practices; examples include: the optional cadenza in *Over the Pavements* (1906–13); the alternative instrumentations of *In the Night* (1906); and the take-it-or-leave-it flute passage at the end of *Thoreau*.

Most importantly, other works—including the percussion and altered-piano pieces written principally by Cowell, Cage, and Lou Harrison (1917–) in the 1930s through 1950s—anticipate the New York School's fundamental questioning of traditional relationships among notation, execution, and perception. For instance, in a conventionally notated score, a given symbol—say an eighth note C4—has a specific meaning. To the performer and score-reader it indicates a precise gesture and sound; and in performance there is a direct and unequivocal correlation between the symbol, the gesture, and the musical result. Thus the visual, physical, and aural dimensions are intimately related. In a prepared piano work, however, the C4 (once prepared) is no longer C4 but instead another sound, whose exact aural realization will depend on the nature of the preparation undertaken by the performer: the score (in terms of its correlation

between symbol and musical result) becomes indeterminate of its perfor-
mance, and increasingly reliant on textual explanation. One logical
though extreme consequence of such a trend is purely textual scores (i.e.,
scores containing no notation as such, but rather only words) the first
example of which, somewhat amusingly, is probably Cage's "soundless"
4'33" of 1952.

VIII

Of course, it couldn't last. If the coming together of the New York School
of composers was serendipitous, then its coming apart was inevitable: as
relationships grow more intense, they also become more fragile. First
came personality issues. Feldman was almost obsessively protective of the
initial group's integrity. Thus, according to Cage, although in 1950 and
1951, "There were other people who wanted to enter the group and enjoy
the exchange of ideas and so forth . . . Morty refused to let that happen. He
insisted upon its being a closed group [of Cage, Feldman, Tudor, and
Wolff]."[99] The arrival in 1952, at Cage's invitation, of Earle and Carolyn
Brown stirred things up. Although Feldman was initially friendly, "the
appearance of Earle Brown on the scene infuriated . . . Feldman, so that
the closeness that I [Cage] had had with Morty and David and Christian
was disrupted."[100] The spark that lit the tinder was a discussion concerning
Boulez, who (presumably unbeknown to Brown) had already made dis-
paraging comments about the work of Feldman and Wolff. According to
David Revill, "Cage, Feldman, Earle and possibly Carolyn Brown stopped
off at a diner . . . Feldman criticized Boulez and his penchant for mathe-
matics. Earle Brown defended the Frenchman, partly because of his own
involvement with mathematics, as a scientist and an advocate of
Schillinger techniques . . . Feldman [took] his response as a personal attack
. . . [and] in fact ignored Brown for three or four years afterwards. At con-
certs, Brown . . . and his wife would enter the foyer, 'and Morty would
embrace Carolyn and cut me dead.'"[101]

The second major factor contributing to the demise of the group was
that of changing locations. In the summer of 1950, activities had been
firmly centered on Bozza Mansion: Cage and Feldman were living there,
while Wolff (and to a lesser extent Tudor) were frequent—sometimes
daily—visitors. However, in the late summer of 1951, Wolff began his
studies at Harvard; at some point in 1952, Feldman appears to have moved
to the Washington Square area; and the Browns, on their arrival in New

York, also settled in Greenwich Village. Finally, in 1953, Cage and his neighbors in Bozza Mansion were served notice to vacate: the tenement was to be demolished, because "a new twenty-million-dollar housing project was planned for the area."[102] For a while, Cage moved in with Merce Cunningham on East Seventeenth Street; but from August 1954, they—together with David Tudor and various other (mainly ex–Black Mountain College) friends and colleagues—decamped to an artistic community founded by Paul Williams, "in Stony Point, Rockland County, an hour and a quarter out of New York City."[103] With its members located at various points from Cambridge, Massachusetts to lower Manhattan, the New York School of composers—as a living entity—had effectively ceased to exist. To partly misappropriate a remark of Cage's, "We loved one another very much, but each life had gone in its own direction."[104]

However, the achievements of the previous four years had been remarkable and unprecedented. For if Cage and Feldman had not met in the lobby of Carnegie Hall on January 26, 1950, neither's work would have developed as it did. Feldman is quite clear on this: "Quite frankly, I sometimes wonder how my music would have turned out if John had not given me those early permissions to have confidence in my instincts."[105] Remember Cage's remark, quoted earlier—"we gave each other permission for the new music we were discovering"—implying that for him the situation was very similar. Without that meeting there would not have been the lengthy discussions among Cage, Feldman, Wolff, Tudor, and—later on—Brown, which subsequently led to a concept of music in which, to quote Feldman, again, "various elements (rhythm, pitch, dynamics, etc.) were decontrolled. Because this music was not 'fixed,' it could not be notated in the old way. Each new thought, each new idea within this thought, suggested its own notation."[106]

These new concepts—especially of notation—had an immediate, profound, and almost universal impact on contemporary composers on both sides of the Atlantic, leading to new attitudes toward performance, performers, and the relationships among notation, execution, and perception, and—ultimately—toward a reappraisal of what music actually is. Thus, we find the emergence at this time of not only graphed and texted scores, but also multimedia and environmental events. Much recent performance art—most notably that of Robert Ashley (1930–) and Robert Wilson (1941–)—ultimately owes more than a small debt to what has been called the first "happening": the particularly glueless Cage-Cunningham-Tudor-Rauschenberg *Black Mountain College untitled event* of summer 1952. Furthermore, the experimentalism of Cage and his colleagues, in its processes, notation, and sound, was an important early influence on the

minimalism of La Monte Young (1935–), Terry Riley (1935–), and Steve Reich (1936–). Like their colleagues in the visual arts, the composers of the New York School have had an enormous impact on their contemporaries and successors, not just in America but also in Europe and elsewhere. Indeed, it is clear that the roots of much of our musical experience over the last half century lie at least as firmly embedded in the work of the New York School as they do in that of the more usually feted European avant-garde. As Feldman put it, "four composers—John Cage, Earle Brown, Christian Wolff and myself—became friends, saw each other constantly—and something happened."[107]

Notes

This chapter is a revised and much expanded version of an article first published in the *Journal of American Studies* 27, no. 3 (December 1993): 335–53.

1. Calvin Tomkins, *The Bride and the Bachelors* (New York: Penguin, 1976), 192.

2. Robert Hughes, *The Shock of the New*, 2d ed. (London: Thames and Hudson, 1991), 314.

3. Marco Livingstone, "Robert Rauschenberg," in *The Dictionary of Art*, vol. 26, ed. Jane Turner (London: Macmillan, 1996), 27.

4. Caroline A. Jones, "Finishing School: John Cage and the Abstract Expressionist Ego," in *Critical Enquiry* 19, no. 4 (summer 1993): 638.

5. "Lecture on Nothing" and "Lecture on Something" are published in John Cage, *Silence* (London: Calder and Boyars, 1968), 109–26 and 128–45, respectively.

6. Jones, "Finishing School," 638.

7. Quoted in David Revill, *The Roaring Silence—John Cage: A Life* (London: Bloomsbury, 1992), 141.

8. "Forerunners of Modern Music," in Cage, *Silence*, 62–66. The reference to sand painting occurs on 65. See also "Finishing School," 634–37.

9. James Pritchett, *The Music of John Cage* (Cambridge: Cambridge University Press, 1993), 59–60.

10. From a 1973 interview with Alan Gillmor and Roger Shattuck, quoted in *Conversing with Cage*, ed. Richard Kostelanetz (New York: Limelight Editions, 1988), 67.

11. Cage, *Silence*, 98.

12. Jasper Johns, "The Fabric of Friendship," in *Cage—Cunningham—Johns: Dancers on a Plane* (London: Thames and Hudson, 1990), 137.

13. Tomkins, *The Bride and the Bachelors*, 221–22.

14. On Cage's mushroom supply service, see Revill, *The Roaring Silence*, 182.

15. George Avakian, "About the Concert," in *The 25-Year Retrospective Concert of the Music of John Cage*, booklet accompanying compact disc, Wergo (WER 6247–2: 1994), 18. See also Revill, *The Roaring Silence*, 190–92.

16. Morton Feldman, "Autobiography," in Walter Zimmermann ed., *Morton Feldman Essays* (Kerpen, West Germany: Beginner Press, 1985), 37.

17. Jones, "Finishing School," 636, n. 24.

18. Feldman, "Autobiography," 36–37. For the date of the Webern performance, see Virgil Thomson, *A Virgil Thomson Reader* (Boston: Houghton Mifflin, 1981), 337–38.

19. Feldman, "Autobiography," 37.

20. David Patterson, "Cage and Beyond: An Annotated Interview with Christian Wolff," in *Perspectives of New Music*, 32, no. 2 (summer 1994), 54–87. In the present context, see 56–59.

21. Confusion has long reigned over the precise date of the Browns' move east. In the next quotation, Feldman implies 1950–51. Revill, in *The Roaring Silence*, gives 1950 (see 138–40) but in a source note on 321 concedes that "there is a chance it was 1951." Calvin Tomkins's *The Bride and the Bachelors*, 115–16, implies 1952; and this last date is also given in David Ewen, *American Composers: A Biographical Dictionary* (London: Robert Hale, 1983, 96) and the article on Brown in *The New Grove Dictionary of American Music*, ed. Stanley Sadie and H. Wiley Hitchcock (London: Macmillan, 1986). The Cunningham chronology in *Dancers on a Plane*, 152, is quite emphatic: the initial meeting of Cage, Cunningham, and the Browns took place in 1951; the Browns moved to New York in 1952. Corroborating evidence in favor of 1952 is supplied by the fact that Brown's compositions were unaffected by the innovations of Feldman and Cage until the autumn of that year.

22. Feldman, "Predeterminate/Indeterminate," in *Morton Feldman Essays*, 48. The essay was written in 1966, over fifteen years after the birth of the New York School, which may explain Feldman's faulty memory.

23. John Cage, "History of Experimental Music in the United States," in *Silence*, 71.

24. David Anfam, "Abstract Expressionism," in Turner, ed., *The Dictionary of Art*, vol. 1, 86.

25. For a detailed discussion of *Music of Changes*, see Pritchett, *The Music of John Cage*, 78–88.

26. From a 1965 interview with Michael Kirby and Richard Schechner, quoted in Kostelanetz, ed., *Conversing with Cage*, 64.

27. See John Cage, *For the Birds: Conversations with Daniel Charles* (London: Marion Boyars, 1981), 43.

28. From a 1980 interview with Cole Gagne and Tracy Caras, quoted in Kostelanetz, ed., *Conversing with Cage*, 63–64. For a detailed discussion of Cage's philosophical and musical journey "from choice to chance," and the compositional methodologies employed in the works of this period, see Pritchett, *The Music of John Cage*, 60–78.

29. Tomkins, *The Bride and the Bachelors*, 109.

30. Jean-Jacques Nattiez and Robert Samuels, trans. and ed., *The Boulez-Cage Correspondence* (Cambridge: Cambridge University Press, 1993), 50.

31. Tomkins, *The Bride and the Bachelors*, 108.

32. Patterson, "Cage and Beyond," 71.

33. Feldman, "Predeterminate/Indeterminate," 48.

34. Patterson, "Cage and Beyond," 61, 71–72.

35. Ibid., 69.

36. Feldman, "Autobiography," 38.

37. Ibid.

38. Patterson, "Cage and Beyond," 72.

39. Tomkins, *The Bride and the Bachelors*, 108.

40. For detailed analyses of early Feldman works, see Catherine Costello Hirata, "The Sounds of the Sounds Themselves: Analyzing the Early Music of Morton Feldman," in *Perspectives of New Music* 34, no. 1 (winter 1996): 6–27; John P. Welsh, "*Projection 1* (1950)," in *The Music of Morton Feldman*, ed. Thomas DeLio (New York: Excelsior Music Publishing, 1996), 21–35; Thomas DeLio, "*Last Pieces, #3* (1959)," in *The Music of Morton Feldman*, 39–68.

41. Hughes, *The Shock of the New*, 320.

42. Quoted in William Bland and Keith Potter, "Morton Feldman," in Sadie and Hitchcock, eds. *The New Grove Dictionary of American Music,* vol. 2, 107.

43. Feldman, "Predeterminate/Indeterminate," 49.

44. Feldman, "Autobiography," 38.

45. Ibid., 39.

46. Quoted in Ewen, *American Composers,* 98.

47. From the note accompanying the published score (New York: Associated Music Publishers, Inc., 1961).

48. Quoted in Ewen, *American Composers,* 96.

49. Ibid. On the influence of Pollock and Calder, see also Richard Dufallo, *Trackings* (New York: Oxford University Press, 1989), 107–9.

50. Earle Brown, "*December 1952,*" in *Music by Earle Brown,* sleeve note accompanying vinyl disc (Composers Recordings, Inc. CRI SD 330: 1974).

51. From the note accompanying the published score in *Folio.*

52. Ibid.

53. Ibid.

54. From the notes on, and accompanying, the published score in *Folio.*

55. From the note accompanying the published score of *March 1953* in *Folio.*

56. From the note accompanying the published score of *Music for Cello and Piano* (New York: Associated Music Publishers, 1961).

57. From the note accompanying the published score (New York: Associated Music Publishers, 1962).

58. Ibid.

59. Ibid.

60. Patterson, "Cage and Beyond," 77, 76.

61. Morton Feldman, "Captain Cook's Virst Voyage: An Interview with Morton Feldman, with R. Wood Massi, in *Cum Notis Variorum* 131 (April 1989): 11.

62. Patterson, "Cage and Beyond," 72.

63. William Duckworth, *Talking Music* (New York: Schirmer Books, 1995), 181–82.

64. Patterson, "Cage and Beyond," 58.

65. Ibid., 59–60.

66. Ibid., 61.

67. Ibid., 60.

68. Ibid., 62.

69. Duckworth, *Talking Music,* 191.

70. Ibid., 190.

71. Ibid., 192.

72. Ibid.

73. Ibid., 196.

74. Ibid.

75. On Wolff's notational practices from 1957, see David Behrman, "What Indeterminate Notation Determines," in *Perspectives of New Music,* 3, no. 2 (1965): 65–73; Thomas DeLio, "Structure as Behavior—Christian Wolff, *For 1, 2 or 3 People,*" in *Circumscribing the Open Universe* (Lanham, Md.: University Press of America, 1984), 49–67.

76. From the note accompanying the published score (New York: Henmar Press, 1961).

77. Ibid.

78. Pritchett, *The Music of John Cage,* 92.

79. Ibid., 94.

80. From a 1965 interview with Michael Kirby and Richard Schechner, quoted in Kostelanetz, ed., *Conversing with Cage*, 107.

81. Tomkins, *The Bride and the Bachelors*, 200.

82. Ibid., 202.

83. Ibid.

84. Hughes, *The Shock of the New*, 335.

85. Cage, *For the Birds*, 44.

86. Pritchett, *The Music of John Cage*, 95. For a thorough discussion of "The Ten Thousand Things," see 95–104.

87. John Cage, "Notes," in *The 25-Year Retrospective Concert of the Music of John Cage*, 17. On the *Concert for Piano and Orchestra* and various related works, see Pritchett, *The Music of John Cage*, 112–24.

88. From a 1972 interview with Hans G. Helms, quoted in Kostelanetz, ed., *Conversing with Cage*, 67. On David Tudor's crucial role as a performer of the music of the New York School, see John Holzaepfel, "David Tudor and the Performance of American Experimental Music, 1950–1959," Ph. D. dissertation, City University of New York, 1994.

89. Anfam, "Abstract Expressionism," 83, 88.

90. For a more detailed summary of the relationship between Boulez and Cage, see David Nicholls, "[review of] *The Music of John Cage*[,] *The Boulez–Cage Correspondence*, [and] *Composition in Retrospect*," in *Music and Letters*, 76, no. 1 (February 1995); 128–31. See also Nattiez, *The Boulez–Cage Correspondence*.

91. Quoted in Tomkins, *The Bride and the Bachelors*, 120.

92. Pierre Boulez, "Alea" [*sic*], in *Stocktakings from an Apprenticeship* (Oxford: Clarendon Press, 1991), 26–38.

93. See Michael Kurtz, *Stockhausen*, trans. Richard Toop (London: Faber and Faber, 1992), 87.

94. Ibid.

95. Feldman, "Captain Cook's First Voyage," 11.

96. Duckworth, *Talking Music*, 192.

97. Henry Cowell, *New Musical Resources* (New York: Alfred A. Knopf, 1930. Reissued with an introduction and notes by Joscelyn Godwin, New York: Something Else Press, 1969. Subsequently reissued with notes and an accompanying essay by David Nicholls, Cambridge: Cambridge University Press, 1996).

98. On the "rip-off" of Cowell, see Kyle Gann, "Subversive Prophet: Henry Cowell as Theorist and Critic," in *The Whole World of Music–A Henry Cowell Symposium*, ed. David Nicholls (Amsterdam: Harwood Academic Publishers, 1997), 171–222, particularly 186–87.

99. From a 1985 interview with William Duckworth, quoted in Kostelanetz ed., *Conversing with Cage*, 14–15. See also Duckworth, *Talking Music*, 16.

100. Ibid., 14.

101. Revill, *The Roaring Silence*, 148. Whether the disagreement took place before or after Boulez's stay in New York is unclear, though the latter possibility is more likely. For further details, see Patterson, "Cage and Beyond" 72; Kostelanetz, ed., *Conversing with Cage*, 14–15; Duckworth, *Talking Music*, 187–88, 192; Revill, *The Roaring Silence*, 140.

102. Revill, *The Roaring Silence*, 179.

103. Ibid., 180.

104. Duckworth, *Talking Music*, 16–17.

105. Feldman, "Autobiography," 37.

106. Feldman, "Predeterminate/Indeterminate," 48.

107. Ibid.

[2]

The Physical and the Abstract

Varèse and the New York School

Olivia Mattis

"It is many years now since painting freed itself from the constraints of pure representation and description and from academic rules. Painters responded to the world—the completely different world—in which they found themselves, while music was still fitting itself into the arbitrary patterns, called forms, and following obsolete rules."
—Edgard Varèse (1963), quoted in L. Alcopley, "Edgard Varèse on Music and Art"

In the aftermath of World War II, many composers looked to Edgard Varèse as a precursor and a model in their creation of a new sound world. Surprisingly, a group of painters, anxious to revitalize the art of painting through an imitation of music, also turned to Varèse for inspiration and confirmation in their quest for artistic freedom. These were the abstract expressionists, also called the New York School. As art historian Irving Sandler wrote in a letter to this author, "The Abstract Expressionists very much admired Varèse. He was a friend of many of them, and they attended his concerts. John Cage once told me that the artists did not like [Cage's] music but came to [Cage's] concerts because he was avant-garde and if they didn't attend, the hall would be empty. But that they really liked Varèse's music."[1]

We now know that Varèse, for his part, took an active interest in the New York School's theory and practice. He participated in their gatherings, published in their journals, and even painted in their style. He read Hilaire Hiler's 1945 manifesto *Why Abstract?* as soon as it appeared.[2] And, most interesting of all, Varèse's encounters with this circle of young artists marked his first real exposure to, and interest in, improvisation and jazz. The post–World War II period marked a new beginning for Varèse, both

in terms of his own work and in the recognition he began to receive. "I am in an ascending phase," the composer wrote optimistically to publisher Merle Armitage in 1947.[3]

From the earliest moment in his professional development, Edgard Varèse was immersed in the world of visual arts. In 1905 he was taken under the wing of the great sculptor Auguste Rodin. Shortly thereafter, the young composer lived with the poets and painters of a group calling themselves the Rénovation esthétique. His first article was published in their journal of the same name,[4] and his earliest music was performed at their polyartistic gatherings.

During the First World War, Varèse was the musical director of the important *Midsummer Night's Dream* project,[5] which was the earliest example of the type of surrealist ballet/theater that flourished in Paris in the 1920s but that is normally thought to have originated with *Parade* in 1917. In fact, the *Midsummer Night's Dream* project—which united poets Jean Cocteau and Henri-Pierre Roché, cubist painters Albert Gleizes and André Lhote, and composers Varèse, Erik Satie, Igor Stravinsky, Georges Auric, Florent Schmitt, and Maurice Ravel—beat *Parade* by a full two years. It would have been a remarkable production, staged in the famous Médrano circus, with actual clowns playing some of the roles, but the project was doomed by the war.

By late 1915, Varèse was living in New York. Once there, the composer immediately attached himself to the circle of photographer Alfred Stieglitz and became a habitué of the artistic and intellectual salon of Walter and Louise Arensberg. He became best friends with Marcel Duchamp and, together with Man Ray and Joseph Stella, participated in the birth of the New York Dada school. He published music, poetry, manifestos, and aphorisms in Dada journals, including *391*, *New York Dada*, and *Broom*.

In the 1920s Varèse's International Composers Guild (ICG) owed its very existence to sculptor and patroness Gertrude Vanderbuilt Whitney, who had been the chief benefactor of the famous 1913 Armory Show. Thanks to the intercession of Juliana Force, who was Gertrude Whitney's amanuensis, the Whitney Studio Club subsidized the ICG for the duration of its existence, and paid two of its members—Varèse and Carl Ruggles— monthly stipends. Whitney also provided them with office space, and offered an intellectual forum—the magazine called *The Arts*—in which they could engage in a free exchange of ideas. The composers, for their parts, each dedicated a piece to Juliana Force in appreciation: Ruggles his "Parting at Morning" from the song cycle *Vox Clamans Deserto;* Varèse his chamber work *Intégrales.*[6]

In the 1930s Varèse collaborated with painter Joan Miró on the organiza-
tion of a grandiose international festival of the arts: the Fourth Interna-
tional, or Quatrième Internationale des Arts. The climax of this ill-fated
festival, to be held in Barcelona, was to have been the premiere of Varèse's
own *Gesamtkunstwerk*, his spatial symphony *Espace*. He intended this
never-completed work to be a space-age multimedia choral symphony,
combining text, music, color, movement, and projected lights or film. The
choral text was to consist of leftist political slogans in all languages, along
with "laugh[ter], humming, yelling, chanting, mumbling, hammered decla-
mation," and other extended vocal techniques. The composer conceived the
work to be sung simultaneously from many points on the globe, so that the
world could be symbolically united. The rhythms, "quick, slow, staccato,
dragging, racing, smooth," were to erupt into a "final crescendo . . . project-
ing . . . into space."[7] The music was to coincide with "quick visual images."[8]
Again, war—in this case, the Spanish Civil War—interrupted these grand
plans. Abundant documentation survives, however, to show Varèse's collab-
oration with Miró.

When after World War II a group of artists formed in New York who
were interested in creating a new type of art, Varèse naturally became
extremely interested. Not only had he always been drawn to groups of
avant-garde visual artists, but they in turn had been his main loyal audi-
ence from the beginning. "Music is the most abstract of the arts and also
the most physical,"[9] Varèse declared in 1936, and repeated in 1947. These
two qualities—abstraction and physicality—were goals that the New
York School painters strove to achieve in their art. The atmosphere of high
intellectual debate that reigned at their gatherings helped Varèse to enlarge
his creative scope in ways that had not been possible before the war.

Clement Greenberg, one of the main art critics representing the New
York School, has discussed abstractionism's special relationship to music.
According to Greenberg, each historical era witnesses the rise of a "domi-
nant art form,"[10] which in the twentieth century was music. He writes,
"[M]usic as an art in itself began to occupy a very important position in
relation to the other arts. Because of its 'absolute' nature, its remoteness
from imitation, its almost complete absorption in the very physical qual-
ity of its medium, as well as because of its resources of suggestion, music
had come to replace poetry as the paragon art. It was the art which the
other avant-garde arts envied most, and whose effects they tried hardest to
imitate.[11] This is the point of view of a historian of art—not of music—
as twentieth-century composers never felt their music to be the art of ref-
erence for their age. Regardless of Greenberg's diagnosis for the twentieth

century as a whole, his assessment is no doubt valid for this particular artistic manifestation: here at last was an artistic movement whose very nature was predicated on an imitation of music.

Not only was absolute music in general a paradigm for the artists of the New York School, because of its nonrepresentational nature, but specifically jazz, with its improvisatory aspect, was an important inspiration. In 1946 the Samuel Kootz Gallery in New York hosted an exhibition, *Homage to Jazz*, that included canvasses of many artists in the movement, including William Baziotes, Adolph Gottlieb, and Robert Motherwell. Jackson Pollock's wife Lee Krasner recalled that Pollock was fanatic about jazz, and would listen to jazz recordings round the clock for days at a time.[12] But other music captured their interest as well. Mark Tobey often thought about Frédéric Chopin while making his art.[13] And there was an intimate association between New York School painters and certain of their composer contemporaries. Varèse in particular had a special status to these painters in that he represented the "heroic generation" of early modernism. We need only recall Robert Motherwell's seminal book on Dadaism to realize how important that early generation was to these artists.

Music was published and discussed in some of the New York School's publications. Motherwell and Cage were the art and music editors of one of these journals, called *Possibilities* (see figure 2.1). This magazine, which published its one and only issue in 1947, contains a raucous roundtable discussion on music organized by Cage, in which sixteen composers ask questions of Varèse and three others (Virgil Thomson, Ben Weber, and Alexei Haieff).[14] *Possibilities* published facsimiles of musical scores by the four interviewees, including the last page of Varèse's "Étude for Chorus, Percussion and Piano (study for a work in progress)" (now known as *Étude pour Espace*), which had just been given its unique performance a few months before (see figure 2.2).[15] This score was a fitting illustration for an article appearing in a journal for artists; as Varèse wrote to Merle Armitage in January of 1947, "Still working on *Espace* but I have decided to do like the painters and *show* some of my *studies* for it at a concert of the New Music Society in April."[16]

In 1949, twenty members of the group, including Franz Kline, Willem de Kooning, Milton Resnick, and Varèse's close friend L. Alcopley, founded a club at 39 East Eighth Street in Greenwich Village, where the painters could exchange ideas. This locale became known as the Eighth Street Artists' Club, or simply, The Club. According to Irving Sandler, "The Club became the core of a subculture whose purpose was as much social as it was intellectual—like that of the Paris cafés. For artists venturing into

Figure 2.1 The cover of *Possibilities*, 1947.

untried areas in art, the need to exchange ideas was urgent."[17] Philip Pavia, who was the group's treasurer, recalled that The Club "offered an artist the chance for healthy growth in a professional fashion, without the present day pressures of journalism and society."[18]

Alcopley, who in the 1970s made a series of automatic drawings in response to Varèse's music,[19] recalled the composer's connection to this group: "I introduced Varèse to 'The Club' on Eighth Street and to the artists of my generation. . . . Some of them were very much interested in him and in his work. They actually were the main public he had."[20] John Cage confirmed this assessment in an interview:

> Cage: I think one thing I know that's significant [about Varèse] is that in the Artists' Club on Eighth Street, where the artists and all were in the majority, the composers were a minority.

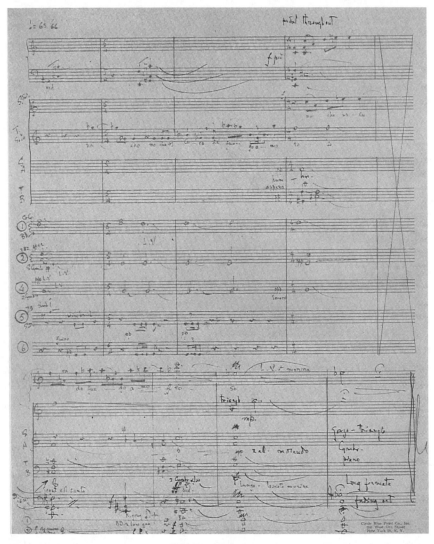

Figure 2.2 The last page of Varèse's "Etude for Chorus, Percussion and Piano (study for a work in progress)," now known as *Étude pour Espace*, 1947.

Mattis: There were three of you, I think.

Cage: There were four: Varèse was the oldest; older than I was Stefan Wolpe;[21] I was in the middle; and the youngest one was Morton Feldman. And we were always present at those meetings, and often talked. . . .

Mattis: Why were you the four musicians who went to the Eighth Street Artists' Club?

Cage: Most musicians are not interested in art. But we all were. That's the only reason. Artists are very open to music. I think all of the artists who knew Varèse were open to listening to his music. They were open to listening to my music. I could get one hundred artists to come to listen to a concert that I would give.

Mattis: And how many musicians?

Cage: None. No musicians would come. In fact, when I went to apply to the music section of the WPA to get a job as a composer, they said, "But you're not a musician." And they would have said that to Varèse.[22]

Varèse himself confessed as much to Alcopley: "At a time when only a handful of musicians understood my work, the painters and sculptors who heard my music rarely failed to respond to it. We spoke the same language in spite of the difference in the medium of expression."[23]

It was their closeness to the other arts that made Varèse, along with Wolpe, a role model for young Morton Feldman. Feldman was also deeply interested in what the painters were doing. He recalled that "the intellectual life of a young New York composer of my generation was one in which you kept your nose glued to the music paper. Wolpe was intimate with many painters and constantly spoke of other things besides music. Varèse, too, was a composer with vast interests in other areas."[24] Feldman, who formed deep attachments to his painter contemporaries, took Varèse on visits to Philip Guston's studio on several occasions.[25]

Jazz and avant-garde classical music were presented side by side in Club gatherings. Both were respected, discussed, and debated in an equally serious way. Between the late 1940s and the early 1960s, numerous musicians appear in Club records as lecturers or as subjects of discussion. In addition to Varèse, Wolpe, Cage, and Feldman, these included Pierre Boulez, Henry Brant, Earle Brown, Henry Cowell, Lucia Dlugoszewski, Alan Hovhaness, Minna Lederman, Kurt List, Gunther Schuller, Alan Stout, Virgil Thomson, David Tudor, and Ben Weber. Joel Forbes came to speak in 1953 on "Bop and Progressive Jazz." Howard Kanovitz led a "Jazz Workshop" in

February of 1955.[26] On November 10, 1950, Varèse delivered his lecture "Music, an Art-Science" at a Club gathering. Alcopley recalled the atmosphere at the event: "When Edgard Varèse spoke on contemporary music and his work as a composer, . . . The Club was so overcrowded that some people present, among them Sidney Janis who was a volunteer fireman, were scared stiff that the entire building would collapse."[27]

In the late 1950s, a younger generation began to dominate the meetings of The Club. The original members, meanwhile, continued their discussions within the pages of a magazine called *It is*. Edited by Philip Pavia, the magazine was "intended to be a permanent record, continuing The Club in a new form [and] is now considered a crucial document of the New York School."[28] The second issue of the journal, from 1958, contains an important article by Morton Feldman entitled "Sound • Noise • Varèse • Boulez," in which he announces "news from Europe that Boulez is adopting the chance techniques of John Cage and perhaps myself," though with "neither elegance nor physicality." In the article Feldman exalts the status of noise: "It bores like granite into granite. It is physical, very exciting, and when organized it can have the impact and grandeur of Beethoven. . . . It is only noise which we secretly want, because the greatest truth usually lies behind the greatest resistance." On Varèse, Feldman comments: "[T]hose moments when one loses control, and sound like crystals forms its own planes, and with a thrust, there is no sound, no tone, no sentiment, nothing left but the significance of our first breath—such is the music of Varèse. He alone has given us this elegance, this physical reality, this impression that the music is writing about mankind rather than being composed."[29] With these remarks, appearing in a journal by and for the abstract expressionist artists, Feldman highlights the points of commonality between Varèse's aesthetic stance and that of the New York School of painters: both seek to return to a "first breath" and proceed outward in an expressive, "physical," and hence quintessentially "American" way. Their art is about paint on a canvas; Varèse's music is all about sound.

In November 1958, *Poème électronique* was given its American premiere in New York, followed by other performances at Sarah Lawrence College and Princeton University. All of these concerts were accompanied by Varèse's now celebrated lectures. The Princeton lecture on the subject of form and rhythm was first published in 1960 in the exhibition catalog of a young French painter of the abstract expressionist school: Michel Cadoret. Varèse and Duchamp organized an exhibit of his work, titled *La Passoire à Connerie*, at New York's Norval Gallery that ran from November 14 until December 10, 1960.[30] Varèse attended the opening along with Cadoret,[31] and Varèse's "early compositions and recent electronic experiments were

Figure 2.3 Michel Cadoret, *La Passoire à Connerie*, exhibition catalog, Norval Gallery, New York, 1960.

played in accompaniment to the exhibition."[32] The exhibition catalog declares on the cover, "oils on canvas CADORET, music VARÈSE"; on the inside cover appears the handwritten subtitle, "texte de Cadoret, notes de VARÈSE." These "notes" are comprised of the composer's Princeton lecture, arranged in a fanciful typographical manner (see figure 2.3). According to art critic Dore Ashton, the exhibition was an utter failure because the paintings were not worthy of Varèse's musical accompaniment: "In the far-too-many paintings on view, there is scarcely ever the spark of the experience that inspired the paintings. . . . Varèse, on the other hand, for all his abstraction, always suggests a rallying point for his imagery. There is always some true experience which is the core of his abstract elucidations."[33]

Varèse was one of a handful of composers—along with Arnold Schoenberg, Carl Ruggles, George Gershwin, Paul Hindemith, John Cage, and Earle Brown—who maintained secondary creative lives as painters and draftsmen. Between 1951 and 1963, Varèse produced about a dozen abstract paintings (see figures 2.4–2.7). In addition, through his friendships with artists, Varèse amassed a very rich and interesting collection of modern art that included abstract works by L. Alcopley, Roger Bissière, Alexander Calder, Herman Cherry, Hans Hartung, Toshimitsu Imai, Fernand Léger,

Figure 2.3 Michel Cadoret, *La Passoire à Connerie*, exhibition catalog (continued).

Joan Miró, A. G. Regner, Chi Chou Watts, and Zao Wou-ki.[34] Odile Vivier has remarked that Varèse was a visually oriented person.[35] She describes the significance of painting to him: "[Varèse] readily explained that if he was stuck on a difficulty in a score, he went to paint, and that painting allowed him to break out of the impasse, to find the sought-after solution."[36] Varèse's style of painting is very dynamic: filled with movement, energy, a suggestion of subject matter, and the rich use of color. His works—in oil on canvas, chalk on cardboard, gouache and ink on paper, or oil on wood—are reminiscent of New York School artists such as William Baziotes or Arshile Gorky, who incorporated surrealist and even symbolist tendencies in their art. For these works Varèse adopted such evocative titles as *Epure* (projection), *Portes* (doors), and *Non si volta chi a stella e fisso* (He who is fixed to a star does not waiver).

When asked about his paintings in 1963, Varèse had the following exchange with his friend Alcopley:

Varèse: I have always drawn and painted a little, but I am not a painter. Playing with colors and lines gives me great pleasure and is a diversion—a relaxation from composing. Because I was destined by my father to be an engineer, I did a good deal of mechanical drawing at school—

Figure 2.4 Edgard Varèse, untitled, c. 1953, collection Olivia Mattis.

Figure 2.5 Edgard Varèse, untitled, 1951.

an excellent manual discipline—so that I am a pretty good doodler. But how I envy you painters!

Alcopley: Why should you envy painters?

Varèse: Because you painters are in immediate communication with your audience. A painter hangs his canvas on a wall—a finished work. Anyone with eyes can see it. A score is only a blueprint, and cannot be said to be finished until it is played. It is at the mercy of performers and risks the distortion of their "interpretations."[37]

Varèse's use of electronic resources in his postwar music compositions *Déserts* (1954), *Procession de Vergès* (1955), and *Poème électronique* (1958) was his way of seeking *direct access* to the public, like a painter hanging a canvas in plain view.

Varèse's involvement with the circle of young artists in New York during the postwar years led him to open his mind to their favorite music, jazz. In a series of Sunday afternoon sessions organized by Earle Brown, in the presence of both John Cage and Merce Cunningham, Varèse tried working with jazz musicians. Cage remarked in 1958:

Figure 2.6 Edgard Varèse, ***Baroque Toto***, c. 1953.

Recently (1957–1958) he [Varèse] has found a notation for jazz improvisation of a form controlled by himself. Though the specific notes are not determined by him, the amplitudes are; they are characteristic of his imagination, and the improvisations, though somewhat indeterminate, sound like his other works.

In these respects Varèse is an artist of the past. Rather than dealing with sounds as sounds, he deals with them as Varèse.[38]

This was a radical turn of events for Varèse, who had spoken of jazz thirty years earlier in the most disparaging way. In 1928 Varèse remarked in an interview, "Jazz does not represent America any more than slow waltzes represent Germany. . . . Jazz is without ideas. It's noise on which you hop around."[39] Moreover, the concept of performer freedom was anathema to a composer who believed in complete authorial control. Cage elaborated in an interview: "I can tell you about a piece that he made—and even that was very 'Varèsian': it didn't have any notes. All it had were dynamics and time indications. There were no pitches, so it could be used as a basis for improvisation."[40] When asked how the piece sounded, Cage replied, "It sounded like Varèse."

Figure 2.8 is a fair copy—with bar lines omitted—of a portion of the untitled score that Cage described. This is a part of a very large score (about two feet by three feet) on onion-skin paper that Varèse gave to Teo Macero, a well-known jazz musician and producer at CBS Records. In the

Figure 2.7 Edgard Varèse, *Portes*, 1952.

corner of the score, Varèse wrote, "Here is the first sketch of our experiment. Cordially, Varèse." The score contains eight lines, numbered one through eight, representing eight musicians. The only part he designated for a specific instrument is the fifth one, labelled "Perc.," for percussion. There are indications of general pitch contours, scattered rhythms, and a very precise indication of dynamic levels. In certain spots, Varèse indicates that the line is a "solo," and further on in the score (not illustrated) there are numerous places where the composer indicates "ad lib."

Earle Brown, the organizer of these sessions, has a vivid recollection of how they came about. He explains, in an interview,

> Varèse was very much admired—probably more admired—by the jazz musicians than by "classical" musicians. And I have evidence of that, because I remember talking to Varèse about that and telling him how

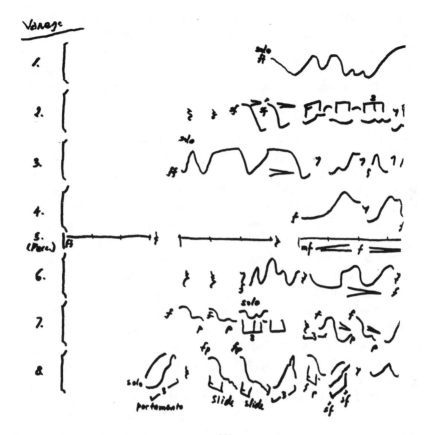

Figure 2.8 Edgard Varèse, untitled graphic score, c. 1957.

terrific I thought a lot of these musicians were. He said, "You know, I'm very interested in that too." . . . And I said, "They like you. They ask about you, and they like your work." And so he and I together—or probably it was mainly at his suggestion—he and I decided that we would have a Sunday afternoon get-together with a group of jazz musicians at the Greenwich House Music School. . . .

There were two or three of them; they were like collective improvisation sessions. . . . And as much as Varèse told me to be careful of giving musicians any leeway, he was very interested in what these musicians could do. . . . I had already long ago, long before that, I had done graphic scores . . . –scores with just graphic indications of a kind of action—and so Varèse and I both did these little sketches of things. . . . I remember Merce came, and John must have come too. . . .

Art Farmer was the trumpet player; Ed Shaughnessy, who's a drummer on the Johnny Carson show; Frank Rehak was the trombone player; Hall Overton, the composer and pianist, was the pianist; Teo Macero, who is a producer of all those Gil Evans–Miles Davis records, was the tenor saxophonist; and Hal McKusik was the alto saxophonist. So we had trumpet, trombone, alto sax, tenor sax, piano and drums.

Clearly there must have been two other musicians as well, to make up eight lines. It seems that there was also a double bass and possibly a clarinet. When Earle Brown was asked to describe the piece, he replied, "Well, it wasn't a piece; it was just a kind of collective improvisation. . . . It wasn't new to me, 'cause I had been a jazz musician, but it was new to Varèse."[41]

This series of collective improvisation sessions is the only known example of Varèse's flirting with performer freedom. Brown's comment that "as much as Varèse told me to be careful of giving musicians any leeway, he was very interested in what these musicans could do" is quite telling: while Varèse had no use for virtuosos and prima donnas who "interpreted" his music in the composer's absence, he welcomed a chance to guide the improvisations of a jazz ensemble in the playing of "simultaneous rhythms." Moreover, although a small audience was present, the aim of these sessions was experimental and exploratory, rather than the presentation of a finished product to a concert audience. Recall that Varèse even referred to the event as "our experiment." This was a radical change for a composer who had always sought complete authorial control over his music and the listener's experience.

At the end of his life Edgard Varèse told Gunther Schuller, "I want simply to project a sound, a musical thought, to initiate it, and then to let it take its own course. I do not want an *a priori* control of all its aspects."[42] This is why Varèse's postwar output includes not only his electronic compositions (eliminating the "middleman") but also the "study" for *Espace* and the "experiment" in jazz. His contact in the postwar period with the New York Schools of music and art perhaps made Varèse's own approach to artistic creation a little less rigid, a little more free.

Notes

1. Irving Sandler to Olivia Mattis, December 20, 1990.

2. A letter from Varèse to Hilaire Hiler of 24 October 1945, Archives of American Art, reads: "Merci, cher Vieux, pour ta carte. J'allais t'écrire / pour te dire qu'il y a 2 ou 3

semaines, James / Laughlin est venu nous voir. Nous avon parlé / de toi et le surlendemain j'ai reçu "Why / abstract?["] que j'ai lu avec plaisir et intérêt."

3. Varèse to Merle Armitage, New York, 5 May 1947, Merle Armitage Collection, Harry Ransom Humanities Research Center, University of Texas at Austin.

4. Edgard Varèse, "Musique," *La Rénovation esthétique*, February 1906, 221.

5. For more on this project, see Olivia Mattis, "Theater as Circus: *A Midsummer Night's Dream*," *The Library Chronicle of the University of Texas at Austin* 23, no. 4 (1993): 42–77.

6. On the genesis of *Intégrales*, see Olivia Mattis, "Edgard Varèse: *Intégrales* (1924–25)," in *Settling New Scores: Music Manuscripts from the Paul Sacher Foundation*, ed. Felix Meyer (Mainz: Schott, 1998), 174–76.

7. Dorothy Norman, "Edgar Varèse: Ionization-Espace," *Twice a Year* 7 (1941): 259–60.

8. "Projet pour Espace dans une version pour orchestre," typescript, Fermand Ouellette Collection, National Library of Canada, Ottawa, n.d.

9. Calla Hay, "River Sirens, Lion Roars, All Music to Varese," *Santa Fe New Mexican*, August 21, 1936.

10. Clement Greenberg, "Toward a Newer Laocoön," *Partisan Review*, July/August 1940, reprinted in *Abstract Expressionism, A Critical Record*, ed. David Shapiro and Cecile Shapiro (Cambridge: Cambridge University Press, 1990), 62.

11. Ibid., 68.

12. Lee Krasner, quoted in Chad Mandeles, "Jackson Pollock and Jazz: Structural Parallels," *Arts Magazine* 56, no. 2 (October 1981): 139.

13. Eliza Rathbone, "The Role of Music in the Development of Mark Tobey's Abstract Style," *Arts Magazine* 58, no. 4 (December 1983): 99.

14. John Cage, ed., "Edgard Varèse and Alexei Haieff Questioned by Eight Composers [Arthur Berger, Paul Bowles, Merton Brown, Elliot Carter, Carter Harman, Lou Harrison, Wallingford Riegger, Stefan Wolpe]," *Possibilities* 1 (1947): 96–98; and "Ben Weber and Virgil Thomson Questioned by Eight Composers [Milton Babbitt, John Cage, Henry Cowell, Kurt List, Jacques de Menasce, Robert Palmer, Harold Shapero, Adolph Weiss]," *Possibilities* 1 (1947): 18–24.

15. The performance was held on Sunday evening, April 20, 1947, at the Greenwich House Music School in New York, with soloists Barbara Gibson, Edith Klein, Radiana Pazmor and Edward Caldicott, percussionists Josephine Cnare and Pompy Dodson, and Varèse conducting a subset of his Greater New York Chorus.

16. Varèse to Merle Armitage, New York, January 18, 1947, Merle Armitage Collection, Harry Ransom Humanities Research Center, University of Texas at Austin.

17. Irving Sandler, *The Triumph of American Painting: A History of Abstract Expressionism* (New York: Harper and Row, 1970), 214.

18. "Interview with Philip Pavia," typescript, Archives of American Art, November 21, 1967.

19. Grete Wehmeyer, *Edgard Varèse*, with 261 spontaneous line drawings by L. Alcopley, (Regensburg: Bosse Verlag, 1977).

20. Olivia Mattis, "Alcopley Talks about Himself, Varèse and Others," in *One Man, Two Visions: L. Alcopley–A. L. Copley, Artist and Scientist*, ed. Alexander Silberberg (Oxford: Pergamon Press, 1993), 393.

21. Wolpe had been involved in the Dada movement in Berlin in the early 1920s. See Austin Clarkson, "Lecture on Dada by Stefan Wolpe," *The Musical Quarterly* 72, no. 2 (1986): 202–15. This lecture, not surprisingly, begins, "I am not a Dadaist."

22. John Cage, interview with the author, New York City, July 28, 1988.

23. "Edgard Varèse on Music and Art," 187–88.

24. Morton Feldman, "Crippled Symmetry," in *Morton Feldman Essays*, ed. Walter Zimmerman (Kerpen, West Germany: Beginner Press, 1985), 136.

25. Dore Ashton, *A Critical Study of Philip Guston* (Berkeley and Los Angeles: University of California Press, 1976), 95.

26. Philip Pavia notebooks, Archives of American Art.

27. L. Alcopley, "The Club," *Issue, A Journal for Artists* 4 (1985): 45.

28. Gerald Nordland, *Philip Pavia*, exhibition catalog (Washington, D.C.: Washington Gallery of Modern Art, 1966), 7.

29. Morton Feldman, "Sound • Noise • Varèse • Boulez," *It is* 2 (autumn 1958): 46.

30. Formerly the Curt Valentin Gallery, and now defunct.

31. A copy of the catalog may be found in the Fernand Ouellette Collection, National Library of Canada, Ottawa. In addition, the Ann McMillan Collection at the Electronic Music Foundation in Albany, New York, contains a copy of the invitation to the opening that reads, "You are cordially invited to meet Michel Cadoret and Edgar Varèse / Galerie Norval, 53 East 57 Street, New York / Monday, November 14, 1960 / Reception: 5 to 8 p.m. / This invitation admits two." Duchamp contributed to the catalog by means of what Arturo Schwarz calls a "musical introduction" [Arturo Schwarz, *The Complete Works of Marcel Duchamp* (New York: Abrams, 1969), 598]. This introduction consists of the five pitches e–g–f–c–d notated on a treble staff line. These pitches, read with their solfège syllables "mi–sol–fa–do–re," form the vowel pattern of Michel Cadoret's name. This is the sixteenth-century technique of *soggetto cavato*, used for example by Josquin de Prez in his *Missa Hercules dux Ferrariae* written for his patron Ercole d'Este, Duke of Ferrara, and built on the solmization syllables "re–ut–re–ut–re–fa–mi–re" corresponding to the vowels of the duke's name.

32. Dore Ashton, "Other Exhibitions," *Arts and Architecture* (January 1961): 5.

33. Ibid.

34. For a complete listing of art works sold from the Varèse estate in March 1991, see Olivia Mattis, "Edgard Varèse and the Visual Arts." Ph.D. dissertation, Stanford University, UMI #9302260, 1992.

35. Odile Vivier, "Varèse et les Artistes de son Temps," *La Revue musicale* 383-84-85 (1985), Varèse issue, 84; "Varèse était un visuel."

36. Ibid. "Il expliquait volontiers que s'il butait sur une difficulté, dans une partition, il allait peindre, et que la peinture lui permettait de sortir de l'impasse, de trouver la solution cherchée."

37. L. Alcopley, "Edgard Varèse on Music and Art," 187.

38. John Cage, "Edgard Varèse," *Nutida Musik*, fall 1958, reprinted in John Cage, *Silence* (Middletown, Conn.: Wesleyan University Press, 1973), 8.

39. Varèse, quoted in Ruth Phelps and Henri Morane, "Artistes d'avant-garde en Amériques," *Le Figaro hébdomadaire* (New York?), July 25, 1928, 8–9.

40. John Cage, interview with the author, New York City, July 28, 1988.

41. Earle Brown, interview with the author, Venice, California, March 30, 1990.

42. Varèse, quoted in Gunther Schuller, "Conversation with Varèse," *Perspectives of New Music* 3, no. 2 (1965); reprinted in *Perspectives on American Composers*, ed. Benjamin Boretz and Edward T. Cone (New York: W.W. Norton, 1971), 39.

[3]

Stefan Wolpe and Abstract Expressionism

Austin Clarkson

Good is to know *not* to know how *much* one is knowing.
— Stefan Wolpe, "Thinking Twice"

Two Pioneers of Abstract Expressionist Music

The play with synesthetic correspondences that so intrigued nine-teenth-century romantics and symbolists intensified in the middle of the twentieth century, when a loose group of New York composers, poets, and visual artists began to borrow from one another. This environment soon produced a movement—now called abstract expressionism—that would eventually offer a new sensibility, a new way of living through art. Nowadays the abstract expressionist group in music is often too narrowly limited to Morton Feldman, Earle Brown, and sometimes John Cage. This unfortunately dismisses the role of two émigré composers, Edgard Varèse and Stefan Wolpe, who in truth must be considered the chief pioneers of this movement in music. Indeed, I will argue that Wolpe, twenty years younger than Varèse, belongs to the later group, and that several of his compositions from the late 1940s and early 1950s stand as crucial documents of abstract expressionism.

Varèse and Wolpe shared much in common. After youthful forays in Europe against bourgeois aestheticism, they immigrated to the United States, where they became staunch friends. They participated in the highly charged abstract expressionist milieu in New York City and eventually served as mentors to many young composers of the New York School. Feldman, who knew Varèse and Wolpe well, said, "Both these men admired each other—and there are great similarities in both their per-

sonalities and music. With both Wolpe and Varèse you feel the idiom can barely contain the granite-like substance of its musical thought."[1]

The basis for the innovations of Varèse and Wolpe lay in the confluence of visual and audial imagination. As youths, Varèse in pre–World War I Paris and Wolpe in post–World War I Weimar saw that painters had begun responding to the modern world while musicians remained tied to nineteenth-century rules and forms. The young composers set out to derive musical material from the interplay of sight and sound. When Varèse saw the cubist paintings of Georges Braque and Pablo Picasso, with their depictions of guitars, fiddles, and scraps of sheet music, he may already have heard "bodies of intelligent sounds moving freely in space."[2] Wolpe witnessed multimedia experiments conducted by the masters of the Bauhaus, many of whom were competent musicians interested in correspondences between audial, visual, and choreographic media. Both Varèse and Wolpe admired Ferruccio Busoni, who gained many ideas about new music from his sensitivity to paintings. About his own education, Wolpe said, "I learned mostly from the painters. From the musicians I really learned only to liberate myself from my teachers."[3]

During the 1920s—when Varèse was living in New York and Wolpe in Berlin—both experimented with the shaping of plastic masses and planes of sound. In *Intégrales* (1925) Varèse went far toward realizing his concept of projecting geometrical figures moving freely in a nongravitational space. In the same year Wolpe composed his *Sonata Stehende Musik* (*Music of Stasis*) with similar aims. In the program note for a concert in 1927 called *Stehende Musik*, Wolpe and his collaborator Hans Heinz Stuckenschmidt wrote, "The music is formally experimental in nature. Thematic and modulatory design elements move to the background in favor of purely rhythmic and dynamic elements. . . . Formal tension and relaxation are developed from the principle of repetition (in contrast to the principle of variation)."[4] Both Varèse and Wolpe, then, had largely turned away from the principle of developing variation, the method of working out thematic material that dominated nineteenth-century Austro-German music. The *Stehende Musik* manifesto cited the Third Orchestra Piece of Schoenberg's opus 16 and Stravinsky's *Piano-Rag-Music* as models for the "music of stasis." The young Berliners would surely also have mentioned Varèse had they known what he was composing in America.

Wolpe and the Painters

The Beethoven of the Hammerklavier Sonata was Wolpe's hero of heros, and he admired Aleksandr Scriabin and Arnold Schoenberg passionately in

his youth, but he identified even more strongly with visual artists. In Berlin in the 1920s Wolpe formed his closest associations with painters and art critics from the Bauhaus; he was drawn in particular to the work of Paul Klee and Oskar Schlemmer. In the 1930s and 1940s he developed a deep admiration for Picasso. In New York in the 1940s he formed close friendships with the art historian Max Raphael, and with Friedrich Alexan, an art dealer and writer. In the 1950s and thereafter it was Paul Cézanne who provided Wolpe the model of a life lived through art. Indeed, the notes Wolpe made during his visit to the 1952 Cézanne exhibition at the Metropolitan Museum of Art reveal a highly developed visual sensibility.

Thus, when Wolpe began attending meetings of the Eighth Street Artists' Club in New York in the fall of 1950, he encountered an atmosphere that was both familiar and exciting.[5] In her memoirs the poet Hilda Morley, who attended these meetings with Wolpe, captures the excitement and ambience of that community, noting that

what mattered was the talk, the laughter, the seriousness, the sometimes desperate seriousness of people saying ultimate things about themselves, about what they were doing, about what they wanted to do. . . .

The beginnings of it were there, even that first evening. Eyes lit up to see us, with a curiosity of wanting not only to know but to meet, to touch with inwardness, to join in a circle of affection. Each pair of eyes, each mouth moving in talk or smiling was the center of that circle for a time, the individual circles joining in a larger circle, one that never closed, was always open for the next possible word, idea, glance, sharing of whatever kind. . . . So we could almost not let go—we could have gone on all night.

And some of them did, in smaller groups (in the Cedar Bar or elsewhere) as Mercedes Matter, who was to be the founder of the Studio School, can attest. She was there that first evening. We were standing, talking in a small group, which of us I'm not sure, but I think that Franz Kline was in it, for he loved music, grand music, and when he heard that Stefan was a composer would embrace him verbally and physically. Mercedes came up to us, tall, slender, finely boned, her eyes huge and dark, half-shy, half determined, and pushed her head between the two men who formed a little circle with us, one arm around each of them, so that she seemed at that moment like the tutelary goddess of the place. And, indeed, I was a little frightened of her at first as the reigning woman deity there (whose attitude toward the other women was uncertain) until Elaine de Kooning turned up. But she took to Stefan and he

to her, their Mediterranean looks and seemingly banked fires making for an affinity.

Franz Kline lit up the place where he stood, partly because of the sweetness which streamed out of him. And the gallantry—by which I mean courage, risk-taking—but all that for the sake of taking a new step where perhaps no one had been before. He was small, dark, lithe, agile, quick-moving, quick-glancing, ready to embrace those for whom he felt love, and it was real love.

Bill de Kooning must have been there that first evening. His head, his whole person filled with radiance, a knotted, fibrous radiance, wiry, rooted, harsh and open at once. And this gave him what Elaine was to call "this amazing abstract spiritual quality about him." His laughter, a true hilarity, would be heard above the others, his voice raised in delighted assertion, saying something like, "But nature is the opposite of peaceful!" or "Style is a fraud. I think it is a most bourgeois idea to think one can make a style beforehand."[6]

Wolpe seemed to find a radical milieu similar in character to the one he had enjoyed at the Bauhaus. As Morley explains,

For Stefan it seemed like an approach to the possibility of finding adequate friends, men on his own level of development as an artist. Stefan, when he was articulate in public about what he was doing, sometimes expressed himself in a way that was more precise, slower and more involved in the European tradition, than the painters were used to. Their articulateness was of a more sudden, explosive, even spasmodic kind. Stefan would listen intently to the talk of visual space, his eyes glistening as he transposed their terms into the sphere of musical space. He could join with them there because of his own fantastic imagination, his experience of dada, and his occasional forays into surrealist imagery when he wanted to provide telling examples in his talk. But emotionally, imaginatively, his artistic self found a kind of a haven there.[7]

Wolpe's Social Conscience

While Wolpe enjoyed his newfound friendships with painters, he differed with some of the prevailing terms of discourse he heard at The Club. He particularly objected to what he took to be a regression to the aesthetics of purism. A show of paintings in December 1951 prompted him to com-

plain, for example, that the images of the painters were not sufficiently well formed, that their eyes were "clouded by bourgeois dust" and the "misty images of a dying culture." They refuse "to look at what truly must be seen."[8] Wolpe's reaction was no doubt shaped by his belief that artists must declare a moral stance and adhere to it. A lecture on Martin Heidegger at The Club left Wolpe feeling "deeply molested" by "a hell of blown-up profundities about life-death-existence-finiteness-authentic-inauthentic-and so forth." He had no desire to participate actively in gatherings of self-styled modernists for whom modernism was nothing more than a superficial question of style and form. Club discourse ultimately led Wolpe to conclude that he couldn't belong to a group of artists who failed to ask about "the purposes and contents of the tendencies of living."[9]

Wolpe felt that modernism should deal not with matters of structure and technique but with deeply ethical questions about the role of an artist within a culture of militarism, capitalism, and consumerism. After a symposium on abstract expressionism and purism with artists Ad Reinhardt, Jack Tworkov, Franz Kline, William Baziotes, and Philip Guston, moderated by the critic Harold Rosenberg, Wolpe exploded in his diary that it "signifies the total trap in which they all are caught."[10] He visited The Club in 1952, for the last time, to see a presentation of abstract films. He mocked them mercilessly in a letter to Hilda Morley: "I am through with all that snapshotting and seeing through a whimper's instance." He craved instead an art that gathers all instances and knots them together "in an extreme interembodiment." Deriding the use of fleeting, insufficiently explored images, he demanded instead the need to dwell with a "lingering eye."[11]

The discomfort felt by Wolpe amid these artists may in part be explained by his deeply held political and social beliefs. Like many in the early abstract expressionist movement, Wolpe had been active politically during the thirties. Though he did not actually join the German Communist Party, he threw himself into the fray from 1929 to 1933. He attended MASCH, the Berlin Marxist Workers' School, read Karl Marx, Vladimir Lenin, G. W. F. Hegel, and Friedrich Engels, and learned their method of dialectical analysis. He heard Hanns Eisler lecture young composers on methods of creating a new type of aggressive marching song. Wolpe moderated his native bent for dissonant atonality in order to make dozens of tonal marching songs for agitprop troupes, anthems for unions, and music for dance and theater companies. Some of his songs became as popular as Eisler's and were published in songbooks distributed internationally from Russia. After the war, when some of his colleagues in the workers' movement faded in their commitment to social politics, Wolpe

continued to regard composing and teaching as functions of a social con-
tract.[12] In exile in Palestine (1934–38), where he returned to the composi-
tion of advanced twelve-tone concert music, he continued to produce
simple choral songs for choirs on the socialist *kibbutzim.*

Wolpe maintained his belief in the link between progressive social and
musical ideals after arriving in New York in 1938. Though he recognized
that the "army of artists" had failed to stop the Nazis in Germany, a diary
entry in 1939 shows that he still argued that artists should place their sub-
jectivity in the service of "human society."[13] Nevertheless, World War II
finally taught socialist artists that art alone could not replace political and
military power in opposing capitalism and totalitarianism. In the postwar
period attention shifted from extroverted address to the citizenry at large
to introverted engagement with the individual, from regionalism in paint-
ing and social realism in music to an investigation of deeper levels of the
psyche. Wolpe, too, moved in this direction, but he refused to abandon the
dialectical method and the social contract. He aimed instead for a revolu-
tionary synthesis that would encompass the individual and the collective
in "a massive musical language."[14]

Wolpe As Mentor

As a teacher in the budding abstract expressionist milieu, Wolpe had a
decisive impact on composers and performers of the New York School as
well as on musicians who made important contributions in film music
and modern jazz. In 1939, soon after settling in New York, Wolpe and his
wife, the Romanian pianist Irma Schoenberg (1902–1984), commuted to
Philadelphia to teach two days a week at the Settlement Music School. In
1943 Irma was appointed to the faculty of Swarthmore College, after
which Stefan remained in New York and continued to build his private
teaching practice. This led to his founding the Contemporary Music
School in 1948. For both Stefan and Irma teaching was a core activity of
their lives as creative artists, and their students were in awe of the energy
that they invested in it. But above all it was their innovative musical ped-
agogy and their charismatic personalities that attracted many talented
musicians. Wolpe's interest in jazz and his openness to popular music
attracted musicians with limited classical training, many of whom were
already successful in film, jazz, and at orchestrating for big bands, and his
progressive ideas had a substantial effect in those fields as well as in con-
cert music.[15]

The Contemporary Music School curriculum was built on creative work in composition and study of the modern masters. Wolpe based his teaching on ideas from the masters of the Bauhaus, from his coaching with Busoni and Anton Webern, and from a conducting course with Hermann Scherchen. Wolpe rejected the traditional notion of requiring a basic course in musicianship before composition could begin; in his view, students gained musicianship through composing new music. He taught sixteenth- and eighteenth-century styles of harmony and counterpoint only to those who expressly requested it. The prime objective was for students to develop their ears for contemporary materials and to discover their authentic musical voices through free composition. Wolpe had little interest in systematizing his pedagogy in the way that Schoenberg and Hindemith had done. He urged students to study scores and perform twentieth-century repertoire, and he analyzed this repertoire in a vital fashion, emphasizing the processes of formation and deformation rather than themes and forms. He did not teach in terms of style, whether diatonicism or twelve-tone, but focused on the student's piece at hand. He thus gave them confidence in their individual musical imaginations.

Morton Feldman greatly appreciated Wolpe's teaching, noting, "Stefan was never authoritarian in his teaching. When you teach, there are two ways of doing it. There are only two ways to teach. Either you help the student do what they are doing better, or you try to lead them into something else. And what's interesting about the years I was with Stefan is that he didn't employ any one of those approaches. He didn't help me make what I was doing better, and he never led me into something else. Which has become a model of my own teaching, that particular *attitude*. . . . With Stefan it was always that confrontation actually with *the piece at hand*. And that's some kind of overriding point of view of what you're going to have in a piece. . . . That became a very important model for me."[16]

Wolpe's career as teacher forms an interesting parallel with that of Hans Hofmann, another German emigré who brought to America a stylistically nonpartisan, nonauthoritarian, highly creative pedagogy grounded in European expressionism. Hofmann (1880–1966), a generation older than Wolpe, arrived in the United States a decade earlier, but his impact as a teacher on the world of visual art was similar to Wolpe's impact on the musical world. Like Wolpe, Hofmann regarded teaching as an integral function of his life as an artist; thus he emphasized the need for bringing spontaneous processes into the creative act. Hofmann, too, founded his own school in New York, which drew upon a similar philosophy of instruction, and affected decisively a generation of American abstract expressionists.[17]

A vital feature of the Wolpe circle was the way in which Stefan and Irma modeled a creative partnership between the performer and the composer. The Wolpes held weekly musicales in their New York apartment, where their students presented new work. The level of music making was high: both the Juilliard Quartet (Claus Adam and Robert Mann studied composition with Wolpe) and the LaSalle Quartet made their informal debuts at the Wolpe apartment. This mutually supportive community helped shape the careers of many progressive musicians, including Adam and Mann, Jacob Maxin, Edwin Hymovitz, Ralph Shapey, and David Tudor. Tudor turned out to be a special case, of course, because he became the pianistic genius for another community of abstract expressionist artists, dancers, and composers that formed around John Cage and Merce Cunningham. But, for a few years in the early 1950s—in New York, at Black Mountain College, and at Darmstadt—the Wolpe and Cage circles overlapped. Even after these circles drifted apart, Tudor continued to perform Wolpe's music until the early 1960s. An extraordinary amalgam of performer and composer, Tudor did much to advance the abstract expressionist agenda in music.

Battle Piece

Tudor began piano studies with Irma Wolpe and composition studies with Stefan Wolpe in 1943. At that time, Irma was the leading exponent of her husband's works, and Tudor's passion for new music soon drew him from the classics to the avant-garde. During the next decade he performed all of Wolpe's works for the piano. But it was while learning *Battle Piece* that Tudor discovered his vocation for collaborating with composers in the realization of their work: "I think I learned the most about [Wolpe] when I was studying the *Battle Piece*. That kind of challenge is, I think, most what I learned from, something that was new to me, and something I couldn't do to begin with."[18]

During the darkest days of World War II, Wolpe returned to the genre of *Kampfmusik* [music for the struggle], to which he had dedicated himself during the last four years of the Weimar Republic. He planned a series of pieces titled *Encouragements* that were intended as a contribution to the war effort. The first item comprised a march fantasy for piano (*The Good Spirit of a Right Cause*, 1942), and the second was a set of aggressive marching songs similar to those he had written ten years before for the workers' movement in Berlin. The third item of *Encouragements*, unlike the earlier

two occasional pieces, evolved into a concert work of epic proportions. It began with the programmatic title, "Battles hopes difficulties, New battles new hopes no difficulties." The words "Destroyed cities, fields, destroyed men," put onto the sketch leaf beside the thematic material, indicated Wolpe's intent. By the time the work was finished four years later, it had become a cyclically integrated, self-referential, seven-part epic nearly thirty minutes in length. Moreover, in both scope and subject, *Battle Piece* stood as a musical analogue to the great mural *Guernica* by Pablo Picasso.

In 1939 a Picasso retrospective at the Museum of Modern Art (MOMA) highlighted *Guernica*. Picasso had painted the mural in 1937 partly in response to the bombing of the Basque town by fascist forces. After the exhibition ended, the mural remained at MOMA.[19] During the years Wolpe worked on *Battle Piece* he maintained close friendships with the Marxist sociologist and art historian Max Raphael (1889–1952), who at the time was writing an extensive essay on the Picasso mural.[20] Wolpe, too, was outraged by the Guernica atrocity, and immediately afterward composed his own response, *Zwei Chinesische Grabschriften* (1937), for mixed chorus and percussion. The score carries the epigraph, "Rache für Guernica!" (Revenge for Guernica).[21] Picasso's mural soon became a paradigm for socialist artists everywhere to express political outrage with modernist means. The artist depicted the burning, fleeing, screaming, dead, and dying figures with a hard-edged synthetic cubism, and the black-and-white monochromatic scheme makes viewers confront the horror without sentimentality.

Ellen Oppler documents the enormous impact of *Guernica* on New York artists: "Guernica reached New York at a crucial moment for American artists who were polarized between realism and abstraction. Social realists and admirers of the Mexican muralists expressed their leftist convictions often in conservative styles, while avant-garde abstractionists appeared divorced from the urgent concerns of the age." The mural, she notes, strongly affected the painters John Graham, Arshile Gorky, Lee Krasner, Jackson Pollock, Willem de Kooning, Robert Motherwell, and Ad Reinhardt. Reinhardt, for instance, wrote an illustrated guide to viewing the mural for his newspaper *P.M.* Even the huge scale of the mural exerted an influence, prompting painters to greatly enlarge their canvases.[22]

Guernica may well have affected Wolpe similarly while he was composing *Battle Piece*. The epic scale of *Battle Piece*, its all-over intensity, and its remorseless dialectic between contrasting materials suggest analogies to the Picasso painting. The technique Wolpe developed for presenting multiple transpositions of the thematic material simultaneously compares to Picasso's superposition of differing views of an image. The likelihood that

Guernica influenced *Battle Piece* is underscored by the fact that Irma Wolpe wrote the word *Guernica* at the head of her copy of the second part of the score, as though it were the title of the movement. She often wrote Wolpe's explanatory phrases in her scores; it is highly unlikely that she would have written down "Guernica" unless Wolpe had meant it as a specific comment on the music.

Wolpe composed the end of the fourth part of *Battle Piece* in early 1944 and then set the score aside. Ideas had been released for which he did not yet have the necessary techniques. During the next five years he worked out these ideas in a series of compositional studies and theoretical investigations. A study composed in 1946 has the title "Displaced spaces, Shocks, Negations, A new sort of relationship in space, Pattern, Tempo, Diversity of actions, Interreactions and intensities."[23] This in effect summarizes Wolpe's aesthetic agenda: to create a music of complex interactions, in which the dialectic between sharply contrasting materials produces a rhetoric of negation. The resulting disjunction and overlapping of elements in space and time prevent the listener from relying on the traditional functions of harmony, melody, and rhythm. One purpose of these investigations was to escape the constraints of the classical twelve-tone method through the use of all types of pitch cells (both atonal and triadic), but Wolpe's fundamental goal was the creation of a radically modernist music.

Comparison of the first four parts of *Battle Piece* with contemporaneous works for piano written in America by three fellow emigrés reveals the distance Wolpe had covered in his journey from European expressionism to American abstract expressionism. Hanns Eisler's Third Piano Sonata, Ernst Krenek's Third Piano Sonata, and the Ciaconna dei tempo di guerra of Erich Itor Kahn were all composed in 1943. Whether twelve-tone (Krenek and Kahn) or freely atonal (Eisler), the material is governed by such traditional elements as thematic melody and chordal accompaniment, imitative counterpoint, accompanied recitative, and metrical period structure. The Kahn Ciaconna comes closest to *Battle Piece* in its vigorous, hard-edged intensity, but the form is constrained by the continuous iteration of the twelve-note chaconne theme. These three composers still thought in terms of the more or less homogeneous thematic space that Wolpe sought to "displace."

Tudor gave the premiere of *Battle Piece* on March 11, 1950. The stunning achievement of the young pianist in memorizing and performing such intricate, dense, and tumultous music affected the audience enormously. The unrelenting energy of the playing—with its jabbing, slashing, punch-

ing attacks scattered throughout the musical space—projected an image of commitment, suffering, and heroic struggle. The parallels are evident beween the ferocious energy of the performance and the gestures used by such "action painters" as Pollock and de Kooning. Recognizing the emotive power of *Battle Piece* when he compared it with Tudor's performance shortly after of the Second Sonata of Boulez, John Cage noted in an interview, "The music closest to Boulez that Tudor had played until then was Stefan Wolpe's *Battle Piece*. It's a horribly difficult and very fascinating score. Like the Second Sonata it at first reduces you to a nearly total absence of comprehension. The difference is that it contains more passion than the Sonata. The effect of the two works is to make you tremble, at least when you hear them for the first time. But the *Battle Piece* not only makes you tremble, it also overwhelms you with its power."[24] Tudor's one recorded performance of *Battle Piece*, made in 1956,[25] makes clear that Wolpe's work—and in particular Tudor's performance of it—stood as an important harbinger of American abstract expressionism in music.

As a member of the Wolpe circle, Tudor gave private and public premieres of many pieces by Wolpe students, among them Morton Feldman, Kenyon Hopkins, Isaac Nemiroff, Ralph Shapey, and Netty Simons.[26] At the same time, Tudor began to perform the music of the group that gathered around Cage. Tudor first performed music by Cage in the fall of 1949 as accompanist for the dancer Jean Erdman. Cage introduced himself to Tudor, and Tudor soon invited Cage to one of the Wolpe musicales. At the Wolpes, Cage felt that he had discovered "the *true* center of New York. And yet it was almost an *unknown* center of New York."[27]

Set of Three Movements, Seven Pieces for Three Pianos, and *Enactments*

The music Wolpe began to compose late in 1949 moved beyond *Battle Piece* to a far greater level of abstraction. His *Set of Three Movements for Two Pianos and Six Hands*, written for Irma Wolpe, Tudor, and Jackie Maxin, survives as eleven numbered studies and four leaves from the beginning of the composition. Studies 8 and 9 contain descriptive words, written in or below the score, that reveal some of Wolpe's concerns (see figures 3.1a and 3.1b). In study 8, Wolpe wrote the word "solo" in the score of the second pianist (figure 3.1a); below the system he wrote, "inside action: fully spaced, outside is less dense, bass open settings. Sound environment non-thematic." Pianist II, with the loudest dynamic, presumably has the "inside action," while pianist I adds a less

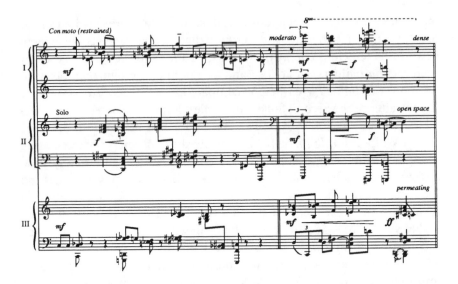

Figure 3.1a and 1b Studies Eight and Nine for *Set of Three Movements*. Sammlung Stefan Wolpe, Paul Sacher Stiftung. Quoted by permission.

dense shape in the upper register, and pianist III provides clusters and chords spread over the lower region, the "bass open settings." On the score of the ninth study, Wolpe entered the words "dense," "open space," and "permeating" (figure 3.1b). The "permeating" aspect of the music played by pianist III involves its position in the middle region of the pitch space. In the high region, pianist I presents four- to nine-note "dense" chords, while pianist II plays more widely spaced events in the low region. Wolpe's avoidance of thematicism in this passage, along with his focus on contrasting physical qualities, seems to confirm both the "abstract" and the "expressionist" components of his newly emerging "nonthematic environment."

The opening four bars of *Set of Three Movements* further demonstrate Wolpe's interest in the nonthematic juxtaposition of contrasting sound qualities. The first and second pianists together present one strand of music; meanwhile, the third pianist presents a strand that opposes the first (see figure 3.2). The music of the first strand (i.e., for pianists I and II) covers a wider range (six octaves) than the second strand, which spans no more than three octaves at any one time. The first strand features irregular and spasmodic rhythms, while the rhythms of the second strand are more persistent and stable. The harmonies of the first strand use mainly

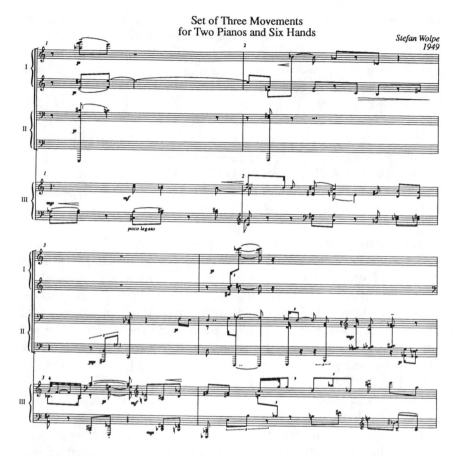

Figure 3.2 Set of Three Movements, measures 1–4. Sammlung Stefan Wolpe, Paul Sacher Stiftung. Quoted by permission.

seconds and fourths (plus their inversions and compounds), while those of the second strand use mostly thirds. Regarding expressive content, the first strand might be described as impulsive, uncouth, and disorderly, while the second strand behaves in a more contained, goal-directed, and placid manner. Wolpe identifies both strands of music not with a "theme" but rather by abstract qualities of gesture and behavior. The dialectic between opposed actions, which breaks the music into nonhomogeneous space, could easily remind one of similar dialectics in the visual worlds of Franz Kline and Mark Rothko.

By 1951, when Wolpe urged himself in his diary to complete the *Set of Three Movements*, the score must have been quite extensive.[28] Because no

other manuscript materials of the work survive, we may assume that the music was eventually absorbed into the *Seven Pieces for Three Pianos* (1951) and *Enactments* (1953). Wolpe's newly developed language of abstract expressionism, then, was created in a group of works for three pianists, and it emerged over a period of four years.

In the spring of 1952, Wolpe entered in his diary

> 16 May. I am going to give up my studio where I have grown up immensely towards my own re-integration, where I've written a few important works, where I've thought a few of my essential thoughts (the orders of organic modes, the orders of spatial relations / of proportions / of *definite harmonic structures* / of specific harmonic courses).[29]

This review of his most recent accomplishments shows that, after many years of intense material and psychological struggle, he had at last in his own mind found his authentic voice. The "important works" included the *Battle Piece*, the Sonata for Violin and Piano, *Music for a Dancer*, and the Saxophone Quartet. His "essential thoughts" were those he had presented in a lecture entitled "Spatial Relations, Harmonic Structures, and Shapes," which he gave at Yale University in March 1951. To illustrate this lecture, he had composed both a series of brief examples and the *Seven Pieces for Three Pianos*. While the manuscript of the lecture perished in a fire, we can infer much about his "essential thoughts" from the music he composed for the lecture.

Wolpe dedicated the *Seven Pieces* to Edgard Varèse, and he must have discussed his ideas with his friend, for this was the only work that he dedicated to a fellow composer. Varèse would certainly have been receptive, because his own music was based on similar principles. Unlike Wolpe, however, Varèse protected the secrets of his compositional methods, and thus it is doubtful that he would have shared much specific information with Wolpe about his own music. This is borne out by the fact that Wolpe's techniques of spatial proportions closely resemble the method Varèse employed in the 1920s, and yet Wolpe continued to believe that these ideas were his own.[30]

If Wolpe's approach to musical space paralleled Varèse's, his concept of "organic modes" was his own. The idea of associating characteristic qualities of behavior with a pitch series originated in Wolpe's study of Arabic music—in particular of *maqām*—while in Palestine. Wolpe first articulated the idea of organic modes in 1950 in relation to his piano piece *Music for a Dancer*: "The music that I wrote for Shirley [Broughton] is a big step

forward for me. Popular elements (already produced according to the consequences of heightened images). The utterances exist in a kind of primordial series of qualities regarding the diversity of the quality of the utterance."[31] Conceiving of musical material in terms of a "primordial series of qualities" rather than as a theme or a row involved a deeper level of abstraction and was analogous to the primitive symbols from mythology and anthropology that painters were investigating at the time. Some composers—the neoclassicists—looked to historical models for their "primordial" materials, but Wolpe now rejected preexisting style elements and older models. By "popular elements" Wolpe meant progressive jazz and popular song, from which he drew elements for abstract designs. His application of the notion of *maqām* from Arabic music and his incorporation of popular elements was for Wolpe the equivalent of what has been referred to as the "primal heritage."[32]

The *Seven Pieces for Three Pianos* demonstrate techniques for spatial proportions and organic modes by proceeding from simple to complex instances. The first piece presents a single proportional concept and a single organic mode, whereas the last piece gives each pianist a different organic mode and the proportions vary greatly. Figure 3.3 provides a graph of the first piece, entitled "Calm." The graphs show Piano I as gray, Piano II as white, and Piano III as black. Pitch is marked on the vertical axis and time on the horizontal axis, with each bar indicated by its respective meter signature. The ovoid shape of the notes is meant to suggest the envelope of the piano sounds.

In "Calm," the three pianos each play one pitch at a time, so that no more than three notes are heard at once. A symmetrical bell-like shape is formed in the upper pitch field. Wolpe orders the three sounding pitches in such a way that, at any one moment, the tones of Piano II lie more or less half way between the tones of Pianos I and III. He named such structures "proportions," and described them as shapes with an upper outside, a lower outside, and a middle. The resulting organic mode of "Calm" exhibits balance, containment, and poise.

Wolpe begins the sixth piece ("Taut like a high voltage wire, rather slow") with asymmetrical vertical shapes, in which the distances between notes are unequal in size. (Figure 3.4a provides the full score; figure 3.4b provides a graphic realization.) The governing proportion of the piece involves the interval of a third combined with a compound seventh or ninth, which in Jonathan Bernard's notation for such a structure would be [04][25] (see Piano I, m. 1). Pianos II and III respond with verticals based on similar proportions (e.g., [04][21] and [03][25]). Piano I, meanwhile,

Figure 3.3 Seven Pieces for Three Pianos, No.1. Graphic realization. © 1977, 1981 by Southern Music Publishing Co., Inc. International Copyright Secured. Reprinted by permission.

proceeds to develop its original proportion with an expanded version that covers four and one-half octaves ([15][37], mm. 2–3). The expansion in dynamics from piano to quadruple forte (mm. 1–4) reinforces the expansion taking place in pitch space, thus aggressively thrusting the proportion from a distant aural plane to one very close to the listener. In other words, the soft-to-loud, small-to-large dynamic progression serves to zoom in on the basic proportion. In notes Wolpe made in the margin of the score (next to mm. 4–5), he refers to a "return to more moderate proportions of the beginning," where Piano III has the shapes [03][22] and [04][35]. Near measures 4–9 Wolpe also notes that the piece will involve itself in the dissipating and dissolving of the concrete, well-defined shapes of the opening. Thus, he writes, "aperiodic succession of dynamics" (Piano II, mm. 4–5); "recession of insides" (Piano I, m. 6); "reciprocal recession" (Piano II, m. 6); "process of reduction of preceding proportions folded compact" (below Piano III, m. 6); "sideline withdrawal" (Piano III, m. 7–9); and "recession complete (within the empiric framework of sounds)" (below Piano I, m. 8). Later Wolpe conducted one of the players into the most extreme degree of dissolution, when Piano I recedes into "no longer audible spheres" (mm. 9–10). At this point all that remains is a very quiet pitch from Piano II, while Piano I departs into the ineffable.

Earlier elements recur in the final bars, but in a disorderly way and with extreme dynamic contrasts. Wolpe calls it a "reprise of the preceding bars in the form of a chaos" (m. 11). Symmetrical shapes (Pianos II–III, mm. 11–14) are disrupted by flurries in Piano I. The last cluster of Piano I is "indifferently far" from the penultimate cluster, "outside, off centre, sideline withdrawal." The asymmetrical shapes of the beginning are deformed in a mixture of organic modes that is tense, conflicted, and disruptive.

Interlude: Morton Feldman's Graphic Scores

The reader familiar with the music of Morton Feldman will see immediately the connection between his interest in the manipulation of abstract vertical sonorities and the compositional aesthetic embedded in Wolpe's *Seven Pieces for Three Pianos*. Feldman acknowledged, somewhat elliptically, various concepts learned from his teacher:

> When I first went to study with Wolpe [in 1946] soon after finishing high school, I was just another smart kid who thought that writing music was some clever way of pushing notes around. I soon learned differently. The

VI

Figure 3.4a *Seven Pieces for Three Pianos*, No. 6. © 1977, 1981 by Southern Music Publishing Co., Inc. International Copyright Secured. Reprinted by permission.

Figure 3.4a Seven Pieces for Three Pianos, No. 6.

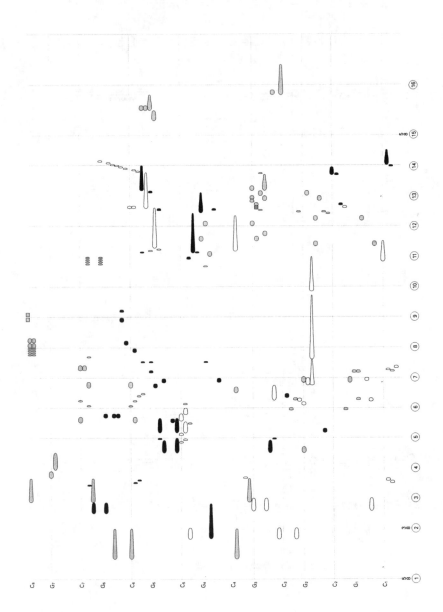

Figure 3.40 Seven Pieces for Three Pianos, No. 6. Graphic realization. © 1977, 1981 by Southern Music Publishing Co., Inc. International Copyright Secured. Reprinted by permission.

rules of the game were clear enough, but how to jump the hurdles were not. I learned it was a lie, that old dictum, "Rules are made to be broken." They were, in fact, obstacles to be jumped—that our musical history and the realities of note-pushing into shapes and forms was a treacherous steeplechase. . . . Logic is more than walking a straight line, especially if there is an obstacle in front of you. Wolpe used these obstacles as part and parcel of his musical language. Though, as I have just remarked, they were referred to as opposites. I took this overall concept with me into my own music soon after finishing my studies with Wolpe. It was the basis of my graph music. For example: the time is given but not the pitch. Or, the pitch is given and not the rhythm. Or, in earlier notated pieces of mine the appearance of octaves and tonal intervals out of context to the overall harmonic language. I didn't exactly think of this as opposites—but Wolpe taught me to look on the other side of the coin.

In particular, Feldman was inspired by Wolpe's concept of "shape." He writes, "That element of shape . . . I would say that it's essentially what influenced my music. Stefan's big influence. It's a big *influence* when a teacher talks about shape, in so far as that consciousness of just that word could go into any style. I could bring a shape into a simultaneous chord, I could shape a chord, so to speak."[33]

By 1950 Feldman was certainly familiar with Wolpe's musical ideas and, indeed, in 1951 he served as one of several Wolpe students who sat on the stage while their teacher gave his lecture on "Spatial Relations, Harmonic Structures, and Shapes" at Yale. The pianists David Tudor, Larry Smith, and Arthur Komar were also there to perform the musical illustrations from *Seven Pieces*. There is thus a direct connection between Feldman's early graph pieces (e.g., *Projection 1* for cello, written late in 1950) and the Wolpe workshop. The connection is further strengthened by David Tudor's performances of Feldman. When, for example, Feldman handed Tudor a graphic score for piano entitled *Intersection 3* (1953), Tudor, as he did habitually with indeterminately notated pieces, took great pains to write out his own realization. John Holzaepfel's analysis of Tudor's realization of *Intersection 3* shows that the latter did not simply divide the keyboard mechanically into high, middle, and low ranges, but shifted the ranges in the course of the piece. This solution accords with Wolpe's practice in *Seven Pieces*. Nevertheless, while Wolpe based his choice of pitches on intervallic proportions, Tudor, as Holzaepfel points out, determined his own pitch selections by the way the notes fell under his hands. And yet,

his performance of *Intersection 3* bears resemblance to the last of Wolpe's *Seven Pieces.*[34]

Feldman's graphic scores have been interpreted as early essays in indeterminacy, but there was little that was indeterminate about Feldman's conception or Tudor's realization. Feldman's brand of musical actionism involved a less determinate structure, but not an indeterminate intention. It was "the collision with the Instant . . . which is the first step to the Abstract Experience."[35] Not fully understanding Feldman's intent in his graphic scores, Cage interpreted them as examples of what he called indeterminacy and so encouraged this misunderstanding.[36] Heinz-Klaus Metzger, on the other hand, understood Feldman's "reconciliation of opposites" as derived from Wolpe and quite distinct from the methods of Cage's experimental music.[37]

By the early 1950s, while Wolpe's students Feldman and Tudor had begun creating their own versions of an abstract expressionist music, their teacher was composing his own climactic abstract expressionist essay, a work he named *Enactments*. On the title page of the score, Wolpe gave the date he began the composition as 1950, but at other times he noted that the work began with *Set of Three Movements* or with *Seven Pieces*. Indeed, until he finally settled on the title *Enactments* some time in 1953, he referred to the piece as *Set of Three Movements*.

In the spring of 1952, Wolpe wrote to Josef Marx about the concepts with which he was dealing in *Enactments*, "I am busy . . . with writing (writing the music which I started to write in my "Seven Pieces for 3 Pianos," the ones I did for Yale) only doing it on a much vaster and bolder scale. (What intrigues me so thoroughly is to integrate a vast number of *different organic modes*, existing simultaneously under different conditions of age, time, function and substance / The continuity of a piece is the expression (or manifestation) of a number of purposeful reproductions of the modes. . . . I see *a vast orbit* possible, to write music, existing (as definite totalities of organic modes) under most different conditions of complex behaviour. I come close to my ideal of writing a language with a common-sense (and this in a sense of an all-union-of-the-human-tongue)."[38] Wolpe completed the "Inception" movement by 1951, then began to work on "In a State of Flight." By December 1952, he completed "Chant," and finished "Held In" by the middle of January 1953. He spent the remainder of the year finishing the fifth movement ("Fugal Motions") and revising earlier movements.

It was not until late in the compositional process that Wolpe realized that the work would require three pianos. The reasons clearly derive from an abstract expressionist sensibility; as he explained, "I am more convinced

that this work should be played on 3 pianos although I conceived it for 2 pianos . . . and one should rehearse it on 2 pianos, but to play it, each of the pianists would need a greatest expansiveness of his body's farthest reaches, and since much of the music is a 100 eagles wings set afire, or a 100 simultaneities coordinated 'elegantly' and with an extreme concern for the tangibility of multiple (but organically different) modes of action, no player should feel hemmed in (or impaired in its autonomous bodyness) and must feel happily fused (and happily dis-fused) with the other players."[39]

The title of the composition came to Wolpe some time during the summer or early fall of 1953. It first appeared in a letter to Morley in October, when he mentioned that he was revising "Enactments," putting the name in quotation marks as though it were a new idea.[40] The choice of title places Wolpe squarely among the "action painters," the name that Harold Rosenberg gave to the leading abstract expressionists in his seminal essay, "The American Action Painters," published in December 1952.[41] Though Rosenberg identified no artist by name in that essay, contemporary readers knew well that he had in mind Willem de Kooning.[42] For Rosenberg, action painting celebrated process over product; it stressed the artist as subject rather than the painting as object: "What was to go on the canvas was not a picture but an event." Paintings like these, then, connected in an integral way to the artist's life: "the act-painting is of the same metaphysical substance as the artist's existence. The new painting has broken down every distinction between art and life."[43] De Kooning, who would spend months on one painting and was wary of critical tags, once asked Rosenberg with some irony, "Am I an action painter?" During his answer Rosenberg quoted someone who had asked whether it was possible to paint a slow action painting. "Yes!" broke in de Kooning.[44] It was clear that "action painting" did not mean automatism, although some critics preferred to use the term "gestural realism." Elaine de Kooning, both a critic and a painter, approved of the term *action painting*, and in an essay on Rothko and Kline glossed Rosenberg by stressing the importance of the creative act to the individuation process of the painter. She declared that, for the Americans—meaning de Kooning, Rothko, Kline, Pollock, and others of that group—painting was now "a bid for an individual identity. . . . It is as difficult for [the painter] to explain what his art *is* as to explain what he himself *is*; but, since he paints with the question and not with the answer, explanation is not an issue."[45]

Enactments was certainly central to Wolpe's own bid for individual identity. He identified strongly with the music: "it is as central, inclusive and personal as I can make it."[46] After finishing the piece, he felt that he

had come through an encounter with "dangerous depths" that had threatened him with "annihilation."[47] Finishing the work gave him the sense of emerging into "the open sea or a channeled harbor" where he had "won a new form, a new condition, a purer state of myself as a writing, expressing man."[48] Completing *Enactments* was, indeed, the culmination of an intense and lengthy process of individuation.

Wolpe would certainly have heard about action painting during the summer of 1953, when Estéban Vicente came down from New York to teach at Black Mountain College. Wolpe would have recognized the analogies between his six-hand work and the ideas of the action painters, because each movement embodied a particular action to which he had given a brief title. The names of the movements—"Chant," "In a State of Flight," "Held In," "Inception," and "Fugal Motions"—resemble the allusive titles that the painters gave their canvases at the time. Such titles, often assigned after the painting was finished, stir associations but do not define a program. For Wolpe, *Enactments* meant "acting out, being in an act of, being the act itself."[49] The first movement, "Chant," presents a grandly lyrical action, in which a complex gesture—an arch-like shape, a low trill, and a series of soft staccato chords—unfolds into a series of exuberant shapes and motions that spiral, sink, rise, and recur. The following movement, "In a State of Flight," is a scattering action of interruptions. "Held In" features a gathering action that holds the material close to the center of the pitch field, while "Inception"—also fixed within the center of the pitch field—uses a smaller cluster of muted tones to present an action of muffled stirrings. The concluding "Fugal Motions," the longest of the movements, presents an extended play between scattering and gathering actions. Its music offers a kaleidoscope of shapes, in which elements may gather into focused expressions, break into fragments, coalesce slowly, erupt suddenly, or split into several simultaneous layers.

The fugue subject that opens "Fugal Motions" (see figure 3.5, mm. 1–3) harbors a rich assortment of rhythmic gestures, including emphatic quarter notes, striding eighth-note motion, skipping single-note figures, and jazzy dotted rhythms. The sheer variety of these gestures, combined with the unusually angular melodic contour, conveys intense energy and high spirits.

Although the fugue subject appears as a row, it mostly behaves as a trope or a kind of mode. It is more useful, then, to group the twenty-seven pitches of the subject as nine trichords, labeled A through J (see figure 3.6). During the course of the movement, the subject appears in several row forms, nine of which Wolpe noted in the manuscript: "on D-flat" (P0), "on E inverted" (I3), "on F inverted" (I4), "on G-flat" (P5), "on G"

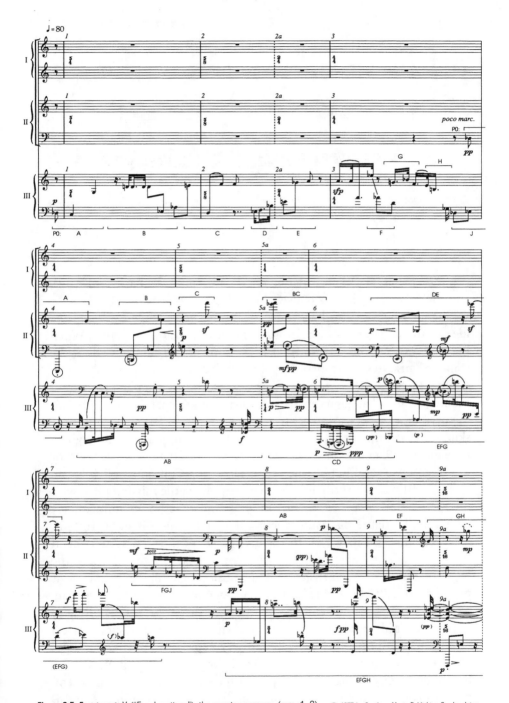

Figure 3.5 **Enactments** V ("Fugal motions"), the opening passage (mm. 1–9). © 1977 by Southern Music Publishing Co., Inc. International Copyright Secured. Reprinted by permission.

Figure 3.6 Enactments V ("Fugal motions"). Three row forms. © 1977 by Southern Music Publishing Co., Inc. International Copyright Secured. Reprinted by permission.

(P6), "on B-flat" (P9), "on B-flat inverted" (I9), "on B-flat backward" (R9), and "on C" (P11). (Figure 3.6 gives three of the row forms.)

The opening of "Fugal Motions" illustrates how Wolpe exploited the idea of the fugal exposition for an abstract expressionist agenda. When Piano II answers the subject (figure 3.5, mm. 3ff), it does not adopt the standard practice of transposing the subject in its original shape to another pitch level. Instead, the answer keeps the original pitch content of the subject and changes its shape. The answer thus expands the contour of the original two-octave subject to five octaves (C1 to F6) and ignores the skipping rhythmic figure, staying mostly with even quarter- and eighth-note motion. Piano II's answer follows the order of the pitches of the subject in groups A and B, but when it gets to group C, it omits pitch D (m. 5). Piano III reacts directly to this event, supplying the missing pitch with the interjection of a forte chord (m. 5). Piano II responds immediately with a similar figure that jams together the pitch groups B and C (m. 5a), then continues on its way with the groups D and E (m. 6). After this it pauses again, as though unsure of what comes next (see the silence at the beginning of m. 7), then rushes to a conclusion by jumbling the last four pitch groups (F, G, H, and J) into a brief cadential figure (at the end of m. 7). The asymmetry of its contour compounds the awkwardness of Piano II's answer: unlike the original subject, which was mainly symmetrical around its midpoint (D4–E4), the answer deploys more than twice as many pitches above its midpoint (A3) as below. Piano II continues on its bumbling way by taking a second pass at the subject. It sets down D3 (m. 7) as a stable axis and presents a flicking figure based on groups A and B (m. 8), but it completely forgets about C and D as it darts with its dotted figure to the final pitch groups E, F, G, and H.

In a "proper" fugue, of course, Piano III would have juxtaposed the subject with a complementary countersubject. Instead, Piano III restates Po freely and with interpolations, doubling several pitches with Piano II (see the circled notes in mm. 4–6). With its dotted rhythms, a lively turning figure, wide leaps, and a loud chord (mm. 4–5), Piano III assumes the nature of a trickster. With a jazzy riff (m. 6) Piano III incites Piano II to loosen up and then jumps on Piano II's high E♭6 with the forte figure on A6 (m. 7). Piano II gets into the jazzy spirit, but awkwardly and clumsily.

In this opening passage of "Fugal Motions," Wolpe established a different kind of counterpoint, one that stresses the juxtaposition of shape and character. His fugue presents a polyphony of organic modes of the kind that he first essayed in *Set of Three Movements* and *Seven Pieces*. In the course of its composition, he encountered associations with earlier pieces. He wrote to Josef Marx that "I am in midst of the Fugal Motions. . . . Peculiarly, it is a synthesis of Battlepiece, last movement of the Oboe Sonata, some elements of the Violin Sonata, some of the Saxophone Quartet, many from the Yale 7 Pieces for 3 Pianos, this all, cored in and a host of new things, events, solutions, concerns, materials, the diction of thoughts, the pattern (and organic function) of the ensemble, the multiplexity of the musical course itself."[50] Never far from Wolpe's consciousness was his conviction that the essence of this music lay in its function as meaningful utterance: "It is as near to matter, to the simultaneity of organic pattern as it is near to human speech and what I wish to say to human beings."[51] Looking back on *Enactments* a year later, Wolpe dwelled on the structures of powerful natural phenomena and the expression of intense human emotions. He wrote that the sounds of his piece exhibited the "plasticity . . . of waves," the "fluid elasticity of river currents, and the generative liveliness of all [that] is life (and Apollo and Dionysus, and the seasons of the heart, and the articulate fevers)."[52]

The painters of the time often talked about the problem of knowing when a picture was finished, and Wolpe faced a similar dilemma at the end of *Enactments*. He pondered his options in a letter to Josef Marx. Not certain of what to do at the coda, Wolpe asked, "Shall I freeze the motion or dissipate it, or soberize it, or acquiesce a tumult, a galaxy of forces, incensed, radiant, inspired? Or slip off with the sounds, the structures, the rhetorics and say, 'Gentlemen, Mein Kunst ist ein Gleichnis [my art is a semblance] of the things to come.'"[53] In other words, the usual strategy for closure would call either for a gathering action (freezing or sobering the motion) or a scattering action (dissipating the motion in a radiant tumult). But he wished to avoid the old rhetoric and

structures and find a new way of bringing the more than thirty minutes of *Enactments* to a close.

The coda unfolds in two phases of about one minute each, the second of which is given in figure 3.7. During the last pages of the movement, the three piano-protagonists continue to display their distinctive characters. Piano III brings back the prime form of the subject on D-Flat (P0), which has not been heard for some while. Out of a combination of varied shapes (mm. 312–17), Piano III builds a series of gestures that culminate in an intricate and many-layered object (m. 335 / 335a / 335b). Piano III concludes with the core sounds of the prime form of the subject (mm. 336a–338), recalled from m. 312, thus giving a well-formed closure to its final utterance. In contrast, the material of Piano I derives from the subject on B-flat (P9), at first retrograde (mm. 312–24), then in the original order (mm. 325–38). As before, Piano I is demonstrative, colorful, and exuberant; it gradually winds down with a series of brusque gestures that end with a very emphatic triple-forte exclamation on B-flat. This contrasts strongly with the sophisticated shapes that conclude Piano III. Piano II, also distinctive, retains its awkward, bumbling character, which now becomes rather autistic. Piano II draws its pitches mainly from the transposition of the subject to G-flat (P5), but ends before the other pianos without having traversed the row even once through. Piano II spasmodically repeats figures of only a few notes within a narrow range, while occasionally mirroring gestures in the other pianos.

Wolpe brings the movement to a close by retaining the independent behavior and material of the three piano-protagonists. The diversity of these bodies of sound in motion, each with its own character and mode of action, evokes a new concept of music in displaced spaces. *Enactments* stops rather than ends, as though a huge mobile of Alexander Calder, with variegated elements in vigorous motion, gradually comes to rest. The condition at rest of these bodies of sound is another aspect of the bodies in motion. Wolpe found a way of bringing the more than thirty minutes of music to a close that did not interfere with the independent characters of the protagonists.

After completing *Enactments,* Wolpe was euphoric and wrote, in a letter to Netty Simon Sr., "I have written on a vast scale (147 pages of music) my most inclusive (self-inclusive, existence-inclusive, man-inclusive) work, my ideas of 'modes of organism,' of simultaneities, of centralisation and decentralisation of pitch units, pitch constellations, harmonic structures, harmonic variations, proportions of volumes, of spatial interdependences, interactions, interferences, of a whole technique of distances, of

Figure 3.7 Enactments V ("Fugal motions"), the concluding passage (mm. 312–338). © 1977 by Southern Music Publishing Co., Inc. International Copyright Secured. Reprinted by permission.

Figure 3.7 Enactments V ("Fugal motions"), the concluding passage (mm. 312–338) (continued).

Figure 3.7 Enactments V ("Fugal motions"), the concluding passage (mm. 312–338) (continued).

Figure 3.7 *Enactments* V ("Fugal motions"), the concluding passage (mm. 312–338) (continued).

Figure 3.7 Enactments V ("Fugal motions"), the concluding passage (mm. 312–338) (continued).

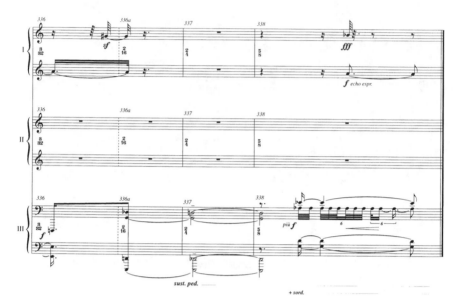

Figure 3.7 *Enactments* V ("Fugal motions"), the concluding passage (mm. 312–338) (continued).

interruptions, congestions, liquidations, of a course of continuation of diversions, or perspectives, a 1000 things have gone in and out of it. (Definitely more than I know!)"[54]

Wolpe was overwhelmed by the joy of having achieved his goal, but he also recognized that he had discovered "more than he knew." As he wrote in the lecture "Thinking Twice," "Good is to know *not* to know how *much* one is knowing."[55] Wolpe shared with the painters and composers who gathered at The Club on Eighth Street the belief that the creative act brings into conscious awareness contents that are as yet unknown. Dore Ashton remarks that this was a central feature of the abstract expressionist milieu: "What I think most distinguishes the whole community of that period was its agreement that the unknown was of higher value than the known. Wolpe, whose message was always that one must plunge into the unknown without preconceptions, was, like the artists he admired, a highly disciplined explorer in the unknown. He knew when to know not to know."[56]

It was in this respect that the younger composers who frequented The Club were convinced that the painters were leading the way to a new approach to the creative process. Varèse, who had drawn some of his ideas from the cubists, and Wolpe, who carred the traditions of Dada and the Bauhaus, were in agreement with de Kooning, who said, "Some painters,

including myself, do not care what chair they are sitting on. . . . They do not want to 'sit in style.' Rather they have found that painting—any kind of painting, any style of painting . . . is a way of living today, a style of living so to speak."[57] Following on from Varèse and Wolpe, Cage, Feldman, and Earle Brown learned from the painters that composing was a way of living. Cage told a meeting of The Club in 1951, "Mostly, right now, there is painting and sculpture, and just as formerly when starting to be abstract, artists referred to music to show that what they were doing was valid, so nowadays, musicians, to explain what they are doing, say 'See, the painters and sculptors have been doing it for quite some time.' "[58] And Feldman said, "Music is not painting, but it can learn from this more perceptive temperament that waits and observes the inherent mystery of its materials, as opposed to the composer's vested interest in his craft. . . . The painter achieves mastery by allowing what he is doing to be itself. In a way, he must step aside in order to be in control. The composer is just learning to do this."[59]

These composers were drawn to the painters not only to be stimulated by the synesthetic correspondences between audial and visual experience, but because they sought an approach to the craft of writing music that rejected notions of system and logic in favor of an encounter with the not-yet-known.[60] Stefan Wolpe's *Enactments* may thus stand as one of the crowning musical achievements of the abstract expressionist movement not only for the scope and power of the composition itself, but for the creative process that Wolpe underwent in bringing it to light.

Notes

This essay is dedicated to the cherished memory of Hilda.

1. Morton Feldman, "Recollection," in *On the Music of Stefan Wolpe: Vol. II, Recollections*, ed. Austin Clarkson (Hillsdale, N.Y.: Pendragon Press).

2. Edgard Varèse, "Spatial Music," in *Contemporary Composers on Contemporary Music*, ed. Elliott Schwartz and Barney Childs, 2d ed. (New York: Da Capo, 1998), 204.

3. Lester Trimble, "Stefan Wolpe, Alone and Self-Contained," *New York Times*, Arts and Leisure Section, April 21, 1963, 28.

4. From the program of the Nineteenth Evening of the Novembergruppe in 1927, which included piano sonatas by Hans Heinz Stuckenschmidt and Hans-Jörg Dammert. For the full text of the program, see Stuckenschmidt, *Zum Hören Geboren* (Munich: Piper, 1979), 94–96.

5. See Dore Ashton and Hilda Morley, "Recollections," in *On the Music of Stefan Wolpe, Vol. II*.

6. Hilda Morley, "The Eighth Street Club," from *A Thousand Birds: A Biographical Memoir*," in Clarkson, ed., *On the Music of Stefan Wolpe, Vol. II*.

7. Ibid.

8. Stefan Wolpe, *Diary VI*, 1951, 38. Sammlung Stefan Wolpe, Paul Sacher Stiftung, Basel (henceforth SSW).

9. Wolpe, *Diary VII*, 1952, 45. SSW.

10. Wolpe, *Diary VII*, 1952, 52. SSW.

11. Stefan Wolpe, letter to Hilda Morley, May 22, 1952. SSW.

12. See Thomas Phleps, "Music Content and Speech Content in the Political Compositions of Eisler, Wolpe, and Volgel," in Clarkson, ed., *On the Music of Stefan Wolpe, Vol. I, Essays*.

13. Wolpe, *Diary III* 1939 (SSW), 138: Gegen die Nacht der Welt/den Tag der subjectiven Initiative setzen./Hell werden in sich selber/und sich der menschlichen/Gesellschaft/vertraut machen/und immer vertrauter/mit ihr werden. (To set the world against the night, the day against the subjective initiative./To be clear in oneself/ and to make oneself familiar with human society/and to become ever more familiar with it.)

14. Wolpe, *Diary VI*, November 21, 1951, 25-27. SSW.

15. Musicians who studied with one or both of the Wolpes in the 1940s and 1950s include Claus Adam* (cellist, composer), Stanley Applebaum (composer, arranger), Elmer Bernstein* (pianist, film composer), Joe Bushkin (jazz pianist), John Carisi* (jazz trumpeter, composer), Morton Feldman* (composer, teacher), Bill Finegan* (big band orchestrator), Kenyon Hopkins (radio and film composer), Edwin Hymovitz* (pianist, teacher), Irma Jurist Neverov* (pianist, theater composer), Ezra Laderman (composer), Edward Levy* (composer, teacher), Jerome Lowenthal (pianist), Ursula Mamlok* (composer), Robert Mann (violinist, composer), Jacob Maxin* (pianist, teacher), Leonard Meyer* (music theory and aesthetics), Isaac Nemiroff (composer, teacher), George Russell* (jazz composer, teacher), Eddie Sauter* (jazz band orchestrator, concert music composer), Tony Scott* (jazz clarinetist, composer), Ralph Shapey* (violinist, conductor, composer, teacher), Netty Simons (composer), David Tudor* (pianist, composer), Bea Witkin* (composer for television), and Eli Yarden* (composer, teacher). Haim Alexander* (Israeli composer, teacher) and Herbert Brün* (American composer, teacher) studied with Wolpe in Palestine. An asterisk indicates those whose recollections appear in Clarkson, ed., *On the Music of Stefan Wolpe, Vol. II*. See also Joy Tudor Nemiroff's recollections in the same volume.

16. Feldman, "Recollection," in Clarkson, ed., *On the Music of Stefan Wolpe, Vol. II*.

17. The following were students of Hofmann: George Cavallon, Lee Krasner (who in 1942 introduced Hofmann to Jackson Pollock), Burgoyne Diller, Helen Frankenthaler, Red Grooms, Allan Kaprow, George McNeil, Marisol, Joan Mitchell, Louise Nevelson, Larry Rivers, and Richard Stankiewicz. See Helmut Friedel and Tina Dickey, *Hans Hofmann* (New York: Hudson Hills, 1997), 10.

18. David Tudor, "Composing the Performer: David Tudor Remembers Stefan Wolpe," *Musicworks* 73 (spring 1999): 28.

19. On the history of the *Guernica* mural, see Herschel B. Chipp, *Picasso's Guernica: History, Transformations, Meanings* (Berkeley and Los Angeles: University of California Press, 1988), 168.

20. Max Raphael, "Discord between Form and Content. Picasso: *Guernica*," in *The Demands of Art* (Princeton: Princeton University Press, 1968), 135. Hilda Morley recalled that Wolpe disagreed with Raphael's contention that in *Guernica* there is a split between the form and the content. Nevertheless Wolpe included Raphael's name in an early dedication of *Battle Piece*.

21. Wolpe, *Two Chinese Epitaphs* (Hamburg: Peer), 1997.

22. Ellen C. Oppler, "*Guernica*—Its Creation, Artistic and Political Implications, and Later History," in *Picasso's Guernica* (New York: Norton, 1988), 111–20.

23. Wolpe, *Two Studies for Piano, Part 1* (1946), from *Music for Any Instruments* (New York: Peer, 1987).

24. John Cage, *For the Birds: John Cage in Conversation with Daniel Charles* (Boston: Marion Boyars, 1981), 123.

25. Tudor's performance from around 1956 is included on the compact disc accompanying *Musicworks* 73.

26. Tudor, "On Performing Battle Piece," in Wolpe, *Battle Piece* (Hamburg: Peer), 1996, v. See also John Holzaepfel, "David Tudor and the Performance of American Experimental Music, 1950–1959," Ph.D. dissertation, City University of New York, 1994, appendix D, 328 ff.

27. John Cage, "Recollection," in Clarkson, ed., *On the Music of Stefan Wolpe, Vol. II*.

28. In Wolpe, *Diary VII*, 1951 (SSW), 1, he writes, "Rückkehr zu vollster Entfaltung persönlicher, künstlerischer kritischer Activität. . . . Absolute: beenden 3 Movement." [Return to the fullest unfolding of personal, artistic, critical activities. Absolutely: finish 3 Movement.]

29. Wolpe, *Diary VII*, May 16, 1952, 101. SSW.

30. Jonathan Bernard, in *The Music of Edgard Varèse* (New Haven, Conn.: Yale University Press, 1987) has analyzed Varèse's method of distributing pitches according to symmetrical and asymmetrical relations. Matthew Greenbaum has demonstrated that Wolpe's theory of proportions is most helpful in the analysis of Varèse's music; see Greenbaum, "The Proportions of Density 21.5: Wolpean Symmetries in the Music of Edgard Varèse," in Clarkson, ed., *On the Music of Stefan Wolpe, Vol. I*. Wolpe consulted with Milton Babbitt while he was preparing the lecture; see Babbitt, "Recollection," in Clarkson, ed., *On the Music of Stefan Wolpe, Vol. II*.

31. Wolpe, *Diary 3.5.24* (SSW), 5–6: "May [1950]. Die Musik, die ich für Shirley schrieb, ist ein großer Schritt vorwärts für mich. Populäre Elemente (*schon nachgeschaffen den Folgerungen erhöhter Ebenbilder)*//Die Äußerungen existieren in einer Art von Ahnenreihe der Qualitäten//über die Vielfalt der Qualität der Äußerung."

32. For the abstract expressionist painters and the notion of "the primal heritage," see Stephen Polcari, *Abstract Expressionism and the Modern Experience* (Cambridge: Cambridge University Press, 1991), 35–51.

33. Feldman, "Recollection."

34. Recordings of *Intersection 3* have been issued on Edition RA 1010, and *Morton Feldman: The Early Years*, Columbia Odyssey 32 16 0302. On Tudor's realization of *Intersection 3*, see Holzaepfel, "Painting by Numbers: The Intersections of Morton Feldman and David Tudor," in this volume.

35. Morton Feldman, "After Modernism" and "Give My Regards to Eighth Street," in Walter Zimmermann, ed., *Morton Feldman Essays* (Kerpen, West Germany: Beginner Press, 1985), 104 and 76–77.

36. See John Cage, "Lecture on Something" and "Indeterminacy," in *Silence* (Middletown, Conn.: Wesleyan University Press, 1961).Cage interprets Feldman's graphic pieces as exercises in indeterminacy. Cage cites Feldman's *Intersection 3* and Brown's *Four Systems* as "indeterminate with respect to performance" (36–37), even though Tudor precisely notated scores for both pieces. In practice, as Cage told Holzaepfel, he would stick to one way of performing an indeterminate score, and Tudor would make changes when the initial challenge of a new work began to wear off. (With thanks to John Holzaepfel for this communication.)

37. Heinz-Klaus Metzger, "Stringquartet—Über das Spätwerk," in Zimmerman, ed., *Morton Feldman Essays*, 32.

38. Wolpe, letter to Josef Marx, June 17, 1952, Josef Marx Archive, New York, N.Y. *Enactments for Three Pianos* is published by Peer, New York.

39. Wolpe, letter to Netty Simons, June 26, 1953. Music Division, New York Public Library (NYPL).

40. Wolpe, letter to Hilda Morley, October 2, 1953. SSW.

41. Harold Rosenberg, "The American Action Painters," in *Abstract Expressionism: A Critical Record*, ed. David Shapiro and Cecile Shapiro (Cambridge: Cambridge University Press, 1990), 75–88.

42. See Polcari, *Abstract Expressionism*, 292.

43. Rosenberg, "The American Action Painters," 76, 78.

44. Sally Yard, *Willem de Kooning* (New York: Rizzoli, 1997), 73.

45. Elaine de Kooning, "Two Americans in Action: Franz Kline and Mark Rothko (1958)," in *The Spirit of Abstract Expressionism: Selected Writings* (New York: Braziller, 1994), 167.

46. Wolpe, letter to Joe Livingston, April 13, 1953. SSW.

47. Wolpe, *Diary VIII*, November 8, 1953, 19. SSW.

48. Wolpe, letter to Joe Livingston, July 14, 1954. SSW.

49. Wolpe, letter to Beverly Bond, February 9, 1961. Stefan Wolpe Archive, York University, Toronto.

50. Wolpe, letter to Josef Marx, April 2, 1953. Josef Marx Archive.

51. Wolpe, letter to Joe Livingston, April 13, 1953. SSW.

52. Wolpe, letter to Joe Livingston, July 14, 1954. SSW.

53. Wolpe, letter to Josef Marx, October 26, 1953. Josef Marx Archive.

54. Wolpe, letter to Netty Simons, November 11, 1953. NYPL.

55. Wolpe, "Thinking Twice," 303.

56. Dore Ashton, "Stefan Wolpe, Man of Temperament," in Clarkson, ed., *On the Music of Stefan Wolpe, Vol. I.*

57. Willem de Kooning, "What Abstract Art Means to Me," in David Shapiro and Cecile Shapiro, eds., *Abstract Expressionism: A Critical Record* (Cambridge: Cambridge University Press, 1990), 219–24.

58. Cage, "Lecture on Something," 144.

59. Feldman, "The Anxiety of Art," in ed., Zimmerman, *Morton Feldman Essays*, 90.

60. For a fuller treatment of this question, see my essay, "The Intent of the Musical Moment: Cage and the Transpersonal," in *Writings through John Cage's Music, Poetry, and Art*, edited by David W. Bernstein and Christopher Hatch (Chicago: University of Chicago Press, 2001), 62–112.

[4]

John Cage and the
"Aesthetic of Indifference"

David W. Bernstein

I

magine how life would be if one lived in the world of a Ludwig van Beethoven piano sonata. Consider, for example, the "Appassionata." The eminently tragic tone evoked by the first phrase of this work becomes even more disturbing when it is transposed into the Neapolitan region, a harmonic move that substantially "challenges" the sovereignty of the tonic. The subsequent unraveling of the theme breaks it up into smaller and smaller phrases. This reduction—or better, "liquidation"—of the work's opening melodic materials culminates at the end of the first thematic group, where the sole "survivors" are two stark chords in a low register a half-step apart.

The arrival of the second theme in the relative major offers us only a brief respite from the increasingly oppressive atmosphere, because Beethoven quickly returns to A-flat minor, the key in which his exposition ends. The "assault" upon the tonic intensifies during the development, which begins in the distant key of e-major. The "tonal tremors" set off by this move continue into the recapitulation, where their resolution is undermined by a dominant pedal that persists during the return of the first theme. Later on, there is a suggestion that the turmoil will finally come to a positive end when the opening theme is stated triumphantly in thickly scored block chords in the major mode. But our prospects for a brighter future are abruptly denied by the conclusion of the movement with its frenzied coda and final desolate statement of the first theme in a low register accompanied by the dissipating palpitations of the C and A-flat in the top voice. E. T. A. Hoffman's comment that "Beethoven's music sets in motion the mechanism of dread, fear, horror, [and] pain" is par-

ticularly apt for this work and it is doubtful that anyone would enjoy life within its terrifying confines.[1]

My intent here is not to criticize Beethoven, as John Cage did during his provocative lecture entitled "Defense of Satie," which he presented at Black Mountain College in the summer of 1948.[2] Cage's critique dealt with technical matters; he criticized Beethoven for defining compositional structure according to harmony rather than by units of time.[3] But the motivation behind his attack was a rejection of Beethoven's romantic worldview with its emphasis on emotional expression and the musical manifestation of the composer's subjectivity. Cage's lecture was among a group of works written during the late 1940s that marked a crucial stage in the evolution of his compositional language and aesthetic philosophy. This essay examines this development within its historical context and, in particular, its relationship to the history of the New York School.

Commonly associated with abstract expressionism and such painters as Jackson Pollock, Mark Rothko, and Willem de Kooning, the New York School was actually a loose affiliation of poets, composers, dancers, as well as artists who represented a broad range of aesthetic sensibilities. In the years following the Second World War, the New York School took the art world by storm, and several scholars have even noted that after the war the cultural center of the West shifted from Paris to New York, taking root in the form of an American avant-garde that reached its height during the late 1940s. But what are the preconditions for an authentic avant-garde movement in the arts? In its well-known military usage, the avant-garde constitutes the leading edge of an invading force. Similarly, in aesthetics and cultural history, the avant-garde functions as a vanguard paving the way for developments in artistic language. Radical innovation and experimentation have in many cases become the sole criteria for the avant-garde,[4] but historically the term has encompassed sociopolitical as well as artistic issues.[5] In the twentieth century, the avant-garde has taken on many forms: from Dadaism, futurism, and surrealism (the so-called early twentieth-century or historical avant-garde) to the various "neo-avant-garde" movements (such as Fluxus) in the second half of the twentieth century. All of these movements had political as well as aesthetic agendas.

Abstract expressionism emerged during a period of economic, moral, political, and social upheaval. Europe had little time to recover from the catastrophic events associated with the First World War before hostilities were renewed, this time with exponentially more destruction and butchery. Many believed that European culture would cease to exist. Current art criticism has shown how abstract expressionism responded to this histor-

ical context, its cultural and intellectual by-products as well as its ideologies (both subliminal and overt).[6] A common goal among abstract expressionist artists was to identify and heal society's moral and spiritual wounds. According to art historian Stephen Polcari, abstract expressionism sought "to transfigure what it considers collective human experience resulting from the collapse of the West in a depression and a modern Thirty Years War. In its attempt both to explicate and redeem the experiences of its generation, Abstract Expressionism sought to affirm and at times regenerate Western life."[7]

Many of the abstract expressionists had been politically active during the 1930s, when the Works Progress Administration enlisted their help in efforts aimed at the revitalization of America during the Depression era. The WPA commissioned artists to create murals and sculptures for public buildings, and their works often took on political and social themes. Their style, influenced by the regionalism and social realism of artists such as Thomas Hart Benton, was conservative, especially compared to European modernism. In the 1940s, when the same artists turned toward abstraction and experimental techniques such as gesture and color field painting, their works seem to lose their political edge. Ideology of any sort was held in disrepute after the Second World War. Most artists withdrew from the political arena with the specter of Stalinist totalitarianism on the left and the repressive politics of Joseph McCarthy and George Dondero (the infamous senator from Michigan known for the phrase "modern art equals communism") on the right. This view was summarized in an editorial that appeared in the first and only issue of *Possibilities*, a journal devoted to issues in contemporary art that was edited by Robert Motherwell, Harold Rosenberg, Pierre Chareau, and John Cage. As the editorial noted, "The temptation is to conclude that organized social thinking is 'more serious' than the act that sets free in contemporary experience forms which that experience has made possible. One who yields to this temptation makes a choice among various theories of manipulating the known elements of the so-called objective state of affairs. Once the political choice has been made, art and literature ought of course to be given up."[8]

Although they shied away from organized political action, artists did continue to address social concerns as individuals. Painting was a means to confront the artist's inner conflicts, and by extension the problems confronting all humanity. As Dore Ashton has pointed out, this tactic was consistent with the tenets of French existentialism, an important influence upon many abstract expressionists.[9] Art was a means by which artists expressed their own subjectivity, and the result of this process of self-definition had an impact

upon the rest of society. As Jean-Paul Sartre explained in his book *Existen-tialism and Humanism*, "If ... existence precedes essence and we will to exist at the same time we fashion our image, that image is valid for all and for the entire epoch in which we find ourselves. Our responsibility is thus much greater than we had supposed, for it concerns mankind as a whole."[10]

The abstract expressionists saw humanity involved in a perceptual struggle with emotional and spiritual forces rooted in our distant past. Inspired by modern psychology and, in particular, Carl Jung's analytic psychology,[11] they explored the unconscious motivations behind contemporary human behavior. Jungian theory claims that there exists a shared or collective unconscious consisting of "archetypes" or universal images present since the first primitive cultures. These images are expressed in humanity's shared legends, rituals, and myths. Jung's work was influenced by Sir James Frazer's *The Golden Bough*, and the abstract expressionists were familiar with this work as well as with Joseph Campbell's *The Hero with a Thousand Faces*, a book that traces the metaphor of a hero's journey in mythologies from around the world. Campbell claimed that through a transhistorical and transcultural study of myth we would arrive at "an amazingly constant statement of the basic truths by which man has lived throughout the millenniums of his residence on the planet."[12]

II

When John Cage arrived in New York City in the summer of 1942, he almost immediately encountered an exciting artistic circle that included both Americans and Europeans who had come to the United States fleeing Nazi oppression. During the late 1940s and early 1950s, there were many opportunities for exchanging ideas across disciplines at such locales as the Eighth Street Artists' Club, the Cedar Tavern, and other meeting places frequented by members of the New York School. Cage had many associations with this group. He presented several lectures at The Club, and was music editor for *Possibilities* and a contributor to another artist-run periodical called *The Tiger's Eye*.

It is not surprising that New York's artistic climate suited Cage because his own work and ideas paralleled that of artists associated with the New York School. As Irving Sandler has explained, Cage's fascination with the materials of music, which included so-called musical sounds as well as noise and silence, is analogous to the abstract expressionist focus on their own materials and deemphasis of the "painterly" aspects of their tech-

Figure 4.1a John Cage, preparing a piano, 1960s. © The John Cage Trust.

nique (see figure 4.1).[13] Cage's works for percussion ensemble and his compositions for prepared piano had expanded the vocabulary of musical sounds much in the way that painters had extended the range of their own medium. Cage quickly found a niche in New York and enjoyed an extremely successful concert of his works at the Museum of Modern Art in February 1943, which was described in an article that appeared in *Life* magazine on March 15.

Cage's interest in non-European and so-called primitive cultures had been inspired earlier by Henry Cowell in the 1930s. In New York he found artists engaged with similar concerns and he responded with several new works for prepared piano including *Totem Ancestor* (1942), *Primitive* (1942), and *And the Earth Shall Bear Again* (1942) whose style and subjects illustrate the continued appeal of humanity's prehistoric past. Cage was personally acquainted with Joseph Campbell,[14] and his interests in mythology are reflected in a major work for prepared piano entitled *The Perilous Night* (1944) as well as in other compositions written during this period.

The extroverted emotionalism and the "physical" nature of the sounds used in Cage's compositions from the early 1940s resonate strongly with the expressive world of many New York School artists. Even before he began writing music via chance operations, Cage, like the abstract expressionist

Figure 4.1b Jackson Pollock
painting *One: Number 31, 1950,*
with Lee Krasner in the back-
ground. Photograph by Hans Namuth.
© Estate of Hans Namuth. Pollock-Krasner
House and Study Center.

"drip and gesture painters," valued spontaneity. Like the abstract expres-
sionists, Cage viewed the creative process in terms of both conscious and
unconscious motivations. In an article entitled "Forerunners of Modern
Music," first published in *The Tiger's Eye*, he explained that "any attempt to
exclude the irrational is irrational. Any composing strategy which is
wholly 'rational' is irrational in the extreme."[15] He carefully described
which elements could be consciously controlled and which were "uncon-
sciously allowed to be" in a diagram accompanying this article (see figure
4.2). Structure—that is, the division of a work into successive sections and
phrases—is controlled by the composer's intellect. The method of com-
position and the composer's materials may either be controlled through
rational decision or may be the spontaneous result of improvisation and
inspiration. Form, the final result, is the actual content of a composition.
According to Cage, "form wants only freedom to be. It belongs to the
heart; and the law it observes, if indeed it submits to any, has never been
and never will be written."[16]

 In 1944 Cage went through a period of emotional distress resulting
from the end of his marriage, a reorientation of his sexuality, and a real-
ization that he was unable to communicate his emotional experiences
through music. *Four Walls, Root of an Unfocus,* and *The Perilous Night,*
composed during that year, are responses to this personal crisis. But the

Figure 4.2 Diagram from "Forerunners of Modern Music," *The Tiger's Eye*, March 1949. © The John Cage Trust.

intense expressiveness of these works with their mercilessly incessant rep-etitions and abrupt changes of texture and mood reveal Cage's general interest in the inner world of psychological conflict, a fascination that he shared with the abstract expressionists (see figure 4.3).[17]

Despite these aesthetic and stylistic parallels, it is important to note that Cage never really endorsed abstract expressionist art. Essentially, he never agreed with the abstract expressionist worldview, which in its more aggressive manifestations placed far too much emphasis on the artist's ego. He found Jackson Pollock particularly unappealing on both personal and professional grounds and preferred the work of Mark Tobey, who he considered a more subtle artist.[18] In general, Cage was attracted to the appearance and not the intentions of abstract expressionist art. He enjoyed the fact that painting now could extend the range of our visual experiences much in the same way that his own use of noise had affected our hearing.[19]

Starting in the early 1940s, Cage became increasingly interested in mys-ticism and Eastern philosophy. This initiated a period of transition, which resulted in changes in his musical style and philosophy, including the beginning of a lifelong preoccupation with chance and indeterminacy and a reevaluation of the relationship between music and artistic expression. Cage rejected the notion that music is a means by which a composer expresses his emotions, this resulted in a departure from the aesthetic assumptions that he shared with many of the first generation New York School artists. For Cage, the creative act no longer entailed a definition of the artist's subjectivity; art now had an ethical and spiritual function. The purpose of music was "to sober the mind and thus make it susceptible to divine influences." Cage's emphasis had begun to shift from the composer to the listener, a change that would later lead him to an almost complete withdrawal of the composer's subjectivity from the creative process. In 1952 he stated, "The most that can be accomplished by the musical ex-pression

XIII

Figure 4.3a Passage from John Cage, *Four Walls*. © 1982 by Henmar Press Inc. Used by permission.

of feeling is to show how e-motional the composer was who had it. If anyone wants to get a feeling of how emotional a composer proved himself to be, he has to confuse himself to the same extent that the composer did and imagine that sounds are not sounds at all but are Beethoven and that men are not men but are sounds. Any child will tell us that this simply is not the case. A man is a man and a sound is a sound."[20]

When Cage presented his "Lecture on Nothing" at The Club in 1950, he had already written the *Seasons* (1947) and the *Sonatas and Interludes* (1946–48) and was likely working on his *String Quartet in Four Parts* (1949–50). The often understated and restrained style of these works clearly indicates a shift in his aesthetic orientation. On the surface, Cage's lecture is a discussion of structure, method, material, and form, basic concepts underlying his approach to composition. But his lecture is also an inflammatory jab aimed at the aesthetics of abstract expressionism.[21] One can only imagine how disturbed the audience at The Club would have been with his statement that "I have nothing to say and I am saying it and that is poetry."[22] The statement's blatant withdrawal of subjectivity was

for Merce Cunningham

ROOT OF AN UNFOCUS

<div align="right">JOHN CAGE
(1944)</div>

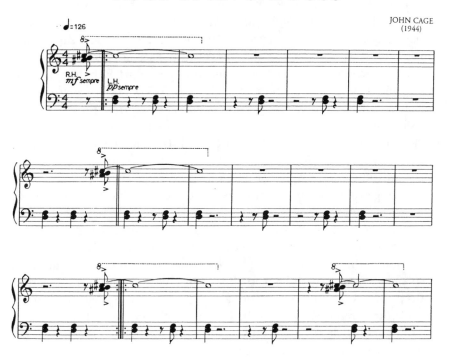

Figure 4.3b Passage from John Cage, *Root of an Unfocus*. © by Henmar Press Inc. Used by permission.

certainly a critique of the overwrought emotionalism and heroic existentialist narcissism that characterized the abstract expressionist aesthetic.

<div align="center">III</div>

Cage's "Lecture on Nothing" marked a pivotal moment in his career. In addition to its critique of abstract expressionism, it was also a statement of aesthetic principles that would occupy him for the rest of his life. In the years following his lecture at The Club he began experimenting with chance operations and his rejection of artistic subjectivity increasingly led him to abandon compositional control. As we have seen, this crucial stylistic development was stimulated by a change in Cage's views regarding

the ethical and spiritual purpose of music. The implications of these ideas would later lead Cage to his own political and social philosophy.

On the surface, Cage's works from the 1950s, such as *Music of Changes* (1952) and *Concert for Piano and Orchestra* (1958), do not indicate that he was engaged with political concerns. During the late 1950s and early 1960s, members of what Irving Sandler has called the second generation of the New York School—a group that included Jasper Johns, Robert Rauschenberg, and Merce Cunningham, as well as Cage—were particularly uninterested in the sociopolitical function of art. The "neutrality" of their work was just as much the result of their political disengagement as it was their negation of emotional expression in general. Their aesthetic stance, which art historian Moira Roth has termed an "aesthetic of indifference,"[23] has been attributed to the oppressive politics of the McCarthy era as well as to the emergence of a muted homosexual aesthetic within the context of a dominant homophobic culture.[24]

Roth traces this aesthetic to Marcel Duchamp, who rejected the notion that art objects are an expression of an artist's emotions. For example, in describing the process through which he chose his readymades he explained, "It is very difficult to choose an object, because, at the end of fifteen days, you begin to like it or hate it. You have to approach something with an indifference, as if you had no aesthetic emotion. The choice of ready-mades is always based on visual indifference and, at the same time, on the total absence of good or bad taste."[25]

Duchamp advocated a sort of aesthetic anesthesia, which resembles Cage's own disavowal of emotionalism in music. This detachment also characterized the way in which Duchamp viewed the world; despite his association with the historical avant-garde, he was disinterested in politics: "I don't understand anything about politics, and I say it's really a stupid activity, which leads to nothing. Whether it leads to communism, monarchy or a democratic republic, it's exactly the same thing, as far as I'm concerned."[26]

There exist many parallels among the work and aesthetic philosophies of Cage, Duchamp, and the second generation of New York School artists.[27] Much of the ultramodernist art of the 1950s was clearly apolitical and it has even been asserted that music written by composers of the New York School was exported to Darmstadt with the covert assistance of the Central Intelligence Agency in order to assure that composers in Germany would remain uninfluenced by cultural politics emanating from the Soviet Union.[28] It would be a mistake to deny the similarities among the works of Cage, Rauschenberg, Johns, and Cunningham from this period. But a closer examination of Cage's aesthetic position in the 1950s reveals that his

seemingly apolitical neutral stance laid the groundwork for his more mature views regarding the social and political function of art.

Toward the end of the 1960s, Cage paid increasing attention to relationships between art and politics.[29] But the basis for his political beliefs had already been formulated during the 1950s within a purely musical context. In *A Year from Monday* (1967), he marked the similarities between his *Julliard Lectures*, written in 1952, and his more recent and overtly political writings, noting, "When I recently reread my Julliard Lectures, I was struck by the correspondences between the thought in it and the thought I consider more recent in my mind, e.g., 'We are getting rid of ownership, substituting use,' 1966; and 'Our poetry now is the realization that we possess nothing,' 1952. My ideas certainly started in the field of music. And that field, so to speak, is child's play. . . . Our proper work now if we love mankind and the world we live in is revolution."[30] "Possessing nothing" for Cage means that we should "let sounds be themselves." Sounds should exist in space without relationships to one another and should not be part of a controlled musical continuity. Cage applied the notion of "unimpededness"—a term borrowed from Zen Buddhism—first within a musical context and later to social and political situations. His lack of interest in musical continuity, and the rules and organizational principles that this approach to musical form entails, was extended to an egalitarian social philosophy:

> Since the theory of conventional music is a set of laws exclusively concerned with "musical" sounds, having nothing to say about noises, it had been clear from the beginning that what was needed was a music based on noise, on noise's lawlessness. Having made such an anarchic music, we were able to include in its performance even so-called musical sounds.
>
> The next steps were social, and they are still being taken. We need first of all a music in which not only are sounds just sounds but in which people are just people, not subject, that is, to laws established by any one of them even if he is "the composer" or "the conductor." Finally (as far as I can see at present), we need a music which no longer prompts talk of audience participation, for in it the division between performers and audience no longer exists: a music made by everyone.[31]

Cage believed that a work of art constituted a model of how an ideal world might be constructed. This idea is stated in his essay "The Future of Music" (1974), where he writes, "Less anarchic kinds of music give

examples of less anarchic states of society. The masterpieces of Western music exemplify monarchies and dictatorships. Composer and conductor: king and prime minister. By making musical situations which are analogies to desirable social circumstances which we do no yet have, we make music suggestive and relevant to the serious questions which face Mankind."[32]

The political intent of a work conceived in this way is expressed by its representation of alternative epistemologies with the hope that these might lead to a radical reshaping of our political and social structures. This approach constitutes what the Marxist literary critic Raymond Williams has termed *alternative culture*, which he contrasts with *oppositional culture*, the latter being a tactic that also strives for social change, but through a much more overt and confrontational political message.[33]

Seen in this light, even Cage's most abstract ultramodernist compositions from the early 1950s are steps toward his formulation of musical works as idealized social structures; by "letting sounds be themselves" in works such as *Music of Changes* he created musical forms that would later offer us models for alternative forms of social and political organization. Cage's preoccupation with relationships between art and politics persisted throughout his career. It led, for example, to the pluralistic vision represented by his "Musicircus,"[34] and his concept of "anarchic harmony" that models an idealized social structure through harmonic configurations that remain free from a central and dominating tone.

Cage's interest in the future of music became a concern for the state of the world. This is especially evident in his writings, beginning with the first installments of the poem "Diary: How to Improve the World (You Will Only Make Matters Worse)" in *A Year from Monday*.[35] His political and social views are a mosaic of ideas drawn from a variety of sources including R. Buckminster Fuller, Marshall McLuhan, and Henry David Thoreau. Through Fuller, Cage saw the necessity for global planning:

FULLER: AS LONG AS ONE HUMAN BEING IS
 HUNGRY, THE ENTIRE HUMAN RACE IS
HUNGRY. City planning's obsolete. What's
 needed is Global planning so Earth
 may stop stepping like octopus on its
own feet.[36]

Cage agreed with Fuller that the problems plaguing humanity could be solved through an efficient utilization of the world's resources. According

to Cage, "The goal, to quote Fuller as he stated it in '63 is '. . . to render the total chemical and energy resources of the world, which are now exclusively pre-occupied in serving 44% of humanity, adequate to the service of 100% of humanity at higher standards of living and total enjoyment than any man has yet experienced.'" [37]

Citing McLuhan, Cage saw technology, and in particular electronic media, as a model and a means to facilitate a new synergetic and holistic thinking:

> Alteration of global
> society through electronics so that world
> will go round by means of united
> intelligence rather than by means of
> divisive intelligence (politics,
> economics).[38]

Cage admired the writings of Thoreau, and believed, as did Thoreau, that "best government governs least"—a position that led him to endorse anarchism and the ideas of Emma Goldman, Peter Kropotkin, and Michael Bakunin, among others.[39] In Cage's view,

> Society, not being a
> process a king sets in motion, becomes an
> impersonal place understood and made
> useful so that no matter what each
> individual does his actions enliven the
> total picture. Anarchy (no laws or
> conventions) in a place that works.
> Society's individualized.[40]

In the absence of government, religion, and property, anarchism emphasizes a balance between individual freedom and social responsibility. For example, as Emma Goldman, a Russian immigrant, anarchist, and advocate for women's rights, explained, "Anarchism is the great liberator of man from the phantoms that have held him captive; it is the arbiter and pacifier of the two forces for individual and social harmony. To accomplish that unity, Anarchism has declared war on their pernicious influences which have so far prevented the harmonious blending of individual and social instincts, the individual and society."[41]

These ideas provided Cage with a political analog for the notions of "unimpededness" and "interpenetration." The relationship between the

individual and society resembled Cage's approach to musical form, where each sound is distinct from all others and, at the same time, part of the whole, "penetrating and being penetrated by all others."[42] Cage's "borrowings" from Zen Buddhism were thus consistent with both his musical and political ideas.

Anarchists like Goldman protested against political organization that accumulated power by means of majority rule. A "majority," proclaimed Goldman, "has never stood for justice or equality. It has suppressed the human voice, subdued the human spirit, and chained the human body. As a mass its aim has always been to make life uniform, gray, and monotonous as the desert. As a mass it will always be the annihilator of individuality, of free initiative, of originality."[43]

Similarly, Cage never stopped believing in the importance of individuals, just as he sought to "let sounds be themselves" in musical works. He even went as far as to reject identity politics, since the notion of minorities also entails the organization of individuals into groups. When Cage was asked, in an interview with Joan Retallack, about minority representation and points of view in society as well as in his own work, the following exchange took place:

> *John Cage*: . . . I don't think of individuals as being massed together in a group. I really think of individuals having their own uniqueness. So that I'm not sympathetic to people who consider themselves members of a minority group. And I don't really support minority groups. I don't like the notion of the power or the weakness of a group. Hmmm? I consider that a form of politics, and I think we've passed that.
> *Joan Retallack*: What would you substitute for the notion of politics?
> *John Cage*: The uniqueness of the individual.[44]

As was the case with his earlier appropriations from South and East Asian philosophy, Cage adapted ideas taken from his political sources so that they fit his own personal views. Unlike many of the anarchists, he was against protest and direct political action:

> The price-system
> and government that enforces it are on
> the way out. They're going out the way a
> fire does. Protest actions fan the

> flames of a dying fire. Protest helps to
> keep the government going.[45]

Cage believed that political and social change must occur from within. Citing a passage from a book written by M. C. Richards, an artist and poet he met at Black Mountain College, Cage wrote, "Revolution remains our proper concern. But instead of planning it, or stopping what we're doing in order to do it, it may be that we are at all times in it. I quote from M. C. Richards book, *The Crossing Point*: 'Instead of revolution being considered exclusively as an attack from outside upon an established form, it is being considered as a potential resource—an art of transformation voluntarily undertaken from within. Revolution arm in arm with evolution, creating a balance which is neither rigid nor explosive. Perhaps we will learn . . . to work together for organic change.' "[46]

Thus, although he went as far as to support Mao Tse-tung and the Chinese Revolution for a brief period of time,[47] Cage was against organized politics. He was particularly critical of social realism, stating that composers in this tradition "do not exemplify in their work the desired changes in society as they use their music as propaganda for such changes or as criticism of the society as it continues insufficiently changed."[48] In addition to their adoption of archaic, nineteenth-century musical practices, composers such as Cornelius Cardew "study the pronouncements of Mao Tse-tung and apply them as literally and legalistically as they can."[49] Cage praised politically inspired music by Christian Wolff and Frederick Rzweski because their works suggested "irresistible change." He was also attracted to their virtuosic efforts. Virtuosity, for Cage, modeled disciplined activity that could lead to a better society: "A necessary aspect of the immediate future, not just the field of environmental recovery, is work, hard work, and no end to it. Much of my own music since 1974 is extremely difficult to play (the *Etudes Australes* for the pianist Grete Sultan; the *Freeman Etudes* for the violinist Paul Zukofsky). The overcoming of difficulties. Doing the impossible."[50]

Perhaps the most eloquent written statement of Cage's social and political philosophy was his mesostic poem "Overpopulation and Art"—delivered with an uncharacteristic emotional intensity at Stanford University in January 1992. Many of the themes of his earlier writings appeared in this poem. What is perhaps most striking is that he remained optimistic that his utopian dream would one day become a reality, despite the persistence of violence and poverty in the world. The poem includes a passage from a letter in which Cage asked Esther Ferrer whether anarchy has a future:

fiRst to yourself and then to society after the
unworkability of caPitalism marxism
 authOritarian socialism anarchy seems for our liberation
 to be a Possibility once again as jorge oreiza said to me
 from failUre
 to faiLure
 right up to the finAl
 vicTory
 I think
 nOw of
 marshall mcluhaN
 the world hAs become
 a siNgle
 minD[51]

IV

 People ask what the
 avant-garde is and whether it's
 finished. It isn't. There will
 always be one. The avant-garde is
 flexibility of mind and it follows like
 day the night from not falling prey to
 government and education. Without
 avant-garde nothing would get
 invented.
 —John Cage, "Diary; How to Improve the World
 (You Will Only Make Matters Worse)"

The failed political, social, and artistic programs endorsed by avant-garde movements in the twentieth century have often led to the conclusion that the avant-garde is no longer viable.[52] We may have witnessed, as Andreas Huyssen has cynically observed, the "fragmentation and decline of the avant-garde as a genuinely critical adversary culture."[53] Yet, unlike many of his iconoclastic predecessors, Cage's approach to social and political change avoided what he termed "critical actions" and emphasized "composing actions."[54] The latter was the creation of artistic works modeling social situations within which we might prefer to live. Thus, for Cage, what appears to be an "aesthetic of indifference" is in fact a new approach toward the social and political function of art.

Cage's transformation of avant-garde aesthetics situates him at the end of a historical narrative dating back to the eighteenth century, to the origins of what Jürgen Habermas has termed the "project of modernity."[55] Thinkers in the Enlightenment, as well as in the nineteenth and early twentieth centuries, shared the belief that developments in the arts and sciences could lead to a just society, and above all, to universal human freedom. Although Cage did not ascribe to the absolutes and universal truths postulated in so many forms during the Enlightenment, romantic, and modernist periods, his views concerning the regenerative capabilities of art place him within this tradition. Cage approached the ephemerality and fragmentation of life in the late twentieth century in a positive way; his optimism and the priestly role that he assumed relate to the early part of this century rather than to its end, and perhaps even to the Beethovenian romanticism that he so adamantly disdained.

While an aesthetic of indifference was never really relevant to Cage's politics, it may, at least on the surface, have applied to his abstract, objective music written after 1950. Throughout his career Cage sought to eliminate boundaries between art and life. In the following anecdote concerning a performance of a composition by Christian Wolff, Cage explained that the experience of a musical work can only be enhanced by "extraneous" sound, writing, "One day when the windows were open Christian Wolff played one of his pieces at the piano. Sounds of traffic, boat horns were heard not only during the silences in the music, but, being louder, were more easily heard than the piano sounds themselves. Afterward someone asked Christian Wolff to play the piece again with the windows closed. Christian Wolff said he'd be glad to, but that it wasn't really necessary, since the sounds of the environment were in no sense an interruption of those of the music."[56]

Blurring the distinction between art and life removes the composer's "voice" from his or her work. In Cage's *4'33"*—perhaps the most radical manifestation of this idea—art and life become the same phenomenon. The listener can experience all sound in a musical way; the composer is irrelevant. Although one can argue that the withdrawal of subjectivity was a hallmark of Cage's aesthetic for most of his career, Cage's late music—such as *13*, his last completed work or *103*, a piece for orchestra that accompanies his film *One[11]*—draws the listener in; sounds other than the actual music are distractions. As Heinz-Klaus Metzger observes, "For many years Cage's compositions had necessitated the revolutionary postulate of the fall of the art empire (*Kunstprivileg*), thereby admitting ordinary and everyday noise into them, so as to soften the borders between art and its surrounding reality, and this was furthered even more by incorporating

the enemy art industry into the compositions, such as converting radios and record-players into musical instruments. However, Cage's late works—like *Études Australes* for piano, the *Freeman Etudes* for violin, or all the 'number pieces'—announce in blinding purity and solemnity their critical difference from the real world and the ideas that rule it, both literally and figuratively."[57]

Cage's late works have a transcendental quality, which seems to grow from the inner world of their creator. Their intense subjectivity—a far cry from the detached "coolness" associated with the aesthetic of indifference—is evidence of an important change in Cage's compositional style. Cage was to be present at the Cologne Philharmonic premiere of *One[11]* and *103* on September 19, 1992, but his death on August 12th must have instead made this event an incredibly moving memorial for a composer who had touched the lives of so many. Cage had returned to the expressive world of his earlier works; the sounds that one hears are not only sounds, they are also John Cage.

Notes

1. E. T. A. Hoffman, "Beethoven's Instrumental Music," cited by Carl Dahlhaus in *Nineteenth-Century Music*, trans. J. Bradford Robinson (Berkeley and Los Angeles: University of California Press, 1989), 90.

2. John Cage, "Defense of Satie," in *John Cage*, ed. Richard Kostelanetz (New York: Da Capo, 1970), 77–84.

3. Ibid., 81.

4. This approach stems from the famous essay "Avant-Garde and Kitsch" written by art critic Clement Greenberg in 1939. See Clement Greenberg, "Avant-Garde and Kitsch," in *Clement Greenberg Collected Essays*, vol. 1 (Chicago: University of Chicago Press, 1986), 5–22.

5. See Donald D. Egbert, *Social Radicalism in the Arts* (New York: Knopf, 1970), 121–22. Gabriel Desiré Laverdant, for example, in his book entitled *De la mission de l'art et du rôle des artist* (1845), defined avant-garde art as that which has the potential to initiate social change and, in 1878, Michael Bakunin prepared a periodical entitled *L'Avant-Garde* that served as a forum for the anarchist movement. See Renato Poggioli, *The Theory of the Avant-Garde* (Cambridge, Mass.: Harvard University Press, 1968), 9.

6. See, for example, Dore Ashton, *The New York School: A Cultural Reckoning* (Berkeley and Los Angeles: University of California Press, 1973) and Stephen Polcari, *Abstract Expressionism and the Modern Experience* (Cambridge: Cambridge University Press, 1991). For works that try to demonstrate that abstract expressionism unconsciously responded to "hidden" social and political pressures see Serge Guilbaut, *How New York Stole the Idea of Modern Art*, trans. Arthur Goldhammer (Chicago: University of Chicago Press, 1983) and Michael Leja, *Reframing Abstract Expressionism: Subjectivity and Painting in the 1940s* (New Haven: Yale University Press, 1993). Guilbaut examines the rise of the New York School in

relation to what he terms the slow "de-Marxization and later de-politicization" of left-wing intellectuals that started circa 1939. He attributes their turn toward abstraction as an attempt to establish a style that was "aloof from both the right and the left" (2). Leja's study is based on what he terms "Modern Man Discourse," which he links to both mass and high culture. He explains that the abstract expressionist emphasis on primitive man and the unconscious resonated with similar concerns in popular literature and film noir. According to Leja, the popularity of these concepts contributed to the success of abstract expressionism, as witnessed by the widespread coverage of the New York School in *Life*, *Time*, *Harper's Bazaar*, and the *New York Times*.

7. Polcari, *Abstract Expressionism*, 3.

8. Robert Motherwell and Harold Rosenberg, "Editorial Statement," *Possibilities* 1 (1947/48): 1. This passage is reprinted in Ann E. Gibson, *Issues in Abstract Expressionism: The Artist-Run Periodicals* (Ann Arbor, Mich.: UMI Research Press, 1990), 239.

9. Ashton, *The New York School*, 174ff.

10. Jean-Paul Sartre, *Existentialism and Humanism*, trans. Philip Mairet (London: Methuen, 1946), 29.

11. Many of the abstract expressionists read Jung and several of them also went through Jungian psychotherapy. For a discussion of Jungian psychology and its influence on abstract expressionism see Polcari, *Abstract Expressionism*, 43ff.

12. Joseph Campbell, *The Hero with a Thousand Faces* (Princeton: Princeton University Press, 1949), vii–viii.

13. Irving Sandler, *The New York School* (New York: Harper and Row, 1978), 163.

14. After staying with Max Ernst and Peggy Guggenheim in their New York City apartment, Cage moved in with Campbell and his wife, dancer Jean Erdmann. See David W. Patterson, "Appraising the Catchwords, c. 1942–1959: John Cage's Asian-Derived Rhetoric and the Historical Reference of Black Mountain College," Ph.D. diss., Columbia University, 1996, 59. Patterson's dissertation contains an extensive chronology of Cage's early life and career.

15. John Cage, "Forerunners of Modern Music," *Tiger's Eye*, March 1949. This article is reprinted in Cage, *Silence*, 62–66, and in Ann E. Gibson, *Issues in Abstract Expressionism*.

16. Cage, "Forerunners."

17. Citing Rainer Maria Rilke, Cage explained that psychoanalysis "might remove my devils, but they would certainly offend my angels." See Richard Kostelanetz, *Conversing with Cage* (New York: Limelight Editions, 1987), 174.

18. John Cage, "Interview with John Roberts and Silvy Panet Raymond" in Kostelanetz, ed., *Conversing with Cage*, 174.

19. John Cage, "Interview with Irving Sandler," in ed., Kostelanetz, *Conversing with Cage*, 175ff.

20. John Cage, "Julliard Lecture," in *A Year from Monday* (Middletown, Conn.: Wesleyen University Press, 1967), 97.

21. This is noted in Caroline A. Jones, "Finishing School: John Cage and the Abstract Expressionist Ego," *Critical Inquiry* 19 (summer 1993): 628–65.

22. David Revill reports that one audience member declared "John, I dearly love you, I can't stand this a minute longer." David Revill, *Roaring Silence* (New York: Arcade Publishing, 1992), 103.

23. Moira Roth, "The Aesthetics of Indifference," *Artforum* 10 (November 1977): 46–53.

24. Caroline A. Jones, "Finishing School." See also Jonathan Katz, "John Cage and the Queer Silence or How to Avoid Making Matters Worse," in David W. Bernstein and

Christopher Hatch eds., *Writings through John Cage's Music, Poetry, and Art* (Chicago: University of Chicago Press, 2001).

25. Pierre Cabanne, *Dialogues with Marcel Duchamp*, trans. Ron Padgett (New York: Viking, 1971), 48.

26. Ibid., 103.

27. George Leonard has shown that there are important differences between Cage and Duchamp. He explains that Duchamp's work was a protest against art and the concept of beauty, while Cage advocated that beauty exists in everything. His Zen inspired rejection of emotionalism notwithstanding, Cage was hardly indifferent to the sounds around us. For Cage, Duchamp's readymades demonstrated that everyday objects have beauty. Leonard explains that this elevation of the "commonplace" is part of a tradition that he refers to as "natural supernaturalism" and traces back to William Wordsworth, Thomas Carlyle, John Ruskin, and Ralph Waldo Emerson. See George J. Leonard, *Into the Light of Things: The Art of the Commonplace from Wordsworth to John Cage* (Chicago: University of Chicago Press, 1994), 230–34.

28. Andrew Huyssen, "Back to the Future: Fluxus in Context," *In the Spirit of Fluxus*, ed. Janet Jenkins (Minneapolis: Walker Art Center, 1993), 146.

29. Natalie Crohn Schmitt, "John Cage in a New Key," *Perspectives of New Music* 20 (fall/winter 1981): 99–103.

30. John Cage, foreword to *A Year from Monday*, ix.

31. John Cage, foreword to *M, Writings'67–72* (Hanover, N.H.: Wesleyen University Press, 1973), xiii-xiv.

32. John Cage, "The Future of Music," in *Empty Words* (Middletown, Conn.: Wesleyen University Press, 1979), 183.

33. Raymond Williams, "Base and Superstructure in Marxist Cultural Theory," *Contemporary Literary Criticism*, ed. Robert Davis and Ronald Scleifer (New York, 1989), 384.

34. See Charles Junkerman, "nEw/foRms of living together": The Model of the Musicircus," in *John Cage: Composed in America*, ed. Marjorie Perloff and Charles Junkerman (Chicago: University of Chicago Press, 1994), 39–64.

35. John Cage, "Diary: How to Improve the World (You Will Only Make Matters Worse)," in *A Year From Monday*, 3–20 and 145–162.

36. Ibid., 5.

37. Ibid., 164.

38. Ibid., 17–18.

39. For a list of Cage's sources see John Cage, "Anarchy," in *John Cage at Seventy-Five*, ed. Richard Fleming and William Duckworth (Lewisburg, Penn.: Bucknell University Press, 1989), 122–23.

40. Cage, "Diary," 161.

41. Emma Goldman, *Anarchism and Other Essays* (New York: Dover, 1969), 53.

42. John Cage, "Composition as Process," in *Silence: Lectures and Writings* (Middletown, Conn.: Wesleyan University Press, 1961), 46.

43. Ibid., 78.

44. *Musicage: Cage Muses on Words, Art, Music*, ed. Joan Retallack (Hanover, N.H.: Wesleyan University Press, 1955), 51.

45. John Cage, "Diary," continued 1968 (revised) in *M, Writings '67–72*, 10–12.

46. John Cage, "The Future of Music," 182.

47. John Cage, foreword to *M*, iv.

48. Cage, "The Future of Music," 183.

49. Cardew launched his own critique of Cage's politics in Cornelius Cardew, *Stockhausen Serves Imperialism* (London: Latimer New Dimensions, 1974), 34ff.

50. Ibid., 184.

51. Cage, "Overpopulation and Art," in *Composed in America*, 37. For the text of Ferrer's letter see Andrew Culver, "Notes on Anarchy and Economy," *Musicworks* 6 (1995): 22–27.

52. See, for example, Hans Magnus Enzenberger, "Die Aporien der Avant-Garde," *Einzelheiten Poesie und Politik* (Frankfurt am Main: n. p., 1962); Leslie Fiedler, *The Collected Essays*, vol. 2 (New York: Stein and Day, 1971), 454–61; Peter Bürger, *Theory of the Avant-Garde* (Minneapolis: University of Minnesota Press, 1984); Andreas Huyssen, *After the Great Divide: Modernism, Mass Culture, Postmodernism* (Bloomington: Indiana University Press, 1986); and Marjorie Perloff, *Radical Artifice* (Chicago: University of Chicago Press, 1991).

53. Huyssen, *After the Great Divide*, 170.

54. John Cage and Morton Feldman, *Radio Happenings I–V, 1966–1967* (Cologne: Edition *MusikTexte*, 1993), 153.

55. Jürgen Habermas, "Modernity: An Incomplete Project," in *The Anti-Aesthetic: Essays on Postmodern Culture*, ed. Hal Foster (Washington, D.C.: Bay Press, 1985), 9.

56. This passage appears in Cage's *Indeterminacy*, a series of ninety stories that were read with musical accompaniment by David Tudor.

57. Heinz-Klaus Metzger, "Über Tod, Urteil, *One11* und *103*," in *Musik der Zeit John Cage: 103 Für Orchestra und One11, ein Film ohne Thema* (Cologne: Westdeutscher Rundfunk, 1992), 16. The translation is by Henning Lohner.

[5]

A Question of Order

Cage, Wolpe, and Pluralism

Thomas DeLio

by multiplication a reduction to one
—William Carlos Williams, *Paterson*, Book I

I t is indeed an understatement to say that we live today in a diverse
musical world. Within the art-music tradition of Europe and America
alone, widely divergent musical styles and compositional methods have
emerged. In the past few decades diverse composers such as Pierre
Boulez, Morton Feldman, Milton Babbitt, and Alvin Lucier, to name but
a few, have plied their trade often within earshot of one another. Under-
standably, at times we may feel overwhelmed by the sheer variety of com-
positional methods and sonic materials that currently dot our musical
landscape. I believe that any effort to understand the music of our time
must be based upon this simple fact: its diversity. To understand the full
range of this diversity within Western art music, we must explore how
these different musics intersect with and complement one another;
indeed, each forms an essential part of our musical world that would be
incomplete and therefore inexplicable if any of them were missing. In the
words of paleontologist and geologist Steven Jay Gould, we should, "trea-
sure variety for its own sake . . . and not from a lamentable failure of
thought that accepts all beliefs on the absurd rationale that disagreement
must imply disrespect. Excellence is a range of differences, not a spot.
Each location on the range can be occupied by an excellent or an inade-
quate respresentative—and we must struggle for excellence at each of
these varied locations. In a society driven, often unconsciously, to impose
a uniform mediocrity upon a former richness of excellences . . . an under-

standing and defense of full ranges as natural reality might help to pre-
serve the rich raw material of any evolving system: variation itself."[1]

In the middle of the twentieth century there began to appear a number
of works that embraced this diversity. These works convey to listeners a
sense that there is not one way to make music but many ways. Many
encompass multiple, even contradictory methods and procedures, and
some feature structures that are literally built upon contradictions. Com-
positions such as Christian Wolff's *For One, Two or Three People*, Robert
Ashley's *in memoriam . . .* series, John Cage's *Variations* series, and Karl-
heinz Stockhausen's *Spiral* and *Pole* spring from a sense of pluralism in the
abstract.[2] Despite obvious differences, each of these allows, within broad
constraints, an apparently endless number of processes to take place using
unspecified materials; in essence, each of these pieces stands as a blueprint
waiting to be realized. Significantly, in the case of the Americans, it was
crucial that their notions of diversity coincided with—and were often
inspired by—developments in the visual arts at mid-century.

The compositions I will discuss in this chapter—John Cage's *Amores*
(1943) and Stefan Wolpe's *Solo Piece for Trumpet* (1966)—are not examples
of open-ended blueprints. Instead, they embrace the notion of pluralism
in very specific ways, as a result of their creator's careful choice of sonic
materials and compositional methods.

Multiplicity of Methods and Materials in Cage's *Amores*

In *Amores* John Cage deals with questions of pluralism in striking ways.[3]
The work represents one of the composer's earliest and most successful
attempts to make a structure that embraces diversity. Indeed, the very
foundation of the structure of *Amores* rests upon the premise of diversity.
The listener hearing this piece for the first time is struck—and perhaps
even puzzled—by the variety of Cage's materials. With one exception,
each movement focuses on a very different type of sonic material. The first
movement features prepared piano, the second tom-toms and pod rattles,
the third Chinese wood blocks, and the fourth returns again to prepared
piano. It is hard, at times, to understand just how these movements con-
nect with one another and how these seemingly disparate musics add up
to a single, unified composition. Actually, it is through this very diversity
that Cage is able to create a new sense of unity. Of course, the return to the
materials of the first movement in the last seems like a bow to tradition,
offering a simple sense of closure; but there are many more dissimilarities

between these two movements, not the least of which is the method of composition employed in their creation.

Two terms—*organic* and *inorganic* structure—will be important in the discussion of this piece. The word *organic* contains two basic meanings: it can refer in various ways to the manner of development of living organisms, or to a codependent relationship between a whole and its many integral elements. Inorganic refers to anything involving the inanimate world, or anything that does not arise from natural growth (where the relationship between the whole and parts is not codependent). Let's begin with a discussion of inorganic structure as it applies to Cage's music.

Referring to his music of the period in which *Amores* was created, Cage wrote, in his 1958 lecture "Composition as Process," "with particular reference to what a decade ago I termed 'structure' and 'method.' ... [by] 'structure' was meant the division of the whole into parts; by "method," the note to note procedure. ... Composition then I viewed ten years ago as an activity integrating opposites, the rational and the irrational, bringing about, ideally, a freely moving continuity within a strict division of parts, their combination and succession being either logically related or arbitrarily chosen. The strict division of parts, the structure, was a function of the duration aspect of sound. ... a division of actual time by conventional metrical means, meter taken as simply the measurement of quantity."[4]

After these comments, Cage, referring to another piece from the period contemporaneous to *Amores*, adds that the materials "were chosen as one chooses shells while walking along a beach. ... *For nothing about the structure was determined by the materials which were to occur in it.*"[5] I will refer to such a structure—that is, a structure no aspect of which was determined by the materials occurring within it—as *inorganic*. *Amores* reflects this inorganic approach to composition in several ways. Most obviously, the diverse sonic mediums of each movement (remember that each movement except the outer two employ very different materials) illustrate inorganicism. On a more local level, inorganic structures permeate the inner workings of the even-numbered movements. Each of these movements consists of ten sections, each of which, in turn, consists of ten 4/4 bars. Cage *imposed* this simple abstract scheme upon the very different materials of each of these movements. In other words, he deliberately poured these different materials into the predetermined scheme without taking into account their specific sonic characteristics. The fact that Cage uses the same scheme twice over the course of the piece, each time with a very different set of materials, suggests that he may have wanted to highlight this fact, a perfect example of the separation of structure and method as out-

lined in "Composition as Process." Much more can be said of these movements, but Cage's inorganic structures are by now well known and often analyzed and discussed.[6]

It is curious that, about a decade after Cage wrote "Composition as Process," a group of visual artists in New York who became part of a movement now known as minimalism began to espouse similar ideas. In his famous *Non-Site* series, sculptor and earth artist Robert Smithson followed a remarkably similar path to that of Cage. *Non-Site, Franklin, New Jersey*, for example, consists of a series of trapezoidal containers, graduated in size, each containing materials from the site named in the title. Each container corresponds to a section of an aerial photo map of the site cut into similarly shaped and graduated forms, and each holds samples of ore taken from a section of the site represented in a photo segment.[7] Smithson's containers are pristine, ordered, and abstract, in direct contrast to the chaotic heaps of raw materials that they contain. The containers themselves constitute a series of fragments, their gradual progression strongly suggesting change over time. Everything about the piece invokes images of entropy.

In Carl Andre's equally well-known metal plate sculptures, we find another example of abstract order imposed upon raw materials. In *144 Pieces of Zinc* Andre arranged a set of 144 flat square zinc plates in a large square on the floor (see figure 5.1). Here we encounter an image of order represented through a series of stylized containers, not so different from Cage's ten-bar temporal containers or, for that matter, Smithson's literal ones.

Figure 5.1 Carl Andre, *144 Pieces of Zinc*, 1967 (zinc plates: each plate 12″ sq., 3/8″ thick; total dimensions 12 ft. sq.). Milwaukee Art Museum, purchase, National Endowment for the Arts matching funds.

In *Amores,* the inorganic forms of the second and fourth movements contrast sharply with those of the first and third movements, where there exists a clear *organic* relationship between materials and structure. Cage's organic structures from this period are less well known, so we shall spend a little more time on them. It is not often acknowledged how beautifully Cage could design such music. Indeed, the first and third movements of *Amores* can easily stand in response to any who still persist in the tired view that Cage was a philosopher whose music is more interesting to talk and think about than to hear (or therefore analyze).[8]

There are several aspects of the third movement to consider. (The score for this movement is given as figure 5.2 and annotated for the purposes of the following analysis.) Cage fashioned the formal design of this movement not from an abstract scheme but from the interaction of two simple rhythmic patterns (see figure 5.3). Every occurrence of the two patterns is marked in figure 5.2.

These patterns themselves present interesting differences. Pattern A consists of a single cell of three eighth notes stated three times. Within the three measures of the pattern, the cell produces a total of nine attacks. In contrast, pattern B is only a single measure in length, but it contains eight attacks, making it far more dense than A. Pattern A, moreover, exhibits a static quality, because it features a single duration value (the eighth note) and, due to its internal repetitions, moves at a steady pace. Pattern B is more dynamic, providing a sense of acceleration when it speeds up to its fastest values at the end of the measure.

As stated earlier, the entire third movement involves various juxtapositions of these two patterns. They always appear in their entirety, and Cage never alters them rhythmically in any way. In the last few measures, several presentations of A overlap within the same percussion part (see mm. 27–28, second percussion part). A similar, though more complex, overlap occurs just after this in the third percussion part (mm. 30–31). The first clue to the overall form of the movement comes from the fact that there exists only two moments when all patterns stop and no overlapping occurs (first, between mm. 12–13; second, during m. 23). While it may be difficult to hear these moments as sectional delimiters, they nevertheless furnish a clue as to the three-part formal scheme of the movement. Further examination confirms this scheme.

If one constructs a cumulative rhythm for the work, a pattern of startling clarity as well as remarkable rhythmic subtlety emerges (see figure 5.4). Indeed, the third movement consists of three sections, as outlined in figure 5.5. The first section concludes with the first cessation (m. 12), the

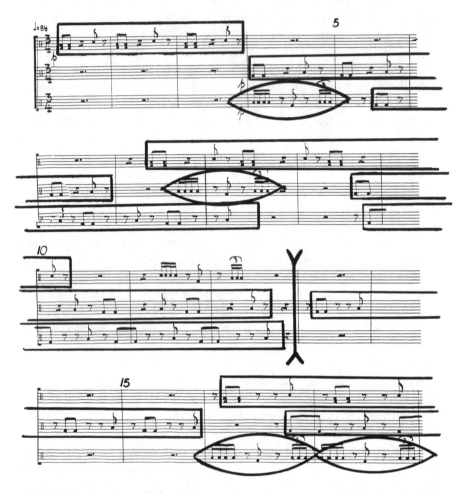

Figure 5.2 John Cage, **Amores**, third movement. © 1960; reprinted by special permission of C. F. Peters Corporation on behalf of Henmar Press Inc. All rights reserved.

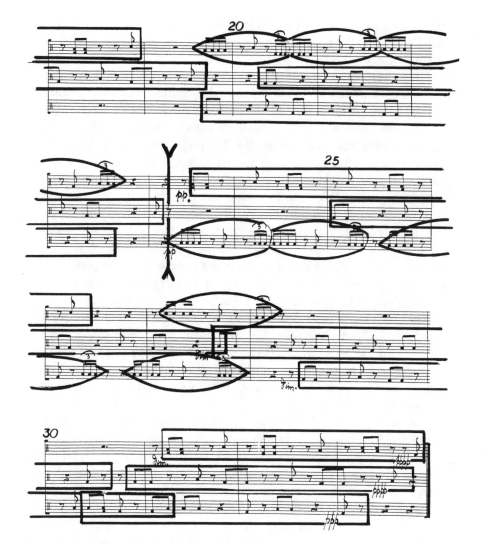

Figure 5.2 John Cage, *Amores*, third movement (continued).

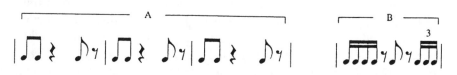

Figure 5.3 The two rhythmic patterns of *Amores*.

second only one beat short of the second cessation (m. 22). The first section divides into three phrases, the second into two phrases; the third contains a single, undivided phrase.

Closer examination of the first phrase of section I reveals the principle underlying all phrase divisions as I have determined them. This phrase is four bars long, the first three of which consist of steady eighth notes, three per measure, followed by one measure consisting of a mixture of sixteenths, eighths, and triplet sixteenths. The phrase, then, obviously derives from a simple concatenation of patterns A and B. This produces a shape that begins slowly and steadily, then suddenly accelerates to its conclusion. The second phrase follows this same pattern but intensifies it. Cage begins with two measures of eighth-note attacks, the result of overlapping several A patterns, and produces a repeated pattern of *four* eighths per measure. Thus the careful overlapping of multiple statements of A—itself the product of a short repeated pattern—creates yet another repeated pattern. The second phrase concludes with the sense of acceleration provided by pattern B. The third phrase continues this process: two measures of steady eighths, this time *five* per measure, concluding with the final acceleration of pattern B. The one change that distinguishes the ending of this third phrase from the previous two is the reversion back to eighths at the very end. This conveys a sense of brief deceleration before moving on to the next section. Also, the phrase ends with the longest rest heard thus far, one and one-half beats.

The second section intensifies the process established in the first. The first phrase of this second section opens with an echo of the first phrase of the first section: three measures of steady eighth notes, *three* eighth notes per measure. Then, however, it speeds up for two measures (through two statements of B). The second phrase begins as did the last phrase of the first section—steady eighth notes, *five* per measure—but then accelerates three times (through three statements of B).

The third and final section consists of only one phrase and completes the process of intensification started in the other two sections. It also provides a rhythmic cadence for the entire work. The first five and one-third bars consist of a mixture of B and A patterns. The final five and two-third bars consist only of A's. Thus, the final five and two-third bars consist only of the slower steady eighth notes (five per measure) that themselves form a new repeated pattern (and thus echo the final phrase of first section). What is new here is the fact that this single long phrase starts with the faster, more active rhythms of B and concludes with the slower, steady eighth note pattern of A. Cage reverses the scheme of every previous phrase, progressing

Figure 5.4 The tripart cumulative rhythms of *Amores*.

Section I mm. 1–12 (+ 1st ♪ of m. 13) 12 1/8 bars

 Phrase a: mm. 1–4
 Phrase b: mm. 5–8
 Phrase c: mm. 9–12 (+ ♪)

Section II mm. 13–22 10 bars

 Phrase a: mm. 13–17
 Phrase b: mm. 18–22

Section III mm. 23–33 11 bars

 Phrase a: mm. 23–33

Figure 5.5 The sections and phrases of *Amores.*

from more activity to less, creating a distinct sense of closure. (Of course, Cage foreshadowed this reversal at the end of the last phrase of the first section where, we recall, he reversed the pattern of the first two phrases of that section and ended with a brief return to eighth notes.)

Finally, we must examine the specific distribution of the A and B patterns among the players that produces this cumulative rhythm (see figure 5.6). Each percussionist takes on a different character—a different role, if you will—in shaping the total design. The second percussionist has a stabilizing influence; after the first section he establishes a steady, unvarying rate of speed. In contrast, as each section progresses, the first percussionist generally increases activity, while the third percussionist always does the reverse. The only exception occurs in the third section where, for the first time, the first percussionist decelerates, contributing to the overall decrease in movement that ends the piece. Clearly, then, the form of the third movement of *Amores* arises from the *interaction of its basic materials as directed by the composer.*[9]

Having identified the different types of structures employed in the piece, we may now consider the form of the entire composition. In *Amores,* Cage employed two types of structure (organic and inorganic) as well as two types of material (prepared piano and unpitched percussion).

	Section I			*Section II*				*Section III*				
perc. 1	A	A	B	A	B	B	B	A	B	A		
perc. 2	A	B	A	A	A	A		A	A	A		
perc. 3	B	A	B	B	B	A		B	B	B	B	A

Figure 5.6 The distribution of the two main rhythmic patterns in *Amores*.

Figure 5.7 The relation between types of material and structure in *Amores*.

The prepared piano is connected to both organic and inorganic structures; and the nonpitched percussion are similarly connected to both organic and inorganic structures (see figure 5.7).

Cage himself once noted the possibility of making music in these diametrically opposite ways. In a book of interviews with the composer entitled *For the Birds*, Daniel Charles asked Cage, "Can you specify the link between structure and materials?" Cage answered, "Structure and materials can [either] be linked or opposed to one another."[10]

Viewed in these terms, one can say that *Amores* represents an instance of maximal diversity, both in terms of method and materials, as well as an instance of the integration of opposites (certainly with regard to method). The inorganic approach, so common in Cage's work from the 1940s, is

presented as only one way of making music. The form of the entire piece becomes a reflection of diverse ways of relating structure to materials. In *Amores*, Cage favors no single method; rather, he embraces a broad range of methods (or at least the suggestion of some broad range of methods). Any consideration of the form of this piece must begin with this premise. Once again, we marvel at Cage's open mind and his far-reaching conceptualizations (especially for 1942). Recognizing that there is no single "correct" way to relate materials and compositional methodologies, he sees truth only in an expression of the full range of such possibilities.

In this regard, Cage belongs among a handful of seminal artists concentrated in the New York area in the post–World War II era. Cage, along with such important colleagues as Robert Rauschenberg, Jackson MacLow, and Merce Cunningham, lay at the center of an artistic movement that sought to embrace the full richness of the material world; their goal was to make art that reveled in the chaotic, entropic nature of that world. Cage not only helped to revolutionize and expand the boundaries of our sonic universe, he also helped break down the barriers that separate the world in which our music lives (the concert world) from the natural world in which all other sounds live. Similarly, visual artists such as Carl Andre and Robert Smithson also embraced the chaos of the world; they demolished the powerful, limiting frames of the gallery and museum, blurring the arbitrary boundaries of art, architecture, and landscape.

A Multiplicity of Contexts in Wolpe's *Solo Piece for Trumpet*

Stefan Wolpe's music often rivals Cage's in its embrace of the same pluralism for which Cage is so renowned. Wolpe often wrote of the need for a flexible musical language that could engage as broad a range of materials and compositional methods as possible. His lecture "On New and (Not-So-New) Music in America" addressed in an all-embracing way music as diverse as that of Milton Babbitt, Morton Feldman, Elliot Carter, John Cage, and Roger Sessions.[11]

Wolpe's *Solo Piece for Trumpet* (1966) exhibits elements of multiplicity in one way by its overlaying of tonal and atonal materials.[12] Wolpe scored the first movement for C trumpet and, though generally nontonal, the movement hovers around a C center at times and seems most strongly rooted to C in its concluding moments (see figure 5.8). He wrote the second movement for F alto trumpet.[13] A copy of the score, renotated in C and annotated for the purposes of the ensuing analysis, appears as figure 5.9. This

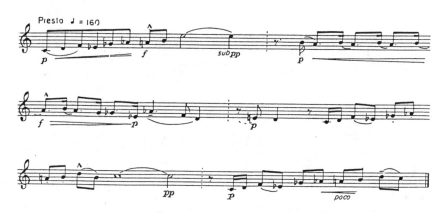

Figure 5.8 The first movement of Stefan Wolpe's *Solo Piece for Trumpet* (1966). © 1968 Josef Marx. Reprinted by permission of McGinnis and Marx Music Publishers.

music, too, begins in a generally nontonal manner. Even at the start, however, it hovers around F and finally moves forcefully to F (with a hint of some B♭) at the end.

I divide the second movement into three sections: the longest rest in the piece clearly marks the division between the first two sections; the difference between the second and third sections is marked by a distinct change in musical language (both pitch and rhythmic). The first section itself divides (by rests) into six phrases that appear to be quite disjunct. In contrast, the various phrases in the second and third sections gradually merge into a more continuous unfolding. As we will see, this transformation parallels the gradual shift from a nontonal language to a more unambiguous tonal one over the course of the piece.

For me, the essence of this movement lies in the opposition of its tonal and nontonal pitch configurations. This opposition determines many local details of the composition as well as its larger form. As said before, the first movement ends with a suggestion of a C center while the second movement points at first to an F center and concludes with F and B♭ centers. (In both cases the tonal elements come most clearly to the fore at the end of each movement.) At the end of the first movement, C sounds like tonic; but as the second movement opens, C sounds more like the dominant of F. Similarly, by the end of the second movement, F itself has begun to sound like a dominant in a B♭-centered tonality, though the F center never really disappears. By the time we reach the end of the second movement, the focus on F is clear: the F major triad repeats and repeats, the E-

Figure 5.9 The second movement of Stefan Wolpe's *Solo Piece for Trumpet*. © 1968 Josef Marx. Reprinted by permission of McGinnis and Marx Music Publishers.

B♭ tritone leads to F–A. At the same time, however, there is a subtle shift to B♭ whenever E♭ replaces E at important moments. The resulting F/B♭ polarity establishes a broader tonal context for the entire work. At the end of the second movement it sets in motion a V-I progression that echoes the V-I progression linking the end of the first movement to the beginning of the second. This emphasis on starting and ending points carries over into the second movement, where the beginnings and endings of the individual phrases consistently emphasize F and its dominant, C (see figure 5.10). Thus, as Wolpe circulates through the full twelve-note collection, he returns again and again at key structural points to certain important tones that emphasize F.

Superimposed upon these tonal underpinnings is a pitch cell that dominates the first section and seems to function both tonally and nontonally. The cell is strongest, indeed omnipresent, in the first section; but it appears less strongly in the second section and virtually disappears in the third. The cell appears twice within the first phrase. (See figures 5. 9 and 5.11; the latter diagrams the pitch content of the cell.) The first presentation of this cell, which spans the phrase and marks its start and end points, fits well within the tonal area of F. (It also outlines the three tonal centers heard over the course of the entire piece.) The second acts as a foil to the first, pulling us away from F and suggesting further transposition throughout the twelve-note collection, though few of the available transpositions of this cell actually appear in the piece. In fact, while the potential for the cell to reproduce at different pitch levels is suggested in this first phrase, the cell remains rooted to those formations (transpositions and inversions) which can be clearly tied to F (see figure 5.12). Most interesting in this regard is the introduction of the leading tone of F in the first

Figure 5.10 The beginning and ending points of the six phrases of the first section of the second movement.

Figure 5.11 Diagram of the pitch cell of the second movement.

section, its linkage to the cell, and its gradual absorption into a new transposition of the cell in the sixth phrase.

The shift from the nontonal context of the first section to the tonal one of the third section parallels a shift from a nonmetric context to a more metric one. There is an inversion of sorts between the end of the second section and the beginning of the third: a pattern of two sixteenths and four eighths becomes one of four sixteenths and two eighths, as the rhythm slips effortlessly into 2/4. The nontonal/tonal transformation also parallels both a general accelerando that progresses through the three sections and a steady reduction in the durations of both phrases and sections (see figure 5.13). All of this projects a sense of increasingly directed motion toward the more linear tonal/metric music of the final section.

The juxtaposition of disparate languages appears in a number of Wolpe's works from this (his last) creative period. In the *Second Piece for Violin Alone* (dating from 1966, the same year as *Solo Piece for Trumpet*), Wolpe opened with a passage that features strong tonal references (see figure 5.14). About the opening of this piece Wolpe wrote, "Three notes found on the major scale—G, A, B—and played simply on the lowest string. Classical music, folk music, how many pieces start that way! How many pieces start that way and then take you on a musical journey . . . then again afterwards, how not to do it! How not to take that trip. Suppose you have a steady state in which you can elect to remain, but a state, the parts of which can be rearranged endlessly, kaleidoscopically. Now let's start again! Take these three notes G, A, B, play them five times and then stop. And then. . . ."[14]

Noted Wolpe authority Austin Clarkson has said that this piece mixes "unique formulations [one assumes, of pitch and rhythm gestures] with memories of tonal gestures."[15] But moments like the opening of this piece are more than "memories of tonal gestures." They create a functional tonal

Figure 5.12 F-rooted progressions in the second movement.

context that exists side by side with another, nontonal narrative that also functions throughout the piece.

Yet one can view this situation from another angle: perhaps the tonal and nontonal idioms represent not separable languages but branches of a much larger system involving the entire twelve-note collection and all its subsets, including the seven-note, "diatonic" set of the tonal language. Wolpe slides in and out of various linguistic contexts as his pieces evolve. Never satisfied with a single world, he shifts constantly between multiple worlds, or multiple representations of the same world. What Wolpe shows us is that there is no single, optimal perspective for hearing; materials

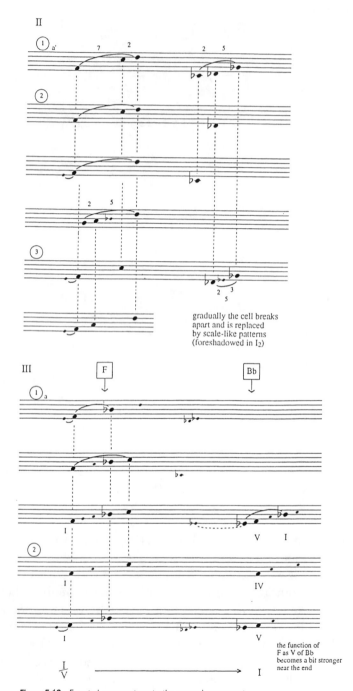

Figure 5.12 F-rooted progressions in the second movement.

Section	I	II	III
tempo (eighth note)	136	136/181	288
Duration	25"	11.2"	7.77"

Figure 5.13 Tempo and duration patterns in the second movement.

have multiple implications, many of which may be embraced within the structure of a single piece. Through such multiple, simultaneously functioning contexts, Wolpe reminds us that each time we hear a piece of music we hear it in the context of all the other musics and musical languages we have ever heard. He also reminds us that these musical languages affect our hearing at all times. Indeed, he literally builds the piece upon this fact. Perhaps Wolpe was the first postmodernist. He certainly makes the pluralistic premises of postmodernism most vivid to this writer. To quote the composer again,

> Where there is unified, centrally guided coordination of elements within a functional ensemble, there is its breakdown: the dissociation of activities, non-gradualness, decentralization, the shift of centers—of multiple centers—of a release of forces independent of each other to the extent of bringing about new types of contrasting modes of action, of contrasting organic modes. They will determine a proper kind of fluctuating continuity. . . .
> The empirical notion of any one-dimensional (that is, causal and argumentative) connection between aspects of an event renders the event conditional and one-sided. The process of gradual approach serves only to narrow the view. . . . To move in all directions, because all aspects are exposed to each other in that space of omnipresent notions, will yield the view from all sides. Everything becomes connectable, and because there is no hierarchic order of succession, everything is equally prophetic and all-inclusively discovered and revealed.[16]

In works such as *Solo Piece for Trumpet* and *Piece for Violin Alone*, Wolpe invoked the language of tonality but not the style of any tonal period. This is in contrast to a composer like George Rochberg, for example, who tended to borrow elements from the style of one tonal period (usually the

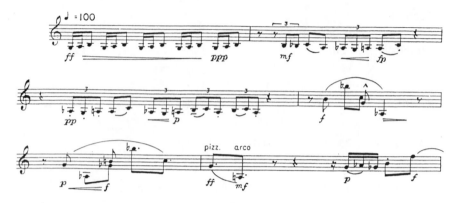

Figure 5.14 The opening passage of Stefan Wolpe's ***Second Piece for Violin Alone*** (1966). © 1968 Josef Marx.
Reprinted by permission of McGinnis and Marx Music Publishers.

nineteenth century) while tonality itself simply rode along as so much baggage. Wolpe does not produce a simple collage of historical by-products. At the end of his trumpet solo, he offers the listener an F-major triad that is *meant* to be heard as an F-major triad. Yet this passage stands free of historical clichés. We hear that familiar triad within its tonal framework as if for the first time, because we hear it simultaneously as part of the seven-note F-major collection and part of the broader twelve-note collection that frames the whole piece. Here is yet another piece, then, in which—to paraphrase Ludwig Wittgenstein—the frame for our perceptions becomes the subject of our perceptions. The ending represents, to me, a beautiful discovery of the present within the past.

In many respects, the multiplicity of contexts that we encounter in Wolpe's musical designs closely resembles the pluralism we encounter in the work of a number of important painters and sculptors from the same period. This similarity is perhaps most readily apparent in the work of Jasper Johns. Just as Wolpe's music often shifts in and out of various sonic contexts, Johns constructs, within the framework of a single painting, multiple and often conflicting visual contexts. Indeed, all of Johns's signature target and flag paintings from the late 1950s seem to evolve from the same premise as Wolpe's music. In these paintings, materials also take on multiple functions simultaneously and so create multiple contexts for our visual experience: representation versus abstraction, two-dimensional space versus textured three-dimensional object, and so forth. We cannot view Johns's flags as purely representational or purely abstract; they are both. Similarly, they are neither just two-dimensional representations nor

simply three-dimensional objects, but both. In the same way that Wolpe's music vivifies the concept that there is no single, or even optimal perspective for shaping or perceiving materials, Johns's work shows us that there is no single context that guides our visual experience. Through his paintings, Johns, too, reminds us that each time we see a painting we see it in the context of all the other visual experiences we have had, and that the cumulative richness of these experiences shapes our understanding of all that we see.

In *Amores,* Cage favored no single compositional method, but suggested instead a broad range of methods. Similarly, Wolpe, while focusing on different languages in his *Solo Piece for Trumpet,* created a work in which multiple, apparently contradictory, interpretations of the same twelve-note pitch collection may stand as equally valid. Recognizing that there is no single "correct" way to organize these pitches he—as did Cage in *Amores*—sought an expression of the full range of possibilities. Both of these composers, then, exhibited locally in these two works a tendency toward pluralism of materials and method that reflected the pluralism of their contemporary artistic—and, indeed, social—landscape.

Conclusion

The pluralism of materials and methods exhibited by these two pieces represents, in each case, local reflections of the broader pluralism of activity that defines our contemporary musical landscape. To return to Steven Jay Gould, in his book on evolutionary theory, *Full House,* he writes, "I am asking my readers finally and truly to cash out the deepest meaning of the Darwinian revolution and to view natural reality as composed of varying individuals within populations—that is, to understand variation itself as irreducible, as 'real' in the sense of 'what the world is made of.' . . . we learn to cherish particulars . . . and to revel in complete ranges . . . a good swap of stale (and false) comfort for broader understanding."[17]

Gould asks us to identify the full range of variation exhibited in a group of specific cases and then define the underlying unity of these individual instances in terms of their broadest collective range of variation. According to Gould this involves "a full inversion in our concept of reality: in Plato's world, variation is accidental, while *essences* record a higher reality; in Darwin's reversal [of Plato's formulation], we value variation as defining . . . reality, while averages (our closest operational approach to 'essences') become mental abstractions."[18]

The mechanisms of natural evolution and those of cultural change differ; Gould argues this very point in his book.[19] However, the need to understand individual variations within the full range of complete and competing systems is just as important to the study of cultural change (and cultural objects such as musical works) as it is to the study of evolutionary theory.[20] If natural evolution is now recognized as neither a singular nor linear process, but rather a multidimensional branching process that embodies along its course a rich range of variation, it follows that any account of that process must accommodate the full range of variety that it embodies. The arts of our time—at least in the hands of some artists— seem to reflect a similar new understanding. Works by composers such as Cage and Wolpe vivify this new understanding for us, and thus reconnect us in a profound way with the inner workings of our world.

Notes

1. Steven Jay Gould, *Full House* (New York: Harmony Books, 1996), 229–30.

2. See Thomas DeLio, *Circumscribing the Open Universe* (Lanham, Md.: University Press of America, 1984); *Contiguous Lines: Issues and Ideas in the Music of the '60's and '70's* (Lanham, Md.: University Press of America, 1985); *Words and Spaces*, co-edited with Stuart Smith (Lanham, Md.: University Press of America, 1989); and *The Music of Morton Feldman* (Westport, Conn.: Greenwood Press, 1996).

3. John Cage, *Amores* (New York: C. F. Peters, 1943).

4. John Cage, *Silence* (Middletown, Conn.: Wesleyan University Press, 1973), 18–19.

5. Cage, *Silence*, 19; emphasis added.

6. See Thomas Moore, "Rhythmic Structures in John Cage's *Amores*," Masters Thesis, University of Maryland, College Park, 1987; James Pritchett, *The Music of John Cage* (Cambridge: Cambridge University Press, 1993); and Richard Kostelanetz, ed., *Writings about John Cage* (Ann Arbor: University of Michigan Press, 1993), in particular the essays by Stuart Saunders Smith, Christian Wolff, Peter Dickinson, and Deborah Campana.

7. A photograph of Robert Smithson's *Non-Site, Franklin, New Jersey* was unavailable for reproduction but may be found in *The Writings of Robert Smithson* (New York: New York University Press, 1979), among other sources.

8. For a somewhat different analysis of this piece, see John Welsh, "John Cage's 'Trio' from *Amores* (1943): A Study of Rhythmic Structure and Density," *ex tempore* 4, no. 2 (spring/summer 1987–88): 80–92.

9. It is interesting to note that rhythmic structures such as the one outlined here have a long and distinguished history. Robert Cogan and Pozzi Escot present a brilliant analysis of the "Amen" section to the "Credo" of the *Notre Dame Mass* by Guillaume de Machaut in their book *Sonic Design* (Englewood Cliffs, N.J.: Prentice-Hall, 1976), 228–39. Machaut's rhythms bear striking similarities to the third movement of Cage's *Amores*.

10. John Cage, *For the Birds: John Cage in Conversation with Daniel Charles* (Boston: Marion Boyars, 1981), 35.

11. Wolpe delivered this lecture at Black Mountain College in 1956. It was first published in the *Journal of Music Theory* 28, no. 1 (1984).

12. Stefan Wolpe, *Solo Piece for Trumpet* (New York: Joseph Marx Music, 1968).

13. At the bottom of the score of the second movement of Wolpe's trumpet solo, a note has been added that states that if an F alto trumpet is not available the movement can be played in B^b on the same instrument used in the first movement. It is not clear if this note was added by the composer or by the editor, Ronald Anderson. (Thus far, it has not been possible to ascertain the source of the note.) In any event, at this time I find the transposition of the second movement to B-flat inexplicable in that its tonal relationship to the first movement becomes unclear. My analysis rests on the use of the original instrument, F alto trumpet, and the appropriate transposition for that instrument.

14. Stefan Wolpe, from record liner notes for *Stefan Wolpe*, Nonesuch Recordings, No. 78024-1.

15. Austin Clarkson, from record liner notes for *Stefan Wolpe*, Nonesuch Recordings, No. 78024-1.

16. Stefan Wolpe, "Thinking Twice," reprinted in *Contemporary Composers on Contemporary Music*, ed. Barney Childs and Elliott Schwartz (New York: Holt, Rinehart and Winston, 1967), 301–2.

17. Gould, *Full House*, 3–4.

18. Ibid., 41.

19. Ibid., 221–22.

20. As the foregoing discussion makes obvious, I view those reductionist, often exclusively pitch-based theories of twentieth-century music currently in vogue as misleading. Even with respect to that music for which such analytic methods may seem most appropriate (the preserial and serial works of Schoenberg and Webern, for example), these theories explain precious little about the music they purport to explicate. Instead, they provide only "stale (and false) comfort," to quote Gould once again (see note 19), and merely constitute a reduction to one by division and subtraction, to paraphrase William Carlos Williams (see the epigraph for this chapter).

[6]

Painting by Numbers

The Intersections *of Morton Feldman and David Tudor*

John Holzaepfel

Hardly a day passes when I don't think of you . . . in some connection with my work which you helped make permissible for me to do.

—Morton Feldman to David Tudor, June 1953

We do not think of Morton Feldman as a composer of virtuoso show-pieces. His reputation—his "stock," as the composer might have called it—rests largely on a body of work characterized by a quietude amounting at times to stasis. Feldman himself seems to have distrusted traditional forms of virtuosity, perhaps in part because of the limitations of his own piano technique. But in the early 1950s, stimulated by the stunning musical and intellectual virtuosity of his friend David Tudor, Feldman composed two of his most unbridled and technically demanding scores. They may be the most uncharacteristic works he ever wrote.

In 1950, Morton Feldman was twenty-four years old and facing a crisis. He had met John Cage in January, and the friendship struck between the two composers marked the beginning of what was to become known, somewhat misleadingly, as the New York School. But despite the importance he later ascribed to the "permissions" he received from Cage—the encouragement to trust his musical instincts—the immediate effect of the friendship seems to have led Feldman not to the flowering of a new musical style but into a wall. For the better part of a year his pen was silent.

The breakthrough came in December 1950, when Feldman began to compose steadily for what may have been the first time in his life (the list of his works prior to 1950 is meager). The permissions given by Cage were not what pointed him in a new direction, however. Rather, it was the

world of painting, specifically, the work of the abstract expressionists, the other New York School, which had been gathering increasing attention since the late 1940s. "The new painting," Feldman wrote in 1961, "made me desirous of a sound world more direct, more immediate, more physical than anything that had existed heretofore."[1]

In his search for a music weighted neither with compositional rhetoric nor musical symbolism, Feldman took two simultaneous paths, aesthetically intertwined but technically distinct. In works such as *Structures* for string quartet (1951), the six *Intermissions* for piano (1951–53), and the five *Extensions* for various instruments (1951–53), Feldman manipulated a fixed collection of sonorities, often nothing more than a few clusters of semitones, in fixed voicings over subtle and fluid rhythmic patterns. These pieces usually proceed at slow tempos and they almost always feature very quiet dynamic levels, marked either *ppp* or with the overall instruction "extremely low." It is these features that make Feldman's music so recognizable; with them, the composer created a style he would continue to develop and refine for the rest of his life.

It is no exaggeration to say that Feldman's other path was as much notational as it was compositional. ("The degree to which music's notation is responsible for much of the composition itself," the composer later wrote, "is one of history's best-kept secrets."[2]) Feldman sought a means of bringing to music the immediacy of impact he found in abstract expressionist painting, in its power to communicate what he called "uncategorized emotion," without relying on emotional or representational symbols. Feldman's solution was the graph score, in which he projected sounds by using numbers, specifying the quantity but not the identity of pitches to be played within icti represented by the coordinate squares on a sheet of graph paper. Read horizontally, the squares show the music's pulse. Read vertically, they show its instrumentation (if in fact the piece called for more than one instrument), and register, which Feldman delineated only as high, middle, and low. The graph score, Feldman hoped, would be "a totally abstract sonic adventure."[3]

In his enthusiasm for the new painting, Feldman went so far as to imitate the painters in their manner of working. Recalling Jackson Pollock in particular, he wrote, "In thinking back to that time, I realize now how much the musical ideas I had in 1951 paralleled his mode of working. Pollock placed his canvas on the ground and painted as he walked around it. I put sheets of graph paper on the wall; each sheet framed the same time duration and was, in effect, a visual rhythmic structure. What resembled Pollock was my 'all-over' approach to the time canvas."[4]

The first graph score, part of a series of four graph scores called *Projections*, was completed by the end of 1950. In January 1951, Feldman began a second series of graph compositions he called *Intersections*. Two of these are for orchestra, one is for cello, and another, Feldman's only venture into electronic music, is for magnetic tape. He wrote the second and third works in the *Intersection* series for piano. Composed in the summer of 1951 and the winter of 1953, they were written for, and came about because of, David Tudor.

This is to say that what immediately distinguishes *Intersections 2* and *3* from Feldman's other graph scores is their staggering technical demands. The eleven pages of *Intersection 2* consist of 1462 coordinate squares calling for the pianist to play as many as twelve or more keys in a single register in combination with groups of keys in one or both of the other registers. The whole is to be executed at a very rapid tempo (in which the ictus equals MM = 158 or faster). A page from the score shows what confronts the performer who would play the work from Feldman's notation (see figure 6.1). Each row of coordinate squares denotes one of three pitch registers: high (H), middle (M), and low (L). Numbers appear in those squares whose borders are highlighted in order to distinguish them from other squares in a system; the latter squares signify silence. Adjacent squares within one register are similarly highlighted to indicate extended durations. Each square represents an ictus, or measure, at the tempo MM = 158. There are four tempo changes near the end of the score, where the ictus becomes MM = 198, then 172, and then a rather outlandish 276 before settling back to 178 for the remainder of the piece. Midway through the piece, Feldman began to modify his basic notation in three ways: by (1) subdividing a graph square into two parts, each specifying a number of pitches in the indicated register; (2) similarly subdividing two or more squares within a single ictus; and (3) adding harmonics, signified by diamond-shaped note heads.

Tudor gave the first performance of *Intersection 2* on New Year's Day 1952, when he made his New York recital debut by staking his claim as contemporary music's most adventurous pianist. (The other works on the program were the Second Piano Sonata of Pierre Boulez, Christian Wolff's *For Prepared Piano*, and the first complete performance of Cage's *Music of Changes*.) On that occasion, Tudor played from Feldman's manuscript,[5] but he must have been unsatisfied with the result, for when the composer presented him with a new *Intersection* the following year, Tudor made a decision that would materially alter his approach to the performance of indeterminate music. Rather than read Feldman's abstract and relative

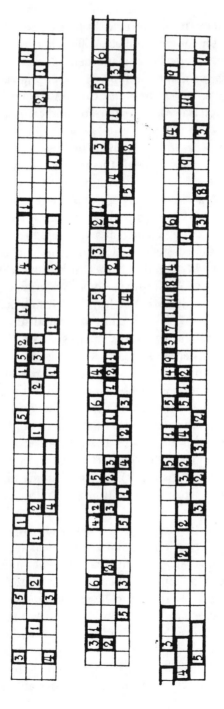

Figure 6.1 Morton Feldman: *Intersection 2*, page 1. © 1962. Used by permission of C. F. Peters Corporation.

representations, Tudor would write out his own performance material. He would translate the composer's notation into a single instance of an infinity of possibilities. He would make the abstract concrete. He would, in other words, prepare a realization.

The density of the textures and the rapid tempos in *Intersection 2* had given Tudor little choice but to read Feldman's numbers as though they signified tone clusters. Faced with an even greater textural density as well as far more frequent subdivisions of registers in *Intersection 3*, Tudor took a similar approach in his realization of the new work. The result is a study in tone clusters that expands the concept of cluster writing beyond all precedent.

Tudor worked either from Feldman's autograph or from a copy of it he made himself, not from the published edition.[6] He wrote his realization in pencil on three folios, recto and verso, of staff paper, using standard, unmeasured staff notation with some slight modifications I shall discuss below. Like all of Tudor's realizations, the manuscript bears no title, date, or signature.

A square in Feldman's graph may contain a single number in a single register, or a pair of numbers to indicate registral subdivision. Examples of both notations appear within the first three measures of *Intersection 3* (see figure 6.2). In the first measure Feldman wrote $\frac{3}{3}$, meaning 3 + 3 pitches to be played in the middle register M. In the second measure he wrote 5 in register H and 4 in register L, and in the third measure he wrote 6 in register M. Figure 6.3 shows in facsimile folio 1r of Tudor's realization. Tudor equated each measure in Feldman's score with a quarter note or, if the square is blank, a quarter rest. He rendered longer durations accordingly, so that, for example, the 3M in Feldman's measures 13–17 becomes the trichord D♯4/A4/B4 written as a whole note tied to a quarter. For simple clusters—that is, those that can be taken with the first or the forearm

Figure 6.2 Morton Feldman: *Intersection 3*, measures 1–3.

© 1962. Used by permission of C. F. Peters Corporation.

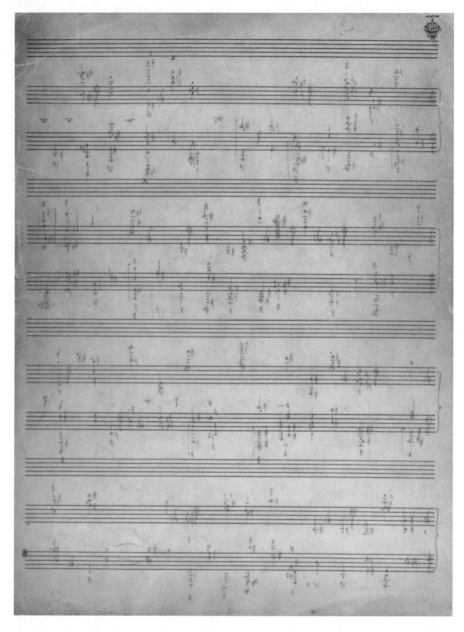

Figure 6.3 David Tudor: realization of *Intersection 3*, fol. 1r. © 1962. Used by permission of C. F. Peters Corporation. Getty Research Institute, Research Library.

alone—Tudor employed the notation Henry Cowell had devised for his own pioneering tone-cluster pieces. Thus, a natural sign above or below a cluster means that the cluster should be played on the white keys; a sharp or flat similarly indicates a black-key cluster. The absence of these signs signifies a chromatic cluster, and a sharp or flat preceding a cluster shows the upper or lower ambitus of that cluster. To notate more elaborate clusters, Tudor extended Cowell's method. In the second system of his realization, for example, he intended the black-key cluster D#6–A#7 and the white-key cluster G6–C7 to be played both simultaneously and as grace notes to the following sonorities.

But most of the clusters Tudor devised for his realization are not simple groups of adjacent keys. Rather, they are pitch-specific and often of enormous complexity. These required other notational techniques. The signs ⌈ and ⌊ demarcate sonorities to be played 8va or 16va *sopra* or *bassa*, as in the second system on the first page of the realization. Applying a notation found in the music of Stefan Wolpe (the teacher of both Tudor and Feldman), Tudor used diagonal lines and inverted wedges to connect single noteheads to the clusters to which they belong. (See, for example, the sixth sonority on the same page or the final sonority of the third system.) The words *add* or *omit*, written above a sonority and followed by a pitch name, are signs of Tudor's experimentation. The cue "omit G♭," for example, written below the final system on the first page, refers to the sonority D♭1/E♭1/G♭1/A♭1/B♭1/C2/D2/E2 in the bass clef above. The source of Tudor's reading is the bottom square in Feldman's measure 63, which shows the number 7. Tudor wrote (or drafted) a cluster of eight pitches, knowing he

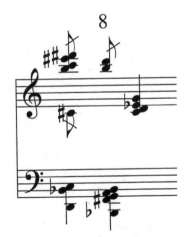

Figure 6.4 David Tudor: realization of *Intersection 3*, sonorities 8–10. © 1962. Used by permission of C. F. Peters Corporation. Getty Research Institute, Research Library.

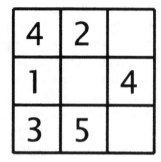

Figure 6.5 Morton Feldman: *Intersection 3*, measures 8–10.
© 1962. Used by permission of C. F. Peters Corporation.

would eventually have to omit one of them in performance to make his reading correspond to the requisite number in Feldman's score.

Feldman's performance instructions for *Intersection 3* allow the performer to "make any rhythmic entrance on or within a given situation." In most cases, Tudor places his sonorities "on the beat," that is, at the beginning of Feldman's ictus. To indicate the second kind of entrance, he wrote one sonority as a grace note to the next, as in sonorities 8–10 (see figure 6.4). The source of this excerpt is measures 8–10 in Feldman's score, where we find the notation 4H, 1M, 3L in measure 8, 2H and 5L in measure 9, and 4M in measure 10 (see figure 6.5). The identity of the three corresponding sonorities in Tudor's realization is as follows: Feldman's 1M in measure 8 has become C♯4 and is notated as an anacrusis (in the form of a grace-note) to the trichord D2–B♭2–C3, Tudor's determination of the pitch content of 3L. 4H in the same measure is rendered as the tetrachord B5–C6–E♯6–F♯6 , notated as an anacrusis to the pentachord B♭1–F♯2– G2–A2–B2, Tudor's reading of 5L in measure 9. Finally, the dyad B6–D7, corresponding to 2H in measure 9, is written as a third anacrusis, this to the following sonority, the tetrachord C4–D4–E♭4–G4, which corresponds to 4M in measure 10.

Tudor used brackets or ligatures to connect two or more notations whose common source is a single coordinate square in Feldman's score (see figures 6.6a and 6.6b). At other times, he notated sonorities as grace-notes in order to facilitate his execution of a highly complex group of pitches, such as the 8H, 4/7M, and 6/5L of Feldman's measure 297 (see figures 6.7a and 6.7b).

Tudor treated the three registers H, M, and L of *Intersection 3* as mobile. While his realization encompasses the entire keyboard from A0 to C8, he did not partition the pitch space into three more or less equal segments. Instead, he frequently reinterpreted certain pitches in the middle register. For example, the right-hand F5 in the second sonority of his realization is

Figure 6.6a Morton Feldman: *Intersection 3*, measure 295. © 1962. Used by permission of C. F. Peters Corporation.

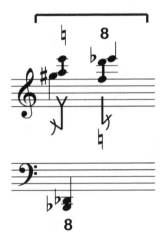

Figure 6.6b David Tudor: realization of *Intersection 3*, sonority 295. © 1962. Used by permission of C. F. Peters Corporation. Getty Research Institute, Research Library.

part of Tudor's reading of the 5H in Feldman's measure 2, but it is lower than the F#5 in the following sonority 6M from Feldman's measure 3.

Nevertheless, in cases where two or more registers coexist at the same time, Tudor was careful not to blur the identities of different textures or densities whose pitch content is numerically equivalent. Measure 408 of Feldman's score, for example, shows 9/9H and 8/1L. Tudor rendered the 9/9H as a pair of chromatic clusters C#5–A6 and A#6–F#7. But a similar reading of the 8/1L would have resulted in a third cluster of 9 pitches. Tudor's realization therefore shows a white-key cluster B1–B2 (8L) above a single G#1 (1L) (see figure 6.8).

The 4/5M and 9L in measure 418 form a similar case. Tudor's realization renders both of Feldman's notations as clusters, but of different

Figure 6.7a Morton Feldman: *Intersection 3*, measure 297. © 1962. Used by permission of
C. F. Peters Corporation.

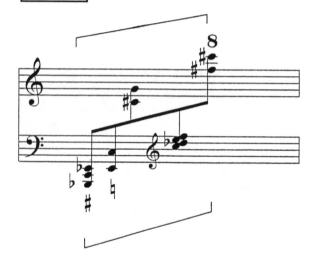

Figure 6.7b David Tudor:
realization of *Intersection 3*,
sonority 297. © 1962. Used by
permission of C. F. Peters Corporation.
Getty Research Institute,
Research Library.

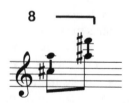

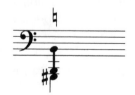

Figure 6.8 David Tudor: realization of *Intersection 3*, sonority 408.
© 1962. Used by permission of C. F. Peters Corporation. Getty Research Institute, Research Library.

Figure 6.9 David Tudor: realization of *Intersection 3*, sonority 418.
© 1962. Used by permission of C. F. Peters Corporation. Getty Research Institute, Research Library.

types: 9L is a chromatic cluster D2–B♭2, while the 9 pitches of 4/5M become a combination cluster: the four black keys A♭4–B♭4–D♭5–E♭5 and the five white keys C4–D4–E4–F4–G4 (see figure 6.9).

At some point after completing his realization of *Intersection 3*, Tudor began to work on a realization of Feldman's earlier *Intersection 2*. I cannot ascribe a more precise date, though probably Tudor made it in the late 1950s, at a time when Feldman was preparing a number of his scores for publication by C. F. Peters. A memo in what appears to be Feldman's hand and written on the back of an envelope postmarked April 9, 1959, refers to changes Feldman made in the score of *Intersection 2*. These appear in the published edition.[7] Tudor may have undertaken his realization in hopes of seeing it published as a companion piece to Feldman's score. But this never happened: Feldman's score appeared in print without Tudor's realization, a fact that explains why the latter manuscript remained incomplete.

Tudor wrote his realization in pencil in a small brown notebook that contained twenty folios of staff paper (see figure 6.10). He didn't number the pages of the score, but he nevertheless added the page numbers of Feldman's score in Roman numerals. Since some of the pages do not correspond to the pagination of the Peters edition of *Intersection 2*, Tudor mostly likely prepared his realization from Feldman's autograph rather than from Cage's fair copy.

This time, Tudor drew bar lines to represent the coordinate squares in Feldman's graph score. At the beginning and at the end, as well as in many measures along the way, Tudor determined pitch and duration to a considerable degree. Additional sketches and revisions appear in staves above and below the principal notation. But beginning on folio 6*v*, the score contains numerous empty patches, as well as cues to the numbers in Feldman's graph. The use of barlines as an aid to other performers supports the hypothesis that Tudor hoped to published the realization, as do the

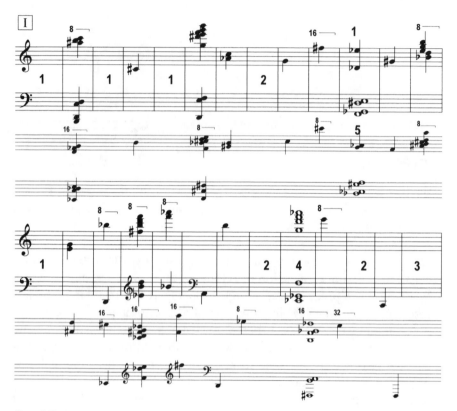

Figure 6.10 David Tudor: realization of *Intersection 2*, folio 1*r*. © 1962. Used by permission of C. F. Peters Corporation. Getty Research Institute, Research Library.

appearance and the condition of the score. *Intersection 2*, written in a notebook containing no other material, is clear and precise down to the empty measures awaiting Tudor's notations. In contrast, the realization of *Intersection 3* contains a number of cues and markings evidently meant for Tudor's eyes alone, and the loose folios on which it was written are fragile and faded, reflecting frequent use in performance.

In the rigor and precision that mark his treatment of Feldman's graph notation, Tudor took the concept of piano technique to a new level. And in his two recordings of *Intersection 3* he does more than demonstrate that this level is attainable. Listening to these recordings while following Tudor's realization, one can hear the pianist play his astonishing array of clusters with an authority, control, and sheer flair that recall the great pianists of the early twentieth century.[8]

It is in fact the *act* of piano playing that I believe guided Tudor as he wrote his realization of *Intersection 3*. This is to say that he determined the pitch content as well as their specific articulations as much by their tactile advantage as by any putative compositional method. There is nothing "unpianistic" about the realization, as long as one is able to modify or even give up habits of playing that are not helpful in new circumstances.[9] Like Ferrucio Busoni's compositions or Leopold Godowsky's paraphrases, Tudor's realization of *Intersection 3* is pianist's music, rewarding to play, its moves over the keyboard a pleasure to make. It is music written with a pianist's feel for the piano and for piano playing.

One can go even further and suggest that Tudor's devotion to the new music of the 1950s was not entirely, perhaps not even primarily, due to its new sounds but to the new possibilities it opened up to piano playing. As with the music of earlier composers such as Franz Liszt, Valentin Alkan, and Busoni—music that Tudor loved and studied to the end of his years as a pianist—experimental piano music was a resource for satisfying what he called his need "to understand the nature of virtuosity." It enabled him to surpass his own prodigious capabilities at the piano, to embrace the new, the unattempted, the impossible. In performances such as those of *Intersection 3*, the result was a breathtaking voyage into both the world of new music and the world of piano technique that Tudor was creating in the 1950s.

Visually, some of Feldman's graph scores bear more than a passing resemblance to the later work of Piet Mondrian (another painter the composer admired). But in the two *Intersections* he wrote for David Tudor, Feldman came closest to the action painting of Jackson Pollock. In a letter to Tudor written two months after he completed *Intersection 3*, he described, in an astonishing image, "the kind of music I would like to write—a music like violently boiling water in some monstrous kettle. . . . The last *Intersection*, which I wrote for you, is just an unrealized hint of what is to come."[10] Feldman's subsequent music left this intriguing possibility unrealized. Tudor's realization of *Intersection 3*, on the other hand, is action painting translated into sound; it is, as the composer had envisioned, a totally abstract sonic adventure. And in Tudor's astounding performances, it is also a breathtaking leap from imagination into experience.

Notes

1. Morton Feldman, "Autobiography," in *Morton Feldman Essays*, ed. Walter Zimmermann (Kerpen, West Germany: Beginner Press, 1985), 38.

2. Morton Feldman, "Crippled Symmetry," in Zimmermann, ed., *Morton Feldman Essays*, 132.

3. Feldman, "Autobiography," 38.

4. Feldman, "Crippled Symmetry,"136.

5. Both the original publication of *Intersection 2* (C. F. Peters 6922 [1962]) and the recent edition by Volker Straebel in *Morton Feldman: Solo Piano Works 1950–64* (C. F. Peters 67976 [2000]) are reproductions of the fair copy made by Cage, who prepared several of Feldman's early autographs for publication.

6. Both Feldman's autograph and Tudor's copy are part of the David Tudor Papers at the Getty Research Institute in Los Angeles. The papers (Accession No. 980039) include all of Tudor's realizations, work notes, sketches, and other manuscript material, as well as programs, correspondence, and autograph scores by numerous postwar composers.

In the second edition of *Intersection 3*, Volker Straebel has corrected the copyists's errors that appeared in Peters 6915.

7. The memo is in the David Tudor Papers, Series 1B, Box 9, Folder 26.

8. Tudor's first recording, made in 1959 for Hessian Radio in Frankfurt, has been released on compact disc (Edition RA 1010 [1994]). His second recording was part of an album of Feldman's compositions released on LP in 1960 (Columbia ML5403/MS 6090) and reissued in 1969 (Odyssey Y32 16 0302); it has not been released on compact disc.

9. I place the word "pianistic" in quotation marks because my piano teacher once reduced the question of awkward piano writing to a simple axiom: "If the hand can play it, it's pianistic." In the case of *Intersection 3*, to the word "hand" we would have to add fists, forearms, and elbows, all of which, Tudor told me, he employed in performing his realization.

10. Feldman, letter to David Tudor, June, 15 1953. David Tudor Papers, Series IV, Box 53, Folder 7.

[7]

Feldman's Painters

Jonathan W. Bernard

If you don't have a friend who's a painter, you're in trouble.
—Morton Feldman, "Darmstadt Lecture"

S omeday, someone will write a comprehensive study dealing with the ways in which Morton Feldman's acquaintance with the members of the so-called New York School of artists and their works influenced most, if not all, of his compositions: not just as a matter of general aesthetic orientation, but from questions of overall form down to the finest details of his scores; not just in the early 1950s, when he first came into contact with these artists, but throughout his entire career as a composer. The aims of the present chapter are a little more modest: I seek simply to establish a basis in the work and thought of the New York School—primarily in the 1950s, although in some cases extending to later years— upon which Feldman may be "read," from the point of view both of artistic outlook in general and of (music) compositional outlook in particular. Ultimately, it seems to me, any analytical approach able to afford significant insight into the workings of Feldman's music must rest upon such a basis.[1]

What can it mean to assert that Feldman learned to compose mainly by listening to painters talk and looking at their work? Such a claim may strike the reader as implausible on the face of it, given the large amount of technical training that composers usually must acquire, training that (it is usually thought) only other composers can supply. Yet there are four kinds of evidence that may be marshaled in its support. One has to do with Feldman's personal history; another is found in the ways in which

critics of the period generally characterized the art of the New York School during the 1950s; a third consists of the statements of artists such as Willem de Kooning, Philip Guston, Franz Kline, Jackson Pollock, and Mark Rothko, all active during this period and all known personally to Feldman; and a fourth is the testimony of Feldman himself in his essays and interviews. All will be drawn upon in what follows.

The New York School, circa 1950

By the time Feldman got to know the New York painters and the bohemian scene they inhabited, the New York School had been an identifiable phenomenon of the art world for at least a decade. De Kooning, Pollock, and Rothko, for example, all had had their first one-man shows by 1945, when they were still in their thirties or early forties, and their promising futures were already well recognized by the more discerning gallery owners and critics. Something began to change, however, around the end of the Second World War. The philosophy that had prevailed among artists during the 1930s and the war years, which stressed involvement with the concerns of society and an explicit, usually left-leaning political stance, began to dissolve: "As the artist moved into the second half of the forties, the issue of his relationship to society was more or less forgotten," reports critic Dore Ashton.[2] Around this time, many painters found themselves turning away from a figurative style, eventually to abandon it entirely. As this was happening, artists began to detect a distinct chill in the air, emanating from the larger political sphere: whereas during the 1930s many had found work through the Works Progress Administration, which commissioned public art projects throughout the country, in the late 1940s they had to contend with a president who publicly derided new styles as "the ham-and-eggs school" of painting, and a secretary of state who in 1947 abruptly canceled an exhibition of new American painting that had been sent, under government auspices, to travel abroad.[3]

For their part, the more conservative critics, especially those who wrote for mass-circulation magazines such as *Time* and *Life*, greeted the stylistic changes they saw in postwar art with open bafflement and even hostility, further convincing artists that withdrawal from the world at large was the only safe course—one, however, that was not entirely unprecedented: "Attitudes expressed in the late forties grew closer to the position that had always been maintained by a few painters—most notably by de Kooning, who had remained aware of but deliberately aloof from everything extrin-

sic to the interior development of his work."[4] By 1950, artist Robert Mother-well could characterize the New York School—among whose members he counted himself—as almost exclusively inwardly directed, as a group of artists "that tries to find out what art is precisely through the process of making art. That is to say, one discovers, so to speak, rather than imposes a picture. What constitutes the discovery is the discovery of one's own feeling, which none of us would dare to propose before the act of painting itself."[5] The emphasis upon feelings over "preconceived ideas" meant also "a distrust of conscious concept" and a rejection of "prevailing ideologies" together with any overintellectualization of the creative process.[6]

It was not long before critics began to coin new terms to identify the style, or group of styles, that came about as the result of this new inward attitude. First and foremost was *abstract expressionism*, which not all artists were happy with but which gained wide currency nonetheless. Writing from the vantage point of a decade later, critic Clement Greenberg explained, "If the label 'Abstract Expressionism' means anything, it means painterliness: loose, rapid handling, or the look of it; masses that blotted and fused instead of shapes that stayed distinct; large and conspicuous rhythms; broken color; uneven saturations or densities of paint, exhibited brush, knife, or finger marks. . . ."[7] What one notices in this description, apart from the features that seem implicated in the move away from representation or depiction, is a focus on the materials of painting as the subject themselves, rather than as means to some other, independently defined end. Arthur C. Danto has particularly emphasized this aspect of the abstract expressionists' work; they were "celebrants of paint. Paint symbolized paint for them. The paintiness of paint, its fluidity, its viscosity, the way it forms a skin, the way it wrinkles when it dries too quickly, the way it conceals and reveals, the way it pours, spatters, splashes, holds the hair marks of brushes—and the way it drips."[8] Both characterizations are entirely in line with Motherwell's *discovery* rather than imposition of a picture—not that the painting was supposed to be some kind of record of the discovery process, but rather that the process and the work of art were one and the same.

Another critics' phrase, more controversial than abstract expressionism, was *action painting*. Harold Rosenberg invented this term, later taken up by others, to evoke and highlight the act of painting as opposed to the physical object that resulted from it, characterizing this act as "getting inside the canvas" and asserting that "What was to go on the canvas was not a picture but an event. The painter no longer approached the easel with an image in his mind; he went up to it with material in his hand to

do something to that other piece of material in front of him. The image would be the result of this encounter."[9] To Rosenberg, the turn away from representation, or "extinguishing the object," was an effect of taking up this approach, not its cause: "The apples weren't brushed off the table in order to make room for perfect relations of space and color. They had to go so that nothing would get in the way of painting. . . . Form, color, composition, drawing, are auxiliaries, any of which . . . can be dispensed with. What matters always is the revelation contained in the act."[10] Although Rosenberg would eventually be faulted—notably by critic Barbara Rose—for overgeneralizing about the new art of the 1950s on the basis of Hans Namuth's instantly famous photographs of Jackson Pollock at work, action painting remained at least provisionally in the critics'—and even the artists'—lexicon for a time.[11]

Morton Feldman, circa 1950

Feldman was born in New York and, apart from a few years spent in semi-exile in Europe, remained there for most of his life, decamping to Buffalo only in the 1970s to take up a university teaching position. The late 1940s found him studying with Stefan Wolpe, a composer who had arrived in America during the war, fleeing from Berlin by way of Palestine. For that time, Wolpe was certainly a progressive composer—though not as radical as the New York avant-garde, some of whom he would join on the faculty of Black Mountain College during the 1950s—but Feldman was already looking for a really different kind of direction, without being able to identify just what it would be, and resisted what Wolpe had to impart: "The one theme persistent in all our lessons was why I did not develop my ideas but went from one thing to another. 'Negation' was how Wolpe characterized this." Feldman felt frustrated, "dangling between various procedures that I knew didn't apply to my music," and must have wondered whether he had not reached a dead end in his aspirations to be a composer.[12]

Help was soon to arrive, in the person of John Cage. Feldman met him in 1950 and was soon swept up in Cage's social circle, which included many of the New York School painters. This role—that of facilitator and go-between—was one of Cage's most important in Feldman's life, although by no means the only one. Feldman eventually came to see Cage as a shining example, "the first composer in the history of music who raised the question by implication that maybe music could be an art form rather than a music form—something about music, always and always

something about music and only about music in a historical sense."[13] Feldman had apparently begun to think vaguely along the same lines, which would explain the "shock of recognition" that he experienced when he first got to know Cage.[14] Yet for Feldman, Cage as a composer went both too far and not far enough. On the one hand, he couldn't agree with Cage's dictum that "everything is music," or that music's process should imitate that of nature; on the other, he found in Cage's professed "self-abolishment" a *religious* position that made him, in that sense at least, close kin to Arnold Schoenberg, Igor Stravinsky, Anton Webern, Alban Berg, and other earlier twentieth-century figures.[15]

In the process of finding his own true compositional voice, Feldman gravitated almost immediately to the painters he had begun to meet. They were a definable movement that nevertheless encompassed strong personalities, a scene where "everybody was totally different," and where consequently a sense of almost limitless freedom reigned: "Painters seemed to believe in infinite options."[16] Paradoxically, it was just this individuality that made them a *school*: fortified with "a powerful, mysterious aesthetic" somehow held in common, "they all searched within their own sensibilities . . . for everything connected with painting."[17] Artists were up to date, much more interesting to Feldman than composers; they didn't talk about cubism, for example, the way a group of his musical contemporaries might have discussed twelve-tone technique.[18] Feldman remembered one particular forum at which the question posed for discussion was "When is a painting finished?"—a fascinating subject that he reckoned would simply fail to come up among composers.[19]

The New York painters also appealed to Feldman for their refreshing lack of interest in their own place in history. As Rosenberg put it, the artist of this period "did not want the world to be different, he wanted the canvas to be a world," and consequently neither defied society nor attempted to change it.[20] Feldman agreed. The painters of his acquaintance were unconcerned about "influence," had no "messianic" tendencies, and did not conceive that the point of their existence was to make an artistic contribution: "What they did was to make the whole notion of artistic contribution a lesser thing in art."[21] Related to this, he felt, was that these artists were shaking off the pernicious effects of the modernism of the first half of the twentieth century, in which the *idea* had reigned supreme, and thinking had come to substitute for looking. What had been lost after Paul Cézanne was in the process of being regained; and the New York painters were regaining it by declaring "complete independence from other art [and claiming] that complete inner security to work with that which was unknown to them"—the utter denial of preconceived ideas.[22]

To Feldman, such a stance seemed the perfect antidote to modernism in music as well, in which "the preoccupation with *making* something, with systems and construction ... has become, in many cases, the actual subject of musical composition." He looked with dismay upon Pierre Boulez's remark "that he is not interested in how a piece sounds, only in how it is made," and observed, "No painter would talk that way. Philip Guston once told me that when he sees how a painting is made he becomes bored with it."[23] Actually music, in his view, had much worse problems than painting, with no salvation in the offing: the "academic avant-garde" of the universities promulgated, not simply music written in the style of Webern or Schoenberg, but music that was "a criticism of Webern and Schoenberg," in the sense meant if one were "to take another man's idea, to develop it, expand it, to impose on its logic a superlogic."[24] Milton Babbitt would have been only the most prominent of Feldman's many examples of this tendency.

In sum, Feldman found that "[t]he new painting made me desirous of a sound world more direct, more immediate, more physical than anything that had existed heretofore"[25]—a world that would be for him what paint was to the New York School. In aspiring to such an artistic goal, Feldman realized that he was facing an immensely difficult task—and not just because of the state of musical composition in his time. "Music's tragedy is that it *begins* with perfection," he noted, whence "the composer's vested interest in his craft."[26] To learn from painting, music must realize that it is *not* painting, and that nothing will come of simply attempting to find a way to do something "equivalent" in music to what painters had done. Rather, composers must learn to appreciate "this more perceptive temperament that waits and observes the inherent mystery of its materials," in which "the painter achieves mastery by allowing what he is doing to be itself."[27]

If this sounds impossibly vague, the impression was to a certain extent deliberate: Feldman was convinced that any effort to learn from painting would fail if one set out with too definite an idea of what one wanted to accomplish. Asked in 1976 what he thought he had gotten from the abstract expressionists, Feldman replied, "Maybe the insight where process could be a fantastic subject-matter."[28] True to this insight, Feldman in his many essays and interviews formulated no comprehensive philosophy of "painterly composition" or anything of the kind. Ideas that arose only in the thick of the creative process, ideas that couldn't possibly be articulated beforehand and that would probably be different every time he sat down to write a piece, obviously could not lend themselves to any kind of systematic presentation. His avoidance on this front seems much like that of

de Kooning, who once confessed that he could never approach ideas directly: "I know there is a terrific idea there somewhere, but whenever I want to get into it, I get a feeling of apathy and want to lie down and go to sleep."[29] Thus Feldman talked around the subject a great deal, rather than talking *about* it—but in doing so, over a period of some twenty to twenty-five years, he allowed, willy-nilly, certain key correspondences and analogies to emerge in fairly consistent fashion.

Feldman's Art/Music Aesthetic

Perhaps the most telling of Feldman's attempts to characterize his activity as a composer is encapsulated in this statement: "I prefer to think of my work as: *between categories*. Between Time and Space. Between painting and music. Between the music's construction, and its surface."[30] The state of being between categories comes up for consideration at frequent junctures, and it suggests a whole range of dichotomies along whose axes many aspects of Feldman's working aesthetic may be viewed. The place in between is not the same as pictorial space in painting, or vertical ("harmonic") or temporal space in music. It seems to be more like the *situation*, of which many painters and critics during the 1950s spoke. Ashton, in her book on the New York School, notes a critic's sentence about de Kooning ("Instead of painting objects he paints situations") and some typical phraseology of Kline (speaking of his opening strokes in a painting as "the beginning of the situation"), and comments, "Such 'situations' were understood by most painters of that period to be unstable, difficult to define, fraught with imperceptible hazards, and in constant danger of being unsituated."[31] The situation had to be maintained, in all its fragility and difficulty, if the art it contained was to succeed. For Feldman, this "inbetweenness," as he also called it, was what the abstract expressionists owed most to Cézanne: "insistence on the picture plane" takes over, obliterating the original pictorial idea that might otherwise have served as the basis of the painting. Feldman noted, "The search for the surface has become the obsessive theme of the painting"[32]—not, it is important to notice, the surface itself: Cézanne's art is suspended between the surface and what it developed from.

We see this quality again in Feldman's account of a Robert Rauschenberg painting that he acquired in about 1950, a large work painted black, with newspapers (also painted black) glued to the canvas. It made him understand, he said some thirty years later, what it was to want "neither

life nor art, but something in between." Rauschenberg's painting wasn't collage, but something else—something more. Feldman stated: "I then began to compose a music dealing precisely with 'inbetweenness': creating a confusion of material and construction, and a fusion of method and application, by concentrating on how they could be directed toward 'that which is difficult to categorize.' "[33] Some clues as to how he went about meeting this challenge that he had set for himself can be uncovered through examination of several other dichotomies that engage "inbetweenness" in a particularly Feldmanesque way.

Change/Stasis

"I'm involved in stasis. It's frozen, at the same time it's vibrating." For Feldman, maintaining stasis meant maintaining a certain tension, a quality that he especially admired in Rothko's work.[34] In one lecture, he recalled that Rothko (presumably in the midst of painting) used to ask him, "Is it there? How much of it is there?"—to which Feldman added, for the benefit of his audience: "Not if it's all there, but how much has to be there for it to be there?"[35] It seems significant that Feldman brought this (almost desperate) query of Rothko's to mind in connection with his *Triadic Memories* (1981), for solo piano, which seemed to him to look as though "nothing is there"—if one were to judge by the appearance of the score alone. Elsewhere, he described his method of writing one section of this piece, "a section of different types of chords where each chord is slowly repeated." He continues,

> One chord might be repeated three times, another, seven or eight— depending on how long I felt it should go on. Quite soon into a new chord I would forget the reiterated chord before it. I then reconstructed the entire section: rearranging its earlier progression and changing the number of times a particular chord was repeated. This way of working was a conscious attempt at "formalizing" a disorientation of memory. Chords are heard repeated without any discernible pattern. In this regularity (though there are slight gradations of tempo) there is a *suggestion* that what we hear is functional and directional, but we soon realize that this is an illusion; a bit like walking the streets of Berlin—where all the buildings look alike, *even if they're not.*[36]

Yet in the end, complete or permanent stasis is an illusion, too. As Feldman points out later in this same essay, stasis as used in painting is not a traditional part of musical technique, but "music can achieve aspects of

immobility, or the illusion of it. . . ."[37] The metaphor of the kaleidoscope suggested itself to him in describing his *Durations I*, a work from the early 1960s, where he "wrote each voice individually, choosing intervals that seemed to erase or cancel out each sound as soon as we hear the next"— much, it would seem, like the amnesia-inducing chords mentioned in connection with *Triadic Memories.*[38]

But how can both stasis and change be illusionary at the same time? Feldman may actually not have solved this somewhat vexing problem to his satisfaction until his later, more explicitly "patterned" work, which developed partly under the influence of the Central Asian nomadic rugs that he began to collect during the 1970s. Here the fine line he trod between variation and repetition suggests another dichotomy: between the two he introduced "hidden variation," that is, *almost* repetition but with very subtle changes.[39] As an analogy to this technique, Feldman posed the color quality of nomadic rugs known as *abrash*, which refers to the slight differences in color within a rug arising from the circumstance of the yarn having been dyed in very small quantities. Thus, the color of some particular area of the rug is "supposed" to be the same throughout, but actually is not.[40] The kind of changes that an analogy to *abrash* seemed to suggest involved repetitive chordal patterns that did not actually *progress* one to another, "but might occur at irregular time intervals in order to diminish the close-knit aspect of patterning; while the more evident rhythmic patterns might be mottled at certain junctures to obscure their periodicity."[41]

Attack/Decay

The location of musical activity somewhere between stasis and change also stimulated a highly original approach on Feldman's part to the question of attack and decay: "Change is the only solution to an unchanging aural plane created by the constant element of projections of attack."[42] Attacks, for Feldman, were a necessary evil: the sound had to begin sometime, but its actual point of onset, he felt, ought to be greatly deemphasized, made as "sourceless" as possible. In a conversation broadcast over the radio in New York City during the 1960s, Cage asked Feldman what had happened to the "sporadic loud sounds" of his earlier pieces. Feldman replied that they had served as punctuation or differentiation in a way that he no longer found necessary or even desirable. Pressed further by Cage, Feldman continued, "Maybe I heard too much of its attack, . . . maybe I have some notion about the purity of the sound itself being lost in the loudness of the attack. . . . It also, in a sense, created a certain amount of energy that I felt I had to use. They became an interference of some kind."[43]

However, as Feldman explained elsewhere, no matter how soft the attack, he still tended to hear it, on some level, as preempting the sound itself. Thus he found it necessary to concentrate his compositional energies even more upon decay: "This departing landscape, *this* expresses where the sound exists in our hearing—leaving us rather than coming toward us."[44] These issues eventually engage the whole matter of instrumentation, which we will turn to later. For now, we can note that these ideas about sound in what amounts to an *ideal* state have highly marked visual affinities and may well owe their ultimate source to the work and statements of the painters Feldman knew. His dislike of electronic sound, for instance, is telling: "The physical impact to me is like neon lights, like plastic paint, it's right on top, whereas I like my paint to seep in a bit."[45] Such sound, in his estimation, has not a hope of attaining a sourceless quality. Here Feldman alludes to the lack of sharply defined edges in much abstract expressionist work—Rothko and Kline certainly come to mind, though in very different ways—resulting from the direct staining of unprimed canvas. The somewhat blurry and irregular boundaries yielded by this seeping-in technique are clearly what Feldman sought in his various notational solutions, also to be discussed later; more metaphorically perhaps, the lack of edge evokes a quality in the work of Pollock and Guston (of which he approves), and excludes the kind of "precompositional" setting up that he despises.[46] In this quality of the sound *leaving* the listener, Feldman sought as well an effect that he had noticed in the work of many abstract painters: "The paintings often 'perform' only as the viewer begins to leave them." He amplifies with an anecdote: "Not long ago Guston asked some friends, myself among them, to see his recent work at a warehouse. The paintings were like sleeping giants, hardly breathing. As the others were leaving I turned for a last look, then said to him, 'There they are. They're up.' They were already engulfing the room."[47]

Duration/Timelessness

Emphasis on decay inevitably brings up issues of time in Feldman's music. But time per se is not something that Feldman has much interest in working with directly: "The idea is more to let Time be, than to treat it as as compositional element. No—even to construct with Time would not do. Time simply must be left alone." And, later, "I am not a clockmaker. I am interested in getting Time in its unstructured existence."[48] It is not difficult to see that Feldman's attitude toward time is very much that of the visual artist, whose work does not make its effect primarily by temporal means

and exists in time, so to speak, only passively. The idea of time being simply a kind of *container* for his work certainly seems clear in his characterization of his compositions as "time canvases in which I more or less prime the canvas with an overall hue of music."[49]

In his later, longer pieces, Feldman was apparently able to realize his ideal of painterly time more explicitly than before. Speaking to the artist Francesco Pellizzi in an interview, he said, "It would be very much like taking a look at any of your paintings here in the changing light, you see. The person that did not take the time would be involved with the light of the moment, as they're looking at it; but the person that did could not help but be distracted by the changes . . . how the painting looks throughout the day, and has a very different eye than the person who didn't take time."[50]

Thus it is not accurate to say that Feldman's pieces are *timeless*, only that they are largely devoid of the conventional time of music. Time, for Feldman, is only the incidental by-product of duration, which in turn exists for the sake of making his sounds audible. Each sound lasts for long enough to lend it the specific quality that he seeks. Feldman has also adopted certain working methods to discourage time from gaining a toe-hold in his music beyond this unstructured role: "One of the reasons I work at the piano is because it slows me down and you can hear the *time* element much more, the acoustical reality. . . . Just sitting down at a table, it becomes too fancy. You develop a kind of system, asymmetrical relations of time. You get into something that has really nothing to do with acoustical reality."[51] Paradoxically, this interest in duration has also made Feldman feel that "the moment, the *rightness* of the moment, . . . is very important." Does the piece live somewhere between the moment and its duration? Perhaps so, if Alberto Giacometti, in a remark admiringly paraphrased by Feldman, is correct: "He said he wants to make his sculpture so that if the tiniest fragment was found, it would be complete in itself in such a way that one might almost be able to reconstruct it."[52]

In their very length, the works Feldman wrote in the late 1970s and the 1980s may also have responded to one of the principal salient features of abstract expressionist art: the notably large physical dimensions of many of the paintings. But they were probably not the first of his pieces to do so. In an interview in 1978, Feldman noted that such large dimensions in American art did not necessarily equal monumentality, that in fact it was quite possible for a large American work to be intimate in a way that large European paintings tended not to be. Asked whether "this intimacy [is] what you've tried for in your music," Feldman answered, "Always."[53] He may very well have been remembering something Rothko said: "I paint

very large pictures"—not out of a desire to be grandiose or pompous, but "precisely because I want to be very intimate and human." And, further, "However you paint the larger picture, you are in it. It isn't something you command."[54] Kline preferred the larger canvas, he said, because "the presence of a large painting is quite different from that of a small one"—more exciting, lending itself more readily to self-confrontation on the part of the artist, which certainly suggests a stronger sense of being up close to the work.[55] Critics have reported that Kline, beginning in the early 1950s, conceived his large paintings "as enlarged projections of smaller sketches," and have noted that in these works "the canvas brings the eye up short, like the form of an immense architectural structure seen at close range," a quality that would certainly help explain why the viewer seems suddenly so *close* to the brushwork and other details of execution in these paintings.[56]

Horizontal/Vertical

Feldman's lack of interest in structuring time is also borne out by such statements as, "My compositional impetus is in terms of the vertical quality, and not what happens in terms of the horizontal scheme."[57] In late 1966, Feldman recalled a work of his for three pianos (possibly *Two Pieces*, composed earlier that year), "where there are three things going on at the same time," and noted that "what I'm pursuing is the whole vertical journey. You know, we know everything about the horizontal. . . . Everything. . . . We really know everything."[58] The vertical, by contrast, still held many mysteries. Like the children's game with the glass full of water right to the brim, into which many pennies can be dropped without causing the water to spill over, "that's how I find the vertical—that no matter how many sounds I throw into it there is a hunger . . . for more. . . . I threw three pieces, actually, into this simultaneity, and it could have much more, it's so full of space, so full of air, it's still breathing. It's endless and it absolutely keeps its transparency."[59] For Feldman, to engage the vertical dimension was to do as the painters did, "to work with that which was unknown to them." The fundamental mysteries of space hinted at the existence of vast worlds *in between*, places that the painters too sought to occupy.

Did Feldman think he would ever fully penetrate these mysteries? Perhaps not; perhaps he hoped never really to get to the bottom of them, lest he become as bored with the vertical as he evidently already was with the horizontal. In any case, one obstacle that he found himself continually coming up against in his attempts to portray the ideal character of sounds—that is, their sonority or verticality—was orchestration. Feldman's attitude

toward orchestration seems, at first glance, ambivalent. On the one hand, he will say, "For me composition is orchestration"; on the other, "I have no loyalty for instruments." He can state that "what leads me to begin a composition is a weight, an orchestration that is new to me" but also that "instrumental color robs the *sound* of its immediacy."[60] For the composer, unfortunately, there is no solution available akin to painting only in black and white, as did Kline for the greater part of his mature years, and as did Guston, too, for a considerable period. "The instrument has become for me a stencil, the deceptive *likeness* of a sound," noted Feldman. "For the most part it exaggerates the sound, blurs it, makes it larger than life, gives it a meaning, an emphasis it does not have in my ear."[61] Composers, it seems, would be stuck with instrumental color no matter what they did.

Yet it was still possible to learn something of relevance to this musical dilemma from the painters, because some of them painted with colors while denying that color was the primary point, or even *a* point. Rothko was particularly insistent on this issue: "I'm not interested in relationships of color or form or anything else."[62] From his personal contact with Kline and Guston, Feldman was well aware that both regarded color as more likely to be an intrusion into their painting than anything they could work with usefully.[63] Kline acknowledged that color had crept into some of his black-and-white paintings, as a kind of accident, which meant that it had no particular importance. "Sometimes a black," he said in an interview, "because of the quantity of it or the mass or the volume, looks as though it may be a blue-black . . . or as though it were a brown-black or a red-black. The whites the same way; the whites of course turned yellow, and many people call your attention to that, you know; they want white to stay white forever. It doesn't bother me whether it does or not. It's still white compared to the black."[64]

As for Guston, much of his work throughout the 1960s was in black, white, and shades of grey: "I have never been really interested in color. . . . I'm more of a tonal painter, maybe, I work with a few tones. I don't think I have ever been a colorist, working with color to create space." Instead, "I become attached to a single color and work with it for years," like the red that shows up in so many of his paintings from the early 1950s on: "[T]his cad red medium seems to stay on the plane. You can't budge it, it's there."[65] As Feldman observed, color was quite patently used in Guston's earliest and late abstract paintings but its real function was simply "to *light* the stage."[66]

Feldman evidently found it somewhat difficult to explain just how the "intrusion" of color from instruments was such a problem for him, or how

it could be neutralized.[67] "My pieces fail if one can say: 'Ah, there's a trombone, there's a horn,' " he said. "I like the instruments to play in the natural way; they become anonymous." This is also in line with the goal, mentioned earlier in connection with decay, of keeping the sound as sourceless as possible. Nevertheless, "I have yet to hear an easy harmonic played beautifully and without vibrato with a slow bow on the cello. I have yet to hear a trombone player come in without too much attack and hold it at the same level." Perhaps such goals are unattainable, but, "[t]hat's why these instruments are not dead for me: because as yet they have not served my function."[68] The goal was to use instruments "only to articulate musical thought and not to interpret it."[69]

Surface/Depth

The picture plane of the artist partakes of both surface and depth, as does Feldman's analogue, the aural plane. But while for painters depth may be something akin to the *space* briefly touched upon in the previous section, in Feldman's world depth seems at times different from the vertical dimension of music: a kind of *third* dimension, perhaps, which depending on the context could be very important or nearly absent.

For painters of this period, *depth* of course did not refer to the effects of illusionist perspective in older styles. To say, however, that there would have been nothing for such a technique to latch onto anyway, since by the early 1950s most of the vanguard New York painters were working in a completely abstract style, makes things a little too simple. According to the critic Clement Greenberg, some of the New York artists eventually began to feel the need for three-dimensional space again, which could only be done through "the tangible representation of three-dimensional objects." This led to de Kooning's *Woman* paintings and to some of Guston's work later in the 1950s, where recognizable images began to appear. Greenberg called this development *homeless representation*, meaning "a plastic and descriptive painterliness that is applied to abstract ends, but which continues to suggest representational ones."[70] Not everyone agreed with Greenberg's formulation, though, and in any case neither Kline nor Rothko, to mention two prominent examples, seemed drawn to representation.[71] The real point here is that issues of surface and depth were fairly complex and differed from artist to artist. Feldman, it seems clear, learned a great deal from considering the different ways in which individual painters had dealt with these matters. He had more to say about Guston and Rothko than about anyone else, although other lessons can be inferred from critical opinion of the time and since.

One aspect of de Kooning's work potentially very important to Feldman, for example, is the idiosyncratic character of his "special kind of space." Dore Ashton has noted that the spaces the Woman inhabits in those well-known paintings "invade her, qualify her," and that "limbs are given in terms of landscape—they can be vast; the eye can imagine them as painted space."[72] Although this is obviously not the same as collage technique, its heritage is collage, and there is a kind of resemblance, as other descriptions make clear: "Shapes do not meet or overlap or rest apart as planes; rather there is a leap from shape to shape; the 'passages' look technically 'impossible.' "[73] By the same token, by his own testimony Feldman sometimes leaves "broken" continuities as he works, crossing out and then later either filling in the resulting gap, or not: "I don't necessarily work in a continuity."[74]

Whether Greenberg is right about such spaces being three-dimensional, Kline's space seems markedly different from de Kooning's. In his statements and interviews, Kline was often at pains to emphasize that he did not simply paint black forms on a white background—that he painted the white areas as well, which were just as important. By doing so, he effectively prevented the black from coming to the fore and the white from receding, compressing the whole into two dimensions.[75] Not that the result was static or simply flat: the critic David Anfam detects a condition of "contradictory impulses" that "clash and cancel out, creating . . . a condition of what might be termed 'in betweenness' "—a term which, in its use here, seems to echo the meaning Feldman assigned to it. To paint the white as well as the black could be seen as analogous to Feldman's desire, in abandoning his graph notation of the 1950s for something more precise, to control silence as well as sound. His further statement that what looks like rhythm on paper is actually *duration* seems to affirm this analogy.[76] A further correspondence to Kline's work comes in the immediacy of these paintings, which "hit the viewer full in the face. . . . All of them seem to arrive with the speed of a collision."[77] The violence implicit in this description does not seem characteristic of Feldman's work, but the immediacy does. Feldman deliberately produces this effect by writing ten measures or so before starting in on the real action of his piece—and then discarding the ten measures, producing the effect upon which Bunita Marcus has remarked, "There's no introduction to his music, ever. It just starts, *there*. . . ."[78]

From observing and listening to Rothko, Feldman took other lessons. He seems most impressed with the *scale* of Rothko's paintings, his "finding that particular scale which suspends all proportions in equilibrium." This, for him, is what "floats" a Rothko painting. Contrasting Rothko with Piet

Mondrian, for whom Feldman also had considerable regard, Feldman sees "virtually no distance between his brush and canvas" and adds, "One views [his work] from a vast distance in which its center disappears"— certainly very different from the "up close" effect of Kline.[79] What made this kind of floating effect at a vast distance possible was a gradation of shadows peculiar to Rothko's work, something Feldman liked so much that he insisted on this effect being duplicated as closely as possible in the stage lighting for the premiere of his Samuel Beckett opera, *Neither* (1977).[80] At the same time, Feldman found Rothko's surfaces an important link with Cézanne, just as he recognized the importance of musical surface to himself. In asserting the picture plane, as Cézanne did, Rothko and other abstract expressionists carried surface one step further into "raw space," as Feldman called it, quoting Philip Pavia.[81] Again, it is clear that surface and depth are inextricably linked, and that the painting exists somewhere between them, partaking of both.

As for Guston, the painter whom Feldman was personally closest to, it was in his work that the quality of inbetweenness was most apparent. Feldman saw Guston's paintings most clearly as "existing somewhere in the space *between the canvas and ourselves.* . . . the play of light and dark *no longer takes place on the canvas per se.* It becomes visible only when you perceive that it is *not* on the canvas."[82] Guston's time, says Feldman, is "moving outward," which no doubt accounts for the sensation it affords of "creep[ing] along the walls" even though it is actually confined to a canvas.[83] Some of Guston's earliest abstract works, the paintings of the early 1950s that he was creating when they first met, seem to have evoked particularly vivid musical analogies for Feldman. Speaking of *Attar* (1953), he said, "As the tones vibrate, they recede beneath the pigment and return, but with another bowing. In music we would say that the sound is sourceless due to the minimum of attack. This explains the painting's complete absence of weight. But the sensation of what you see *not coming from what is seen* is characteristic of all of Guston's work."[84]

Feldman is not speaking in riddles; he is only trying to convey some idea of *where* the visual experience actually is in our perception. That deflection of vision away from what is seen is the effect of what Feldman called the "abstract experience"—something that cannot itself be represented or seen in a painting, but which is nonetheless there.[85] Locating the visible in that sense was crucial to him at the time, as he wrestled with the question of where to place his own music in acoustical space, and how to maneuver it there successfully. By observing that "Guston's paintings tell you instinctively where to stand," Feldman evidently learned that it was

imperative for him to establish the proper acoustical distance between his music and the listener[86]—a realization that may have led to his intense interest in *decay* as opposed to attack.

Finished/Open

Earlier, we remarked upon Feldman's attraction to certain painters' questions that composers might rarely, if ever, think to ask, such as "When is a work finished?" This, in fact, was a question Guston frequently returned to—a question that he never seemed quite finished with. In part, this was because the answer could be different for every work; in part, it was also because "finished" could mean either *closed* or simply *brought to an ideal state*. And however that point was defined, it was hard to get to. As Guston put it on one occasion,

> Usually I am on a work for a long stretch, until a moment arrives when the air of the arbitrary vanishes and the paint falls into positions that feel destined.
> The very matter of painting—its pigments and spaces—is so resistant to the will, so disinclined to assert its plane and remain still.[87]

An insistence, even, on the part of the paint on remaining still is important: "The paint gives me the feeling that I can't peel it off, it won't fall off, and there's nothing I can do to it."[88] So also is a feeling of wholeness: when Guston is done with a painting, "I don't remember parts of it. That's what I want—I don't want to be stuck with parts."[89] Other statements suggest that what Guston sometimes calls stillness might more accurately be described as a kind of dynamic equilibrium: "[W]hen you say, this picture is finished—[it] really hovers over the brink, hovers like a fog over the landscape, and veers one way, then another, and won't settle. . . . A picture is finished when it's in this unsettled, hovering state: not indecisive, though. . . ."[90]

Guston may well have found the question of finishing an occasion for serious inner conflict: Feldman, reporting that Guston "tells us he does not finish a painting but 'abandons' it," proceeds to speculate that perhaps the point of abandonment was "at the moment when it might become a 'painting' "—because, "After all, it's not a 'painting' that the artist really wanted."[91] This makes perfect sense, not only in terms of other remarks of Guston's, such as his desire to *make* rather than *make something*,[92] but also in terms of what Feldman observed about other artists of the New York

School, such as Kline: "There is no 'plastic experience.' We don't stand back and behold the 'painting.' There is no 'painting' in the ordinary sense. . . . There is nothing but the integrity of the creative act."[93] Here we see Feldman drawing upon the "inbetweenness" that informs just about every aspect of abstract expressionism. These paintings end up being both finished and open, a dual quality in the perfect balance that Feldman identifies as unique to the 1950s.[94]

Feldman's remarks about his own compositional process bear some traces of the painters' ways of finishing, although the resemblance is not as striking as one might expect. There is, first of all, the analogy that Feldman makes between the picture plane of the artist and the "aural plane," which he uses to keep from "having the sound fall on the floor."[95] The description of what such an aural plane entails—in the lecture transcription from which this remark is taken—is unfortunately garbled; but the close correspondence he means here to Guston's references to the picture plane, and to a picture not being finished until the paint sticks to it and is no longer susceptible to further moving around, is clear at least.[96]

More explicitly on the question of finishing, Feldman points out that in his String Quartet (1979), a piece of some three hours' duration, not long into the third hour he begins "to take away material rather than bring in . . . and for about an hour I have a very placid world."[97] More generally, he has said that "as the piece gets longer, there has to be less material. . . . I don't have an anxiety that I've got to stop. But there's less going into it, so I think the piece dies a natural death. It dies of old age."[98] On yet another occasion he emphasized that the piece "has to go somewhere, it has to exploit the materials, you have to use up its potential, it has to feed on itself. . . ."[99] Perhaps this gradual culmination is reflected in Guston's account of the "twenty crucial minutes in the evolution of each of my paintings," which from the context of these remarks one would think come at the very end of the creative process: "The closer I get to that time—those twenty minutes—the more intensely subjective I become—but the more objective, too. Your eye gets sharper; you become continuously more and more critical."[100] This seems to connote a tapering-off process, with less and less getting added to or modified in the painting as it nears completion.

Ideas/Materials

The painters' antipathy for preconceived ideas, shared by Feldman, has been already discussed. Guston seems to have been a prime influence in this regard, by both Feldman's testimony and his own. Frequently Guston

emphasized his feeling that one can't "think it out first, will it and put it on." Otherwise, "painting becomes a series of habitual responses"; in following them, "all you've done is illustrate what you were thinking about."[101] In one interview, Guston speaks vividly and ironically of a kind of false start that he often made, a lesson that needed to be learned time and time again, saying, "I have all kinds of wonderful ideas: a little green there, a little blue there, I'll have this there, and you proceed to do it. Then you leave the studio, and it's like having a bunch of rocks in your stomach, you can't stand to see these illustrations of your ideas."[102]

"God knows where you start and how you start," said Guston[103]—and, in a sense, this is the real problem: If the act of creation is supposed to be a leap into the unknown, where does the initial impetus come from? It could, apparently, be something completely arbitrary: "Guston just looked out of the window, made a little mark," said Feldman, who may actually have witnessed him doing this on more than one occasion. Feldman described his own composition process in a similar way: "I never had an idea when I sat down to work . . . with me my ideas came out of the piece." This way of working could be anxiety-provoking, but far worse would be to subscribe to the "terror" of Pierre Boulez and Karlheinz Stockhausen, where "you had to have an idea" up front.[104] Like Guston, "one is propelled to make what one has not yet made, nor seen made. What one does not yet know how to make."[105]

The trouble with preconceived ideas, as far as Feldman was concerned, seemed to be that because they did not arise in the course of working they were forever cut off from the materials used to execute them; thus these materials, not being animate in themselves, remained puppets, dead matter. The trick was to compose directly with one's materials, on the aural plane: "And so I'm involved like a painter, involved with gradations within the chromatic world." The ear travels back and forth between these gradations, gauging the increasing saturation: "I work very much like a painter, insofar as I'm watching the phenomena and I'm thickening and thinning . . . and just watching what it needs."[106]

Consistent with this description is his assertion that he does not hear what he writes before he actually writes it—"Sometimes I almost hear it and I can almost write it. I'm not taking dictation . . . I write it down in order to hear it,"[107]—which sounds like a painter of that period talking about painting something in order to see it. In the course of this same conversation, Feldman complimented the composer Bunita Marcus on a work in which she used multiphonics "as *material*, you know, it's like painting with it and getting out of it and in it, and it is just beautiful."[108]

We get the feeling that Feldman is trying to work in that way in his later music, with the slight intonational variances produced by frequent recourse to double sharps and double flats. Rather than make a system out of them, something which he faults Ben Johnston and other "microtonal" composers for doing ("They immediately conceptualize it; they're not listening"),[109] Feldman instead thinks of these variances as akin to the refraction of light in painting, or to the previously discussed phenomenon of *abrash* in nomadic rugs.[110]

Feldman's Compositional Approach through Art

The clearest evidence we have that Feldman developed as a composer through his contact with the New York painters comes to us in the form of his notation of scores, and in the changes that his approach to notation underwent as he struggled to find a solution that would yield successful performances. A short history of Feldman's notation will provide useful occasion to examine some representative examples, in particular from the works named after or dedicated to the painters he knew.

Before embarking on this history, it would be well to point out that the *look* of notation, its physical appearance, had an importance to Feldman that is in some ways quite surprising, in light of his emphasis upon the sound of music as the aspect he was most interested in—and the aspect that, in his opinion, many of his contemporaries were not sufficiently involved with. Yet it was precisely this physical appearance that Feldman felt he had to get exactly right in order to have any hope at all of obtaining the musical result he sought. Feldman really did seem to have an artist's sensibility about the *act* of writing out his scores; for him it was bound up with the quality of *touch*. It was touch that made one's work one's own, "even if it is nothing more than the ephemeral feel of the pencil in my hand when I work. I'm sure if I dictated my music, even if I dictated it exactly, it would never be the same."[111] Elsewhere, Feldman referred to "the almost hierarchical prominence I attribute to the notation's effect on composition" and argued strongly for its look as an aspect of "role playing" and as a voice, "if not on stage, then off."[112]

Feldman's first confrontation of notational issues came right at the beginning of the 1950s. Wishing to enter that "sound world more direct, more immediate, more physical" than anything he had previously known, he realized that to do so "would require a concentration more demanding than if the technique were that of still photography, which for me is what

precise notation had come to imply."[113] Soon thereafter, Feldman found his initial response to this challenge: graph notation. Figure 7.1 displays a page from *Marginal Intersection* (1951), one of the earliest of Feldman's works written in this notation. Here, the vertical dotted lines demarcate units of four "icti" (as Feldman prefers to call beats) at a uniform tempo of MM=128. The placement of boxes and rectangles within this framework indicates relative register (high, medium, or low; or simply high or low in the case of the oscillators) as well as the ictus within each unit of four. Pitches are freely chosen within these relative registers, whose boundaries are determined by the performers; likewise the dynamics, unless specified (none happen to be on this page). Certain other performance indications are specified for the string parts. Although the score's preface does not say so explicitly, it seems understood that each box or rectangle denotes *one* attack per instrument, whether briefly or extensively sustained depending upon the indicated duration.

Asked in an interview about his graph notation, Feldman stated, "It came about because my music was becoming more complicated . . . and I wasn't interested in organizing everything."[114] One thing, certainly, that he was interested in organizing was duration, analogized to the physical dimensions of the painter's canvas: "Pollock placed his canvas on the ground and painted as he walked around it. I put sheets of graph paper on the wall; each sheet framed the same time duration and was, in effect, a visual rhythmic structure. What resembled Pollock was my "all-over" approach to the time-canvas."[115] Feldman had first become acquainted with Pollock when he was asked to write the music for Hans Namuth's film of Pollock at work. Evidently the graph-notation approach did not occur to Feldman right away, because the music he wrote for that film was notated in quite conventional fashion—but from Feldman's statement that he wrote the score "as if I were writing music for choreography," one can tell that he was already thinking of a kind of parallel to Pollock's painterly technique.[116] As he said on a later occasion, "Pollock is doing a beautiful choreographed dance around the canvas, measuring, and as the paint falls it becomes the painting, it becomes indistinguishable. . . . what he's doing is in a sense what the thing is."[117] And in the film score it is hard to miss the overtly *gestural* character of Feldman's writing, suggestive of Pollock's gestures even though no attempt was made to coordinate music and visual image precisely.

Besides the "dance" with which Pollock executed his pouring and dripping techniques, there may have been other aspects of painterly method on display here that acted as influences upon Feldman. One notes in par-

MARGINAL INTERSECTION

Morton Feldman

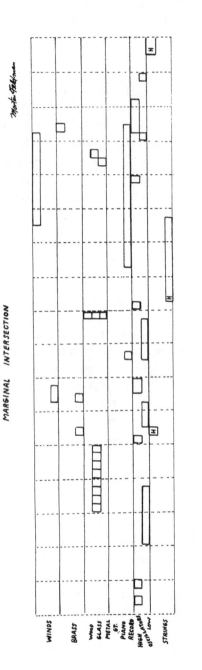

Figure 7.1 *Marginal Intersection*, first page of score. © 1962. Used by permission of C. F. Peters Corporation.

ticular the markedly heterogeneous nature of the scoring in *Marginal Intersection*, which includes not only a large orchestra with piano, xylophone, and vibraphone, but also "amplified guitar, two oscillators (one for high frequencies, the other for low), a sound-effects recording of riveting, at least six percussionists with a large selection of wood, glass (or less breakable substitutes), and metal objects (aluminum pots, etc. etc.)."[118] This seems highly reminiscent of Pollock's mixing of other materials into his paints and his adoption of new ways of applying them, starting in the late 1940s: "I continue to get further away from the usual painter's tools such as easel, palette, brushes, etc. I prefer sticks, trowels, knives, and dripping fluid paint or a heavy impasto with sand, broken glass, and other foreign material added."[119]

Looking back some thirty years later, Feldman opined that the graph notation was quite right stylistically "for the time it was written," even though he hadn't set out to create a style. But clearly it would have been a mistake to persist in this style once its time had passed and its problems had begun to appear.[120] First of all, he began to realize that he was interested "in freeing the sound and not the performer," and that "my most far-out notation repeated historical clichés in performance" in a way that a more precise notation might prevent.[121] He also came to realize that he had had something quite definite in mind, after all, when he set up his grids: "You have a sense of the propriety of it, like the way Jackson Pollock would have a sense of his eye and the scale of things."[122] Over the period 1953–58, Feldman tried returning to precise notation, but found it unsatisfactory after the experience with the grids. Precise notation was "too one-dimensional"; it was "like painting a picture where at some place there is always a horizon . . . one always had to '*generate*' the movement—there was still not enough plasticity."[123] It was at this time too, apparently, that he began to feel dissatisfied with instrumentation, which seemed to be getting in the way of the sounds themselves. As he put it, "It was as though, having had a taste of freedom [in graphic notation], they [the sounds] now wanted to be really free."[124]

What was the solution? A compromise of sorts seems to have been struck by the early 1960s. Feldman's pieces of this period effectively reverse the freedoms and constraints of the earlier graph pieces: pitches are specified, but durations, within what one might call "reasonable limits," are left up to the performer. (Implicit in the simultaneous parts of Feldman's scores in this period is the condition that no part should ever fall too far behind or venture too far ahead of the others.) A typical example of this strategy is *For Franz Kline* (1962), the first page of which is shown in figure 7.2.

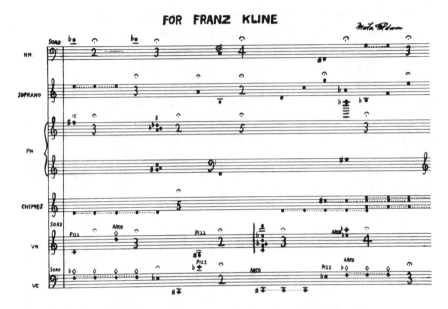

Figure 7.2 For Franz Kline, first page of score. © 1962. Used by permission of C. F. Peters Corporation.

In a work dedicated to the memory of a painter whose mature work was executed almost entirely in black and white—a painter who, as noted earlier, regarded color largely as "an intrusion"—the instrumentation that Feldman has chosen may strike the reader (and listener) initially as rather incongruous. The combination of horn, wordless soprano, piano, chimes, violin, and cello seems destined to be "colorful" in the extreme. Yet somehow it turns out not to sound that way at all. One reason for the curiously neutral effect is that the instruments are not displayed in any of the characteristic figures or passagework that often serve to identify them in "normal" orchestrational situations: the parts consist of single notes, sustained for varying lengths of time, or isolated chords; the soprano's temporally adjacent pitches are all separated by leaps, usually large ones. Another reason is the uniformly low level of dynamics and the minimization of attack, which tends to smooth out the differences that might emerge among the instruments in these dimensions. A third factor, perhaps the most important of all, is the kind of vertical combinations that the instruments and voice form, none of which are recognizable as conventional. Feldman's utterly original ear for sonority means that it is often an exercise in frustration to try to identify which part is lowest, which highest, which in between.

For instance, in the first sonority the lowest and highest notes are C4 and F#7, played by muted violin pizzicato and piano, respectively, neither of which has any power to sustain. Once the violin's pitch has vanished, the lower boundary passes to the muted horn note a semitone higher, but that note is soon gone as well, leaving three sustained pitches: D4 in chimes, E5 in soprano, and F5 in cello (muted harmonic). In the third approximate temporal "slice," D7 (violin harmonic) makes a brief appearance, remotely "doubling" the D4 and momentarily, slightly altering its balance with the other two pitches sounding at that point; in the fourth slice, voice E5 disappears, while D♭4 in muted horn reappears. A little later (slices 6–8), voice, violin, and cello all move to notes near the bottom of their respective ranges, although not at the same time; meanwhile, horn and piano also move lower, but the order of parts from sonority to sonority, top to bottom, is under nearly constant revision. This, combined with the consistently low dynamic level, preserves the sourceless, anonymous quality that Feldman has said he likes his instruments to have; at the same time, it is obvious that this orchestration has a combined instrumental "weight"—again to use Feldman's word—that is quite distinctive, if not particularly *colorful*. In other words, it's not that the instruments can't be recognized and distinguished one from another, but rather that their "hornness" or "violinness" is very far from being the most important thing about them. In this sense, *For Franz Kline* can be heard as an analogue to a painting in black, white, and shades of grey. In another sense, the measured silences of Feldman's score are something like the white of Kline's paintings that is painted just as the black (sound) is, and therefore just as important. The quality of silence in this work, actually, is inseparable from the quality of sound, in which sonorities are not markedly hierarchized by the fact of one, two, three, or more instruments sounding at once (probably in part because notes sounding at the same time are rarely if ever attacked at the same time). This tends to bring everything, including the silences, into the same aural plane—just as Kline's picture plane tends toward the two-dimensional.

Turning now to another, roughly contemporaneous work, *De Kooning* (1963), we find a somewhat different approach to the issue of duration. (The first page of the score appears as figure 7.3.) As in the Kline piece, pitches are specified and durations are only approximate; but now there is a definite sequence of entrances, proceeding according to the trajectory of the dotted lines, and intended simultaneities are clearly indicated with solid vertical lines ending in arrowheads. Silences are only "virtual"—that is, each new entrance in sequence is to be made only as the preceding

DE KOONING

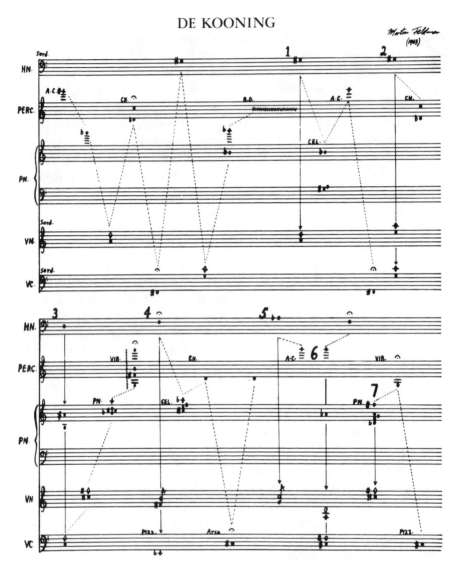

Figure 7.3 **De Kooning**, first page of score. © 1963. Used by permission of C. F. Peters Corporation.

sound begins to fade—until the third and fourth pages of the score, where in four separate locations complete ensemble silence is enforced with strictly measured, actual bars with time signatures and specific metronome markings. There are no other such bars, silent or sounding, anywhere else in the work.

As can be seen in figure 7.3, the dotted- and solid-line trajectories are segregated into what might be called phrases, numbered serially (except, for some reason, the first one) and often, though not always, ending with a fermata. At first glance, the connecting lines might seem superfluous, but they're not, for at least two reasons. One is that they enable the composer to make a distinction between the successive and the simultaneous without recourse to bar lines. The other is what they look like on the score page, which is a series of highly angular and variegated *gestures*—a better word, really, in this context, than phrases. Their rather spare appearance, reflected in their sonic realization, is more reminiscent of drawings than paintings—perfectly appropriate for most of the New York artists, who considered the two media closely related, even to the point of inseparability.[125]

It may be significant that Feldman's composition coincides with the end of a six-year period identified by critic Thomas Hess as one of simplification for Willem de Kooning, when "forms became fewer, . . . larger, more simple" and colors "more concentrated on primary contrasts"—this as compared to de Kooning in the mid-1950s, when "the surface is packed with forms . . . a piling of ambiguity on top of ambiguity."[126] In an interview conducted in 1963, de Kooning—perhaps in this same spirit of simplification—held that "[c]ontent is a glimpse of something, an encounter like a flash. It's very tiny—very tiny, content." On another occasion, he referred to himself as "a slipping glimpser."[127] Observations made earlier about surface and depth in de Kooning's work are also relevant, in particular those about leaps from shape to shape and the "impossible" passages, both of which qualities are reflected in the gestures of Feldman's piece, continually starting and stopping.

Also in 1963, Feldman wrote his *Piano Piece (to Philip Guston)*, a work whose score takes up not quite all of two large sheets of manuscript paper. (The first three braces appear in figure 7.4.) Again, pitches are specified but durations are somewhat approximate (the indicated tempo range could be taken to suggest a playing time of about two to three minutes, although this would hinge a good deal upon the interpretation of the many fermatas). By his own testimony, what Feldman meant most explicitly to convey in this piece was the quality of *touch*: "It's a piece that's involved very much with touch if you play it," he said in an interview.[128]

PIANO PIECE (TO PHILIP GUSTON)

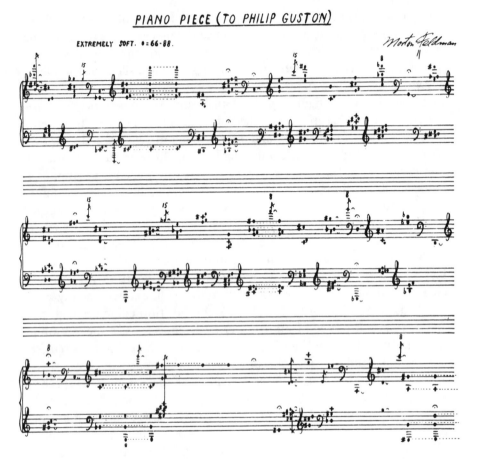

Figure 7.4 Piano Piece (to Philip Guston), first three braces of score. © 1963. Used by permission of C. F. Peters Corporation.

Feldman's remarks, quoted earlier, concerning "the ephemeral feel of the pencil in my hand" give some indication of how important touch was; for him, it was the quality that embodied individuality. Feldman once asked himself, "To what degree does one give up control, and still keep that last vestige where one can call the work *one's* own?" Touch is "that last vestige": the vestige that Mondrian, in Feldman's anecdote, discovered he couldn't preserve if he tried spray painting the solid color areas of his paintings instead of using a brush.[129] This was because, in Feldman's view, Mondrian's act of hiding the brushstroke in these ostensibly uniform areas "only revealed even more clearly the touch, the pressure, the unique tone of his performance." The results put the viewer in that space between surface and

depth: "[Mondrian's] paintings seem to be painted from afar, but must be looked at so closely as not to see the edge of the canvas."[130] It is tempting to speculate that touch in this sense must also have affected de Kooning and Guston, who so greatly admired Mondrian, in similar ways.[131]

What was touch to Guston, as far as Feldman was concerned, and how does it come out in the *Piano Piece*? Dore Ashton has noticed how Guston's and Feldman's work exerted a mutual influence as their friendship deepened: the "pale, trembling calligraphy" of Guston's drawings and paintings in the early 1950s had an affinity to "Feldman's delicate, sparse compositions that often receded almost to inaudibility," an affinity that both composer and artist noticed.[132] As the 1950s advanced and gave way to the 1960s, both underwent changes in style: Guston to the "heavier, blockier" look noted earlier, Feldman away from an aleatory and toward a more "controlled" stance, at least with regard to pitch. Yet the essential aspects of their work that drew them to one another in the first place remained intact, at least for the time being. One incident, related by Feldman in 1971 some indefinite number of years after it happened, shows Guston at work in a way that seems to have struck Feldman particularly keenly. Napping in Guston's studio, waiting for him to finish working so that they could go out to dinner, Feldman suddenly awoke. As Feldman relates the story, Guston "was still painting, standing almost on top of the canvas, lost in it, too close to really see it, his only reality the innate feel of the material he was using. As I awoke he made a stroke on the canvas, then turned to me, confused, almost laughing because he was confused, and said with a certain humorous helplessness, 'Where is it?' "[133] Feldman's sudden stirring startled Guston, momentarily disorienting him and causing him to lose his place: that is, lose touch with the act of painting. What impressed Feldman at that moment was the realization that touch, at least at that point in Guston's working process, was everything—much more important than being able actually to see what he was doing.[134]

This anecdote also suggests that a slight hesitancy or tentativeness may be bound up with the quality of touch.[135] There is something of that in the *Piano Piece*, with its progress in fits and starts, its constant shifts of register, its isolated articulations of the highest registers via slow grace notes,[136] and the irregular occurrences of sustained chords and fermatas (the latter applied either to sounding single pitches or chords, or to silence). These characteristics could be said to involve touch, too, but even more telling from the point of view of touch are the chord spacings at the keyboard, for each hand and for the two hands together. They are greatly variegated; there is no "normative" spacing of any kind. Every brushstroke, so to

speak, is different—and all the more noticeably so because the pressure of application is always the same: no dynamic variation, no differences of attack. Thus, the effect of this piece is very far from static, although there is certainly nothing overtly patterned about its progress. The more frequent recourse to sustained tones and the first silent fermata that arrive on the third brace do serve as harbingers for the rest of the work: these devices are used more and more often from this point on. The resulting increase in spareness of sound could conceivably be taken in analogy to Guston's method of painting, with less and less being added as the painting comes to completion.

The next work of Feldman's to bear a painter's name is the well-known *Rothko Chapel* (1971), commissioned as a memorial to Rothko, who had committed suicide the previous year, and also composed with the paintings and architectual design of the Rothko Chapel in Houston, Rothko's last project, explicitly in mind. Among Feldman's oeuvre, this work is unique—not only in its relationship to a definite group of paintings housed permanently in a space for which they were created by the artist, but also in its autobiographical aspect, which comments obliquely on certain parallels between Feldman's life and Rothko's.

Rothko Chapel has already received considerable—and very perceptive—critical attention from the point of view of its painterly connections,[137] so I will pass over it here except to comment on one particular autobiographical feature that bears some indirect significance for Feldman's other "painter pieces." This is the viola melody that is heard near the end, which at its premiere must have come as a considerable surprise if not indeed a shock to those who knew Feldman's previous work. The melody, very simply composed in a synagogue-like style and certainly quite tonal (or modal), was in fact written by Feldman when he was fourteen years old. Commenting on this usage in a 1980 interview, Feldman said that he did this because he "was thinking of Bob Rauschenberg's photo montages. At that time I would use a tune just the way Bob would put a photo on the canvas. But I now feel that in music it doesn't work the same way."[138] We recall, in this connection, Feldman's remarks (quoted earlier) about Rauschenberg's work being "neither life nor art, but something in between." There seem to me to be two issues worth our attention here. Although Feldman has certainly not repudiated *Rothko Chapel* (or any of the relatively few other pieces in which he used such "collaging" techniques, such as *The Viola in My Life*), he has admitted that some analogies one might propose between music and painting are, effectively, false. The other interesting issue is raised by Feldman's use of a technique

associated with the work of one artist (Rauschenberg) in a piece dedicated to the memory of another (Rothko). That Feldman has done this here suggests in turn that he may have done something similar in other works, such as his other works named after painters. Feldman intended in these works not to make exclusively specific allusions to the work of the painter named in the title,[139] but a kind of generalized application of painterly technique that drew upon the many lessons he had learned from observing and talking to his friends in the New York School.

To a certain extent, this latter issue seems relevant to the last of Feldman's painter pieces, *For Philip Guston* (1984). Written some four years after Guston's death, it evidently cannot be considered a memorial in the same explicit sense as *Rothko Chapel*, although it is not reading too much into it, I think, to detect elegaic overtones at certain points. *For Philip Guston* is a product of Feldman's so-called late style, which developed over the course of the 1970s and had already emerged full-blown in works such as the *String Quartet* (1979). This late style is characterized not only by the precise notation, in a more or less conventional sense, that Feldman had finally settled upon by the early 1970s—though with an interesting twist in the case of this Guston piece, to be discussed—but also by much longer duration: the *String Quartet* takes some three hours to play, *For Philip Guston* over four.

Feldman was often asked about these changes; he was willing enough to talk about them, to all appearances, and he readily admitted that certain new influences had come into his life, notably the paintings of Jasper Johns and the handmade rugs from the nomads of Turkey and Central Asia. Perhaps these outward developments impelled him to compare his "change of style" (if that's what it was) to Guston's of approximately the same time. In the late 1960s Guston suddenly—so it appeared to outside observers—stopped working in his well-established abstract style and switched to the overtly representational, quasi-cartoonish look to which he adhered for the rest of his life. The change distanced him from many among his circle to whom he had previously been close, Feldman among them. "I don't see Guston any more, things kind of cooled off," said Feldman in 1976; and from the further details he divulges we can see that Feldman's initial lack of enthusiasm for Guston's new style may have begun the process of estrangement.[140] Though Feldman did eventually come to accept this new work from his old friend, evidently he was never able to see in it much of a connection with the painter he thought he had known. Writing just after Guston's death for an exhibition of some of the last works Guston finished, Feldman asserted, "There is no attempt in these

late paintings towards any aspect of reconciliation with his past concerns. It was a new life, in which his past *skills* helped him survive on the new ground he immigrated to."[141]

This distancing is all the more interesting because Feldman was certainly in a position to understand, at least on an intellectual level and maybe on a certain visceral level as well, why Guston might have felt compelled to change in the way he had done. The nomadic rugs were a vehicle for this understanding: Guston's late work, Feldman said, exhilarates by its not feeling copied by others, "like an isolated rug culture at its most unbridled peak of development."[142] He was aware, too, of Guston's periodic attempts to ignore his gift and to paint in a deliberately "ungifted" way; and he must have heard Guston on more than one occasion imagine "what it would be like to paint as if there had never been any painting before" and declare that painting "means to divest myself continuously of what I already know."[143] Did Feldman have similar feelings about his own late work?

The possibility of a comparison between Guston's situation and his own might at least have been on Feldman's mind as he undertook *For Philip Guston*, although for the most part he seemed to feel that he was still the same composer he had always been. With regard to the greatly increased length of his pieces, Feldman voiced somewhat different claims on different occasions. In 1984 he stated, in a manner that sounds intentionally flippant, that in writing longer pieces he was simply doing what he previously had had neither the time nor the money for but now did, as if to imply that his music would always have been of the same durational scale had economic circumstances permitted.[144] Four years earlier, he gave a more serious response, pointing out that "the fact that I have more time to compose now means that I'm asking myself different questions," and also hazarding the opinion that the longer pieces were a move away from writing pieces well suited to performance: "Psychologically it's not geared for performance."[145]

Surely, however, Feldman did not actually want to discourage performances of his own work. A more plausible explanation might involve a deliberate attempt on his part to effect a radical change in the performance situation. "Not geared for performance" could mean "not geared for conventional concert programming": works of this sort make special demands upon performers' concentration and endurance, and could be said to neutralize, over time, certain expectations that one might have of Feldman's chosen instrumental combinations at the outset. Faced, as one is in *For Philip Guston*, with a flutist doubling on piccolo and alto flute, a

mallet percussionist doubling on vibraphone, glockenspiel, chimes, and marimba, and a pianist doubling on celesta, one might find the ensemble at first simply strange, an indulgence in timbral exoticism. By the end of the work, it no longer seems strange at all; it has become integral to the music written for it and thereby, in a sense, neutralized. Thus these longer pieces, which as noted earlier enabled Feldman to realize certain durational analogies that he felt could exist between painting and music, also enabled him to pursue his quest for "the sounds of the sounds themselves," as the title of a recent article has so memorably put it: sounds uncontaminated by orchestration.[146]

As far as notation is concerned, not only had Feldman begun his career (not surprisingly) composing in traditionally precise notation, but he had periodically reverted to it throughout the 1950s and 1960s without definitively abandoning the graph or his other less approximate but still quite imprecise types of notation until about 1969. And even after that point, Feldman adopted other stratagems designed subtly to subvert the ostensible exactitude of conventional notation, or at least knock it a little off center. Thus there was never a clean break. "Precise notation is *my* handwriting," Feldman said in 1980; further, "notation, at least for me, determines the style of the piece"[147]—this, as mentioned, in part because of visual appearance. Yet the reason for greater precision could be different in every work, and, in any case, there was no need to strive for absolute precision; Feldman spoke of the notation in *Why Patterns?* for instance, as "very close, but never precisely synchronized."[148]

By the 1980s it was clear that one reason for using a more precise notation was Feldman's growing interest in working with explicit patterns. The influence of nomadic rugs and the paintings of Johns was certainly one factor that pulled Feldman in the direction of patterns, as Steven Johnson has outlined using some fascinating specific examples.[149] But finding an appropriate notation for these patterns proved a more daunting task than might have been anticipated: "The patterns that interest me," said Feldman in a key essay on this subject, "are both concrete and ephemeral, making notation difficult. If notated exactly, they are too stiff; if given the slightest notational leeway, they are too loose. Though these patterns exist in rhythmic shapes articulated by instrumental sounds, they are also in part *notational images* that do not make a direct impact on the ear as we listen. A tumbling of sorts happens in midair between their translation from the page and their execution."[150]

One of the strategies Feldman hit upon for maintaining this difficult balance between "stiff" and "loose" can be observed at work in the open-

ing bars of *For Philip Guston,* displayed in figure 7.5. Here, only the bar-
lines that are drawn continuously through the entire brace reflect exact
coordination of attacks. The others look at first as though they should
align too, but that alignment is only approximate: in the first four bars, for
example, the sequence of time signatures is different for every part.[151] To
make things even more challenging, the durational values specified by
these signatures—3/8, 3/32, 3/16, and 1/4—cannot easily be counted, or
effectively counted at all, in a common unit. Nor, it is clear from the style
of notation chosen, is there any expectation that the performers will try to
count these signatures in a common unit as they unfold simultaneously.
The resulting aural image is a repeated series of four pitches in unison that
is, indeed, not precisely synchronized—that in fact achieves its only true
synchrony during the vacant bars 5, 10, 15, and so on, where the signatures
3/2, 7/4, 4/2, and the like do match up. This circumstance draws the ear's
attention in a particularly striking way to the *decay* of these sounds, as if
they were being revealed in their true identity only by dying away (recall
my previous remarks in the section on attack/decay).

Contemplating the blurriness of image yielded by this notational tech-
nique, we recognize its kinship to the effect of some of Feldman's earlier
notations, particularly the type employed in *For Franz Kline.* The differ-
ence is that, in the later work, the individual parts are under considerably
tighter rein; the composer need not simply trust the performers to avoid
letting any part(s) get "too far" out of coordination with the others—a
trust that often turns out to be misplaced, as it is in both recordings of *For
Franz Kline* that I have heard. However, in both works the interest in
avoiding rigidly defined edges is clearly evident, and from a visual stand-
point is highly reminiscent of the blurred, slightly irregular boundaries of
shapes that result from painting on unprimed canvas, staining it directly
in a manner particularly familiar from the work of Kline and Rothko. As
the music continues on this opening page of the piece, the blurriness of
the repeated, unsynchronized series of pitch unisons becomes more pro-
nounced: first, the piano falls behind, losing its A♭ and E♭ in the process;
then the piano is replaced by celesta an octave lower, at the same time that
the flute is transposed down an octave and a tritone. By page 2 of the score
(not shown in the example), only a vestige of the original material is evi-
dent, and only in the keyboard part. Soon thereafter, it disappears com-
pletely, to resurface periodically throughout the work; its next appearance
is on page 5 (see figure 7.6), where it constitutes the texture almost poly-
phonically, in noncongruent rhythms in simultaneous time signatures and
at several different pitch levels among the three parts. By this time we have,

FOR PHILIP GUSTON

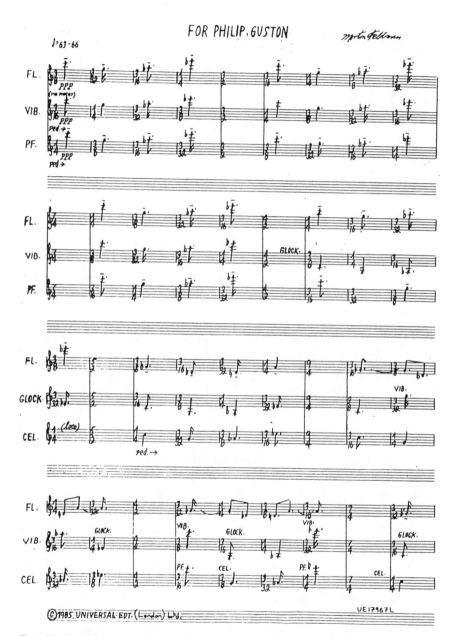

Figure 7.5 *For Philip Guston*, by Morton Feldman, first page of score. © 1984 Universal Edition (London) Ltd., London. All rights reserved. Used by permission of European American Music Distributors, LLC, Sole U.S. and Canadian agent for Universal Edition (London) Ltd., London.

Figure 7.6 For Philip Guston, excerpt from page 5 of
score. © 1984 Universal Edition (London) Ltd., London. All rights
reserved. Used by permission of European American Music Distributors, LLC,
Sole U.S. and Canadian agent for Universal Edition (London) Ltd., London.

not blurriness, but a kind of replication of forms. This condition reminds me most vividly of Guston's evocation of *time* in his painting: not only his reminder that time is the sole available vehicle for continuous creation, but, further, his definition of painting itself as, perhaps, "a kind of mirror reflecting a family of forms. . . . The mirror mirrors change, then, or rather the promise of change."[152]

As a short and undoubtedly inadequate coda to all that has preceded, it would be worth reflecting on the fact that just as Feldman spent his compositional career attempting to situate his music "between categories" in many different senses, so did he spend most of his mature artistic life, by his own testimony, situated between two very strong personalities: John Cage on one side, Philip Guston on the other. As noted earlier, Cage had opened many doors for Feldman, as he had for countless others, simply by proposing that music could be an *art* form instead of exclusively a form of itself, a self-referential activity and nothing more. For that he earned Feldman's undying gratitude; at the same time, Feldman also thought that Cage, in asserting that "everything is music," had effectively given up art in order to adopt a social point of view toward it. Guston, by complete contrast, was "the arch-crank," of whom Feldman observed, "Very little pleased him. Very little satisfied him. Very little was art." At times Feldman must have felt exasperated by Guston's relentless good taste, even as he

recognized that his own painstakingly discriminating ears often caused him analogous problems.[153]

Yet there is no particularly good reason to think that Feldman, in occupying this position between Cage and Guston, was merely passively "influenced" by them. For in a certain sense, he had put himself there, just as he had maneuvered his music into that space between categories. For decades we have been accustomed to hearing of the New York composers' avant-garde of the 1950s as "John Cage and . . . ," with Feldman, Earle Brown, and Christian Wolff in supporting roles—but this is only part of the story. While Cage did introduce Feldman to the world of abstract expressionism and tutored him in his interaction with it, Feldman for his part may have been more of an influence on Cage as a composer than the other way around.[154] As for Guston, it should be clear enough, from the evidence presented here, that he played a uniquely significant role in the formation of Feldman's strikingly original approach to musical composition. But there is more to their relationship than that. One of Guston's more perceptive critics, Dore Ashton, does more than hint that Feldman made a mark on Guston's development, with the composer's "addiction to the 'absolute'" in the "grand modern tradition of quintessentiality" and the way his employment of aleatory struck Guston with its "attenuated forms" and "flirtation with the void."[155] Guston, then, is "Feldman's painter" not only in the sense that Feldman was drawn to him, not only in that he once painted Feldman's portrait. If Guston was in turn influenced by Feldman, were Rothko, Kline, or others similarly affected? Perhaps there are other stories of mutual influence, to date unacknowledged and undocumented, still waiting to be told.

Notes

1. It is worth mentioning, however, that some previously published analytical work on Feldman's music may well be informed by knowledge of such an aesthetic basis, even if it is not explicitly discussed. See, in particular, Thomas DeLio, *Circumscribing the Open Universe* (Lanham, Md.: University Press of America, 1984); Thomas DeLio, ed., *The Music of Morton Feldman* (Westport, Conn.: Greenwood Press, 1996).

2. Dore Ashton, *The New York School: A Cultural Reckoning* (1973; reprint, Berkeley and Los Angeles: University of California Press, 1992), 163.

3. Ibid., 174–75.

4. Ibid., 176.

5. Robert Motherwell, "The New York School" (1950), in *The Collected Writings of Robert Motherwell*, ed. Stephanie Terenzio (New York and Oxford: Oxford University Press, 1992), 78.

6. Ibid., 79.

7. Clement Greenberg, "After Abstract Expressionism" (1962), in *The Collected Essays and Criticism*, vol. 4: *Modernism with a Vengeance, 1957–69*, ed. John O'Brian (Chicago: University of Chicago Press, 1993), 123.

8. Arthur C. Danto, "The Abstract Expressionist Coca-Cola Bottle," in *Beyond the Brillo Box* (New York: Farrar, Straus and Giroux, 1992), 138.

9. Harold Rosenberg, "The American Action Painters," in *The Tradition of the New* (1960; reprint, New York: Da Capo, 1994), 25.

10. Ibid., 26–27.

11. Barbara Rose, "The Myth of Pollock and the Failure of Criticism," in *Autocritique: Essays on Art and Anti-Art, 1963–1987* (New York: Weidenfeld and Nicolson, 1988), 245–52. Actually, as it happened, Rosenberg apparently was thinking of de Kooning, not Pollock, when he coined the term.

12. Morton Feldman, "Crippled Symmetry" (1981), in *Morton Feldman Essays*, ed. Walter Zimmermann (Kerpen, West Germany: Beginner Press, 1985), 134–35.

13. Thomas Moore, "We Must Pursue Anxiety: An Interview with Morton Feldman" (1983), *Sonus* 4, no. 2 (spring 1984): 18.

14. Paul Griffiths, "Morton Feldman" (interview), *Musical Times* 1554, no. 113 (August 1972): 758.

15. Morton Feldman, "The Anxiety of Art" (1973), in Zimmermann, ed., *Morton Feldman Essays*, 92–93.

16. Morton Feldman in conversation, quoted in Ashton, *The New York School*, 2–3.

17. Morton Feldman, "An Interview with Robert Ashley, August 1964," in *Contemporary Composers on Contemporary Music*, ed. Elliott Schwartz and Barney Childs (New York: Holt, Rinehart and Winston, 1967), 365.

18. Peter Gena, "H.C.E. (Here Comes Everybody): Morton Feldman in Conversation," *Tri-Quarterly* 54 (spring 1982): 122.

19. Moore, "We Must Pursue Anxiety," 14–15. Feldman may have been recalling one of the "Artists' Sessions at Studio 35," which appeared in transcription, edited by Robert Goodnough, in *Modern Artists in America*, 1st series (1949/50), ed. Bernard Karpel, Robert Motherwell, and Ad Reinhardt (New York: Wittenborn Schultz, 1951), 9–22. At the first of these sessions (April 21, 1950), the question for discussion, set forth by Motherwell in his role as one of the moderators, was "How do you know when a work is finished?" (10–13). Answers from over twenty artists present were recorded.

20. Rosenberg, "The American Action Painters," 30.

21. Gena, "H.C.E.," 124; Feldman, "Give My Regards to Eighth Street" (1968), in Zimmermann, ed., *Morton Feldman Essays*, 77.

22. Morton Feldman, "After Modernism" (1971), in Zimmermann, ed., *Morton Feldman Essays*, 99; Feldman, "An Interview with Robert Ashley," 365.

23. Morton Feldman, "Predeterminate/Indeterminate" (1966), in Zimmermann, ed., *Morton Feldman Essays*, 47.

24. Morton Feldman, "Boola Boola" (1967), in Zimmermann, ed., *Morton Feldman Essays*, 50.

25. Morton Feldman, "Autobiography" (1962), in Zimmermann, ed., *Morton Feldman Essays*, 38.

26. Morton Feldman, "Some Elementary Questions" (1967), in Zimmermann, ed., *Morton Feldman Essays*, 68; Feldman, "The Anxiety of Art," 90.

27. Griffiths, "Morton Feldman," 758; Feldman, "The Anxiety of Art," 90.

28. Gavin Bryars and Fred Orton, "Morton Feldman: Interview," *Studio International* 192, no. 984 (November–December 1976): 245.

29. Willem de Kooning, "What Abstract Art Means to Me" (1951), in *Theories of Modern Art: A Source Book by Artists and Critics*, ed. Herschel B. Chipp (Berkeley and Los Angeles: University of California Press, 1968), 560.

30. Morton Feldman, "Between Categories" (1969), *Contemporary Music Review* 2, no. 2 (1988): 5.

31. Ashton, *The New York School*, 178, 181. Also note Rothko's characterization of *shapes* in painting: "They are unique elements in a unique situation." Mark Rothko, "The Romantics Were Prompted" (1947), in Chipp, ed., *Theories of Modern Art*, 549.

32. Feldman, "Between Categories," 2.

33. Feldman, "Crippled Symmetry," 135–36.

34. Feldman, "XXX Anecdotes and Drawings" (1984), in Zimmermann, ed., *Morton Feldman Essays*, 168.

35. Ibid., 162.

36. Feldman, "Crippled Symmetry," 127.

37. Ibid., 137.

38. Feldman, "Autobiography," 39.

39. Feldman, "XXX Anecdotes and Drawings," 169, 178.

40. Feldman, "Crippled Symmetry," 128. Feldman has also used *abrash* to explain his way of working with the "imperfections" of intonation between percussion and the other instruments in pieces like *Instruments III* and *Why Patterns?* See Jan Williams, "An Interview with Morton Feldman," *Percussive Notes Research Edition* 21, no. 6 (September 1983): 9–10.

41. Feldman, "Crippled Symmetry," 130.

42. Feldman, "The Anxiety of Art," 89.

43. John Cage and Morton Feldman, *Radio Happenings I–V*, recorded at WBAI, New York City, July 1966–January 1967 (Cologne: Musik Texte, 1993), 147.

44. Feldman, "The Anxiety of Art," 89.

45. Griffiths, "Morton Feldman," 758.

46. Bryars and Orton, "Morton Feldman," 245.

47. Morton Feldman, "Philip Guston: The Last Painter," *Art News Annual 1966* (winter 1965): 100.

48. Feldman, "Between Categories," 3–4.

49. Ibid., 4; also cited in Dore Ashton, *About Rothko* (1983; reprint, New York: Da Capo, 1996), 185.

50. Bunita Marcus and Francesco Pellizzi [with the participation of John Cage], "Conversation with Morton Feldman," *Res* 6 (fall 1983): 118 (first ellipsis in original).

51. "Conversation between Morton Feldman and Walter Zimmermann," in Zimmermann, ed. *Morton Feldman Essays*, 230–31.

52. Cole Gagne and Tracy Caras, "Morton Feldman," in *Soundpieces: Interviews with American Composers* (Metuchen, N.J.: Scarecrow Press, 1982), 172.

53. Stuart Morgan, "Pie-Slicing and Small Moves: Morton Feldman in Conversation," *Artscribe* 11 (April 1978): 35.

54. Mark Rothko, "Statement" (1951), in *Abstract Expressionism: Creators and Critics*, ed. Clifford Ross (New York: Abrams, 1990), 173.

55. Franz Kline interviewed in Katharine Kuh, *The Artist's Voice: Talks with Seventeen Artists* (New York: Harper and Row, 1962), 152.

56. Albert Boime, "Franz Kline and the Figurative Tradition," in *Franz Kline: The Early Works as Signals*, ed. Fred Mitchell (Binghamton, N.Y.: University Art Gallery, State University of New York, 1997), 18.

57. Griffiths, "Morton Feldman," 758.

58. Cage and Feldman, *Radio Happenings*, 107.

59. Ibid., 109.

60. Griffiths, "Morton Feldman," 758; Marcus and Pellizzi, "Conversation with Morton Feldman," 128; Feldman, "A Compositional Problem" (1972), in Zimmermann, ed. *Morton Feldman Essays*, 114.

61. Feldman, "A Compositional Problem," 114.

62. Mark Rothko, quoted in Selden Rodman, *Conversations with Artists* (New York: Devin-Adair, 1957), 93.

63. Feldman, "A Compositional Problem," 114.

64. David Sylvester, "Interview with Franz Kline" (1963), in *Readings in American Art since 1900: A Documentary Survey*, ed. Barbara Rose (New York: Praeger, 1968), 155.

65. "A Conversation between Philip Guston and Joseph Ablow" (1966), in Kim Sichel and Mary Drach McInnes, *Philip Guston, 1975–1980: Private and Public Battles* (Seattle: University of Washington Press, 1994), 38. Guston has reported that as his work became "blockier and heavier" in the late 1950s, and as the delicate pastel hues of earlier in the decade began to disappear, Cage became "very upset" and asked him, "How could you leave that beautiful land?" Guston's somewhat bemused response was, "I agreed with him. I mean, it was a beautiful land—but I left it. I don't think about beauty, anyway, I don't know what the word is." "Recent Paintings by Philip Guston" (1974), in Harold Rosenberg, *The Case of the Baffled Radical* (Chicago: University of Chicago Press, 1985), 184–85.

66. Morton Feldman, "Essay," in *Philip Guston: 1980 / The Last Works* (Washington, D.C.: Phillips Collection, 1981), 6.

67. See Peter Dickinson, "Feldman Explains Himself," *Music and Musicians* 14, no. 11 (July 1966): 22.

68. Griffiths, "Morton Feldman," 758–59.

69. Feldman, "Essay," 6.

70. Greenberg, "After Abstract Expressionism," 124.

71. Some observers thought that Kline was alluding to iron bridgework in some of his black-and-white paintings of the early to mid-1950s, but he usually denied this.

72. Dora Ashton, *Willem de Kooning* (Northampton, Mass.: Smith College Museum of Art, 1965), [5, 8].

73. Thomas B. Hess, *Willem de Kooning* (New York: Museum of Modern Art, 1968), 47.

74. Feldman, "XXX Anecdotes and Drawings," 148.

75. Kuh, *The Artist's Voice*, 144; David Anfam, "Kline's Colliding Syntax: Black, White, and 'Things,'" in *Franz Kline: Black and White, 1950–1961* (Houston: Houston Fine Art Press, 1994), 19.

76. "Conversation between Morton Feldman and Walter Zimmermann," 232.

77. Anfam, "Kline's Colliding Syntax," 9.

78. Feldman, "XXX Anecdotes and Drawings," 148; Marcus and Pellizzi, "Conversation with Morton Feldman," 128.

79. Feldman, "Crippled Symmetry," 137; "After Modernism," 102.

80. Feldman, "XXX Anecdotes and Drawings," 163.

81. Feldman, "Between Categories," 2.

82. Feldman, "After Modernism," 106.

83. Feldman, "Essay," 5; Cage and Feldman, *Radio Happenings*, 135. Recall also Feldman's observation of the paintings on display in a warehouse "engulfing the room" (p. 180).

84. Feldman, "Philip Guston: The Last Painter," 100.

85. Feldman, "After Modernism," 104. Feldman referred on numerous occasions to the Abstract Experience, defining it once as "that other place that's not an allegory. Rothko had it. It's that other place that's not a metaphor of something else." (Bryars and Orton, "Morton Feldman," 246.)

86. Feldman, "Essay," 5.

87. Guston, "Statement" (1956), in *12 Americans*, ed. Dorothy C. Miller (New York: Museum of Modern Art, 1956), 36.

88. William Berkson, "Dialogue with Philip Guston 11/1/64," *Art and Literature* 7 (winter 1965): 65.

89. "A Conversation between Philip Guston and Joseph Ablow," 31.

90. "Philip Guston's Object: A Dialogue with Harold Rosenberg," in *Philip Guston: Recent Paintings and Drawings* (New York: The Jewish Museum, 1966), unpag. Critics have noted the "hovering" effect in the work of other abstract expressionists, particularly in Rothko. See Anna C. Chave, *Mark Rothko: Subjects in Abstraction* (New Haven: Yale University Press, 1989), 184.

91. Feldman, "After Modernism," 107.

92. See, for example, "A Conversation between Philip Guston and Joseph Ablow," 32.

93. Feldman, "Give My Regards to Eighth Street," 78.

94. Morgan, "Pie-Slicing and Small Moves," 36.

95. Feldman, "XXX Anecdotes and Drawings," 168.

96. See also "A Conversation between Philip Guston and Joseph Ablow," 32–33.

97. Feldman, "XXX Anecdotes and Drawings," 160.

98. Feldman, "Darmstadt Lecture," 203.

99. Orton and Bryars, "Morton Feldman," 248.

100. Philip Guston, "Faith, Hope, and Impossibility" (1966), in Ross, ed., *Abstract Expressionism: Creators and Critics*, 63.

101. Berkson, "Dialogue with Philip Guston," 65.

102. "A Conversation between Philip Guston and Joseph Ablow," 31.

103. Rosenberg, "Recent Paintings by Philip Guston," 186.

104. Bryars and Orton, "Morton Feldman," 247.

105. Guston, "Philip Guston Talking" (lecture, University of Minnesota, March 1978), in *Philip Guston: The Late Works* (Melbourne: Centre for Contemporary Art, 1984), 54.

106. Feldman, "XXX Anecdotes and Drawings," 168.

107. Marcus and Pellizzi, "Conversation with Morton Feldman," 129.

108. Ibid., 125.

109. Ibid., 122.

110. See Feldman, "XXX Anecdotes and Drawings," 165; Williams, "An Interview with Morton Feldman," 9.

111. Feldman, "The Anxiety of Art," 94.

112. Feldman, "Crippled Symmetry," 133, 134.

113. Feldman, "Autobiography," 38.

114. Griffiths, "Morton Feldman," 758.

115. Feldman, "Crippled Symmetry," 137.

116. Morton Feldman, quoted in Olivia Mattis, "Morton Feldman: Music for the Film *Jackson Pollock* (1951)," in *Settling New Scores: Music Manuscripts from the Paul Sacher Foundation*, ed. Felix Meyer (Mainz: Schott, 1998), 165–67. See this article for further details about Feldman's unpublished score.

117. Bryars and Orton, "Morton Feldman," 245.

118. Morton Feldman, preface to *Marginal Intersection*, score (New York: C. F. Peters, 1962).

119. Jackson Pollock, "My Painting" (1947), excerpt in Chipp, ed., *Theories of Modern Art*, 546–48.

120. Gagne and Caras, "Morton Feldman," 169.

121. Gena, "H.C.E.," 131; Gagne and Caras, "Morton Feldman," 170.

122. Gena, "H.C.E.," 130.

123. Feldman, "Autobiography," 39.

124. Feldman, "A Compositional Problem," 114.

125. As Feldman noted, it was true to varying degrees in much of the work of the New York School in the 1950s for drawings to have the look of paintings, paintings to have the feel of drawings—qualities that he noted particularly in Guston's case. (Feldman, "Give My Regards to Eighth Street," 76.) This would seem to be yet another manifestation of inbetweenness.

126. Hess, *Willem de Kooning*, 102–3.

127. De Kooning, "Content is a glimpse . . ." (excerpts from an interview by David Sylvester), *Location* 1, no. 1 (spring 1963): 47; de Kooning quoted in Thomas B. Hess, *De Kooning: Recent Paintings* (New York: Walker, 1967), 9.

128. Bryars and Orton, "Morton Feldman," 245.

129. Feldman, "The Anxiety of Art," 94.

130. Feldman, "After Modernism," 102.

131. What Feldman treasured most about Mondrian, perhaps, is that his work embodied this quality of touch in nonobvious ways. The comment about his hiding the brushstroke supports this hypothesis, as does his comment, in an interview, that his music, in being really not as beautiful as it might at first strike the listener, was like Mondrian's paintings, because "if you look at them from a distance they look so clean, and when you get near, the black is smeared into the white, you know." Feldman explicitly excluded the late "Boogie-Woogie" paintings, in which Mondrian used masking tape to keep his lines perfectly clean, from this comparison. (Marcus and Pellizzi, "Conversation with Morton Feldman," 134.)

132. Ashton, *A Critical Study of Philip Guston*, 94.

133. Feldman, "After Modernism," 104.

134. Guston recalled the "desire for direct expression" that suddenly gave birth to his first mature style, in about 1951, when he forced himself to paint an entire picture in an hour without once stepping back to look at its progress. This is what Feldman would have called his leap into the Abstract Experience. (Guston quoted in Irving Sandler, *The Triumph of American Painting: A History of Abstract Expressionism* [New York: Praeger, 1970], 264.)

135. Some critics, such as Sandler, certainly thought so; see *The Triumph of American Painting*, 258.

136. Feldman supplies no performing instructions in this score, but we can probably assume that the grace notes, as in his other scores of this period that make use of them, are meant to be played "slow," i.e. slightly faster than the unadorned solid noteheads that

respect the indicated metronomic range. Likewise, we can assume that entrances are to be made with the minimum of attack, as gently as possible.

137. See, in particular, Steven Johnson, "*Rothko Chapel* and Rothko's Chapel," *Perspectives of New Music* 32, no. 2 (summer 1994): 6–53.

138. Gagne and Caras, "Morton Feldman," 170.

139. Something which, in any case, he has denied doing, in the way he did it in *Rothko Chapel*, in any other piece; see Bryars and Orton, "Morton Feldman," 244.

140. Ibid., 245.

141. Feldman, "Essay," 8. One of the more interesting ironies of Feldman's difficulty with Guston's late work is that Guston's portrait of Feldman, *Friend—To M. F.* (1978), dates from this period. And although it is quite obviously representational and "looks like" Feldman in a most remarkable way—unimaginable if one has never seen it—this is not its only aspect, or perhaps even its most important aspect, as one critic observes: "What at first seems like a burgher-definite image astonishingly changes into what is perhaps the most purely abstract picture Guston ever produced." Ross Feld, "Philip Guston," in *Philip Guston* (New York: George Braziller / San Francisco: San Francisco Museum of Modern Art, 1980), 32.

142. Feldman, "Essay," 7.

143. Marcus and Pellizzi, "Conversation with Morton Feldman," 127; Rosenberg, "Recent Paintings by Philip Guston," 187–88.

144. Feldman, "Darmstadt Lecture," 198.

145. Gagne and Caras, "Morton Feldman," 171.

146. See Catherine Costello Hirata, "The Sounds of the Sounds Themselves: Analyzing the Early Music of Morton Feldman," *Perspectives of New Music* 34, no. 1 (winter 1996): 6–27, for an interesting discussion of this issue.

147. Gagne and Caras, "Morton Feldman," 169.

148. Feldman, "Crippled Symmetry," 129.

149. Steven Johnson, "Abstract Expressionist Content and Minimalist Pattern in Morton Feldman's Late Music," paper delivered at the annual meetings of the American Musicological Society and the Society for Music Theory, New York City, November 1995.

150. Feldman, "Crippled Symmetry," 132.

151. There is some resemblance here in these opening bars to the permutational patterning noted by Johnson in *Why Patterns?* ("Abstract Expressionist Content and Minimalist Pattern") and by Feldman himself in his *String Quartet* ("Crippled Symmetry," 130). In *For Philip Guston*, however, the permuted cells (or "modules," as Feldman might call them) are not in themselves distinctive from one another, either in rhythm or in pitch; nor do they follow any obviously "crisscrossing" or diagonal patterns. In general, as a tentative judgment one could say that the Guston piece exhibits less strongly the particular kinds of patterned behavior that in other works of Feldman's from this time suggest analogies to nomadic rugs and the patterned works of Johns.

152. Guston, "Philip Guston Talking," 54.

153. Feldman, "Give My Regards to Eighth Street," 76; Marcus and Pellizzi, "Conversation with Morton Feldman," 125.

154. Feldman, in fact, makes just this claim in his interview with Griffiths ("Morton Feldman," 758).

155. Ashton, *A Critical Study of Philip Guston*, 94, 160.

[8]

Jasper Johns and Morton Feldman

What Patterns?

Steven Johnson

n a short story by John Updike there is a character named Frank who owns a small art gallery in New York City. At one point in the story, Frank, conversing with a young painter, dismisses with curmudgeonly impatience the great tradition of midcentury American abstraction: "All that abstract-expressionist fuss about *paint*," he says. "A person looking at a Rembrandt knows he's looking at *paint*. The question is, What *else* is he looking at?"[1] Updike's fictional character represents many in our world who regard abstract art with suspicion or even disdain. Frank would probably reject the claim made by so many art-historical commentators that abstract expressionist paintings were *about* something. Painters such as Jackson Pollock, Mark Rothko, Robert Motherwell, and many others steadfastly insisted that their work contained subject matter, and a mass of critical and historical commentary over several decades has backed them up.

It's hardly surprising that the music of Morton Feldman has provoked similar responses, because he derived his core aesthetic from the same group of painters that bothered Updike's fictional Frank so much. In Feldman's case, however, music historians have been much slower than their art-historical counterparts to adjust their thinking. Paul Griffiths, for example, once described Feldman's music as "purposeless."[2] Jonathan Kramer has written that Feldman's aesthetic "had nothing to do with teleology;" he "simply put down one beautiful sound after another."[3] Comments such as these imply that Feldman's music was "just so much fuss about sound." In this case, however, Feldman himself must bear much of the blame for these attitudes. It was he, after all, who credited the painters with teaching him how to escape from compositional rhetoric; and it was he who claimed, with a characteristically polemical tone, that cubism and serialism were the last organizing ideas in art, "thank Heaven!"[4]

But Feldman was far less committed to "purposelessness" and chance than many think, and he said as much. Once, referring to the principle of indeterminacy, he told John Cage: "John, the difference between you and me is, that I opened up a window and caught a cold, and you opened up the door and got pneumonia."[5] The evolution of Feldman's style, in fact, reveals his *un*willingness to forsake the traditional role of the composer who organizes sound in a purposeful manner, who "has *something* to say and says it," to twist Cage's famous remark. During the course of the 1950s and 1960s, Feldman turned steadily toward more fixed notational methods, even though the character of his music remained fairly consistent. Then, beginning in the late 1970s, the music *itself* began to change, albeit incrementally. While he continued to rely for the most part on quiet, isolated, and atonal sound events, he also began to use a variety of regulatory schemes: the very thing that he had renounced so caustically for so many years. In addition, he embraced repetition to such a degree that the listener must unavoidably link his new style with the minimalist methods of the 1960s.

What provoked this shift in style? The composer himself identified— not surprisingly—two *visual* sources. First, he formed an attraction to Middle Eastern carpets, which he had begun to collect in the mid-1970s.[6] His study of the designs in Anatolian rugs in particular stimulated him to dwell on the role of repetition in art and on the nature of symmetry, and thus inevitably led him to explore similar elements in his music.

During this same time, Feldman also developed an interest in Jasper Johns's work of the 1970s. There was probably little chance of the composer borrowing from the painter when the two first met in the early 1950s. Feldman, after all, belonged utterly to the abstract expressionist aesthetic during this time, while Johns had embarked on the now legendary series of flags and targets that many perceived as a rejection of abstract expressionism. Beginning in the late 1960s, however, Johns struck out in a new direction, one that certainly would have appealed more to Feldman. Repetition had always been a major component of Johns's language, of course: consider the many variations on flags and targets, for instance, or those based on stenciled letters, numbers, or Savarin coffee cans. But now, in a new series of paintings, he began creating whole visual fields that involved primarily the repetition of simple abstract patterns. Turning away from the painter's customary subject matter, these new paintings dwell instead on a new motif: crosshatched surfaces. The crosshatch paintings dominate Johns's output of the 1970s, and it was certainly these that so enchanted Feldman. The nonrepresentational and impersonal content

of these works no doubt permitted Feldman to concentrate on their process, and thus led him, first, to see parallels between Johns and Middle Eastern rugs, and second, to imagine musical counterparts.

Feldman's combined interest in Middle Eastern carpets and Jasper Johns's crosshatch paintings, then, helped redirect his compositional aesthetic. The piece that signals the beginning of this new direction is the composition entitled *Why Patterns?* of 1978. I will examine the music in close detail, exploring ways in which Feldman might have transferred elements from Johns into music. Before doing so, however, we need to understand a few main features of Johns's work.

Jasper Johns's Crosshatch Paintings

Johns first used the crosshatch motif in 1972 in a work called *Untitled*, in which crosshatch marks stand as one among several images. The work contains four large connected canvas panels. The left panel is devoted exclusively to crosshatch marks. The middle two panels feature a flagstone motif (another abstract motif that interested Johns at the time), and the right panel presents a collage, with strips of wood fixed to the canvas and plaster casts of body parts fixed to the wood strips. I will not examine all of the possible meanings underlying these images, but it is worth noting that *Untitled* displays a subtle progression from left to right, in which the flat crosshatched surface leads to a faint multilayered surface in the flagstones to the unequivocally multilayered surfaces of the collage panel.[7]

In *Untitled*, Johns mixed nonrepresentational with representational materials in the same work. In *Scent*, a painting completed in 1974, Johns for the first time painted a picture that used the crosshatch motif exclusively. Indeed, it is his first work to adopt an entirely nonobjective subject matter (see figure 8.1). The work, consisting of three separate but joined panels, holds an irony that, as I will argue, also exists in Feldman's late music. The painting shows a surface that is simultaneously simple and complex, simultaneously improvisational and carefully ordered. Minimal in content, it presents just a few easily apprehended elements, which extend through the space by a perceptible but flexible pattern of repetition. At first the viewer will likely perceive only casually distributed bundles of orange, green, and purple lines. No prioritizing marks exist here; one looks in vain for any conspicuous event or set of events that might establish a point of orientation. The surface appears to be as "all-over" in character as are any of Pollock's drip paintings. But Johns used the sim-

Figure 8.1 Jasper Johns, *Scent* (1973–74). © Jasper Johns / Licensed by WAGA, New York, N.Y.

plicity of these marks to direct attention away from surface content toward the process of perception, or, as Johns has phrased it, "the changing focus of the eye."[8] Patient viewers, scrutinizing the picture more closely, will experience a dawning revelation of structure: what at first seemed haphazard turns out to involve systematic, regulated structure.

For one thing, Johns used different materials for each of the three panels. The left panel is made with encaustic—that is, pigment melted into hot wax. This medium, which Johns had been using since his famous *Flag* of 1954, creates a lumpy, lusterless surface. The middle panel uses oil without varnish on an unsized canvas; the right panel uses oil *with* varnish on a *sized* canvas. Johns's deliberate use of materials establishes a sense of direction, in which he invites the eye to travel in a left-to-right progression from dull to glossier to most glossy, and from a lumpy to loose to taut surface. The progression also contradicts other aspects of the work because it introduces a directional pattern into a system of hatch marks that seem to spread out in all directions simultaneously.

But even the all-over arrangement of hatch marks turns out to be more regulated upon closer inspection. The viewer begins to realize that at least

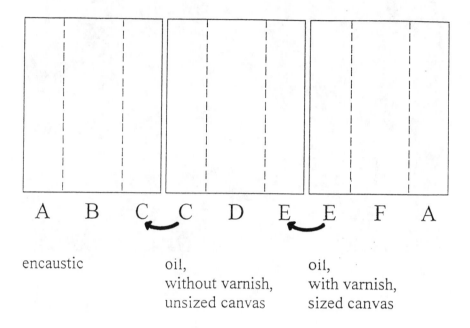

A B C C D E E F A

encaustic oil, oil,
 without varnish, with varnish,
 unsized canvas sized canvas

Figure 8.2 Jasper Johns, *Scent*, structural overview.

one basic rule governs the work: one bundle of marks may not touch another of the same color: an orange bundle never touches another orange one, a green bundle never touches another green one, and so forth. Then, an even deeper scheme emerges (see figure 8.2). It turns out that Johns, with sketched lines that remain visible in the final work, subdivided each of the three panels into three vertical sections. As Michael Crichton has shown,[9] the resulting nine vertical planes present a pattern of repetition that can be expressed as ABC–CDE–EFA. Thus, the left subsection of the middle panel repeats the vertical section just before it—that is, the right subsection of the left panel—and the left subsection of the right panel repeats the right subsection of the middle panel. Ultimately, the pattern of repeated segments in *Scent* refutes the seemingly all-over structure of the painting. It challenges the one structural entity that the viewer instantly sees—the division into three panels—by repeating other, "hidden" squares and rectangles. Moreover, because the painting begins and

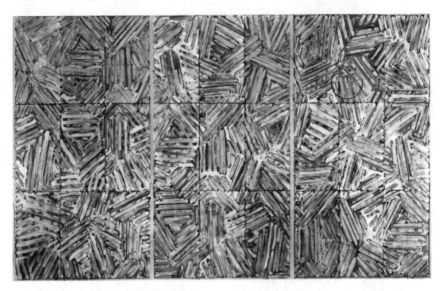

Figure 8.3 Jasper Johns, *Usuyuki* (1977–78). Reproduced by permission from Ludwig Collection, Aachen.

ends with the same vertical subsection (i.e., section "A"), the viewer is invited to read the total space as cylindrical rather than flat.

Johns spent the later 1970s developing more complicated crosshatch patterns. His *Usuyuki*, from 1978, presents a triptych in which the three panels are fixed together as a totality but separated by strips of wood (see figure 8.3). Again, while at first the picture seems to present disorderly— or at least casually distributed—crosshatch marks, Johns executed the painting by means of a carefully predetermined system. Johns told Michael Crichton that, before beginning work on *Usuyuki*, he conceived a "map"—an a priori construct—consisting of fifteen segments.[10] He arranged these in groups of three and stacked them one on top of the other in five horizontal registers. (See figure 8.4a, where the initial construct is given under Roman numeral I, with the individual segments labeled A through O.) Johns then subjected the construct to a series of operations, resulting in two other versions. (In figure 8.4a, the second version appears under Roman numeral II, the third under Roman numeral III.) In terms of pictorial space, as the viewer moves in a left-to-right direction from one construct to another, each three-group unit slips diagonally to the next lowest register (see the descending arrows in figure 8.4a). At the same time, each group is rotated to suggest a cylindrical as opposed to linear reading of the space (see the arrows moving right-to-left

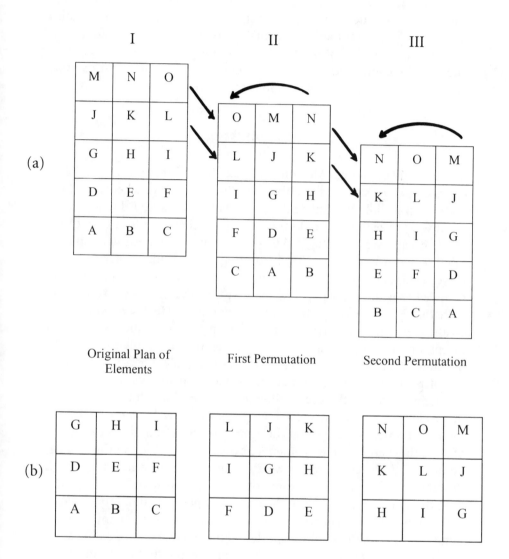

Figure 8.4a and 8.4b Diagram of Johns's predetermined spatial scheme for *Usuyuki* (8.4a); diagram of the actually painted spatial scheme of *Usuyuki* (8.4b).

in figure 8.4a). For instance, the ABC unit in the first construct rotates in the second construct to CAB, which in turn rotates to BCA in the third construct. The concept as a whole may represent, as Mark Rosenthal has written, an "evocation of infinity" because this process can go on indefinitely. [11] The completed painting uses only the three horizontal registers that are present in every permutation (see figure 8.4b).

Feldman's *Why Patterns?*

As we've already noted, Morton Feldman enjoyed these works by Johns because, first, he saw parallels between Johns's repetitive schemes and the patterns in Middle Eastern carpets, and second, because Feldman recognized ways in which he could transfer these schemes into music. In his article "Crippled Symmetry," Feldman wrote of the connection in his own mind between Johns's crosshatch paintings and Middle Eastern carpets. He referred to one of his own carpets, in fact, as his "Jasper Johns rug" and he noted that the rug gave him "the first hint that there was something there that I could learn, if not apply to my music." He described it as "an arcane checkerboard format, with no apparent systematic color design except for a free use of the rug's colors reiterating its simple pattern." [12] In the same article we learn that Feldman was especially interested in Johns's use of process and pattern, and particularly, in Johns's notion of the "changing focus of the eye." Feldman observed that "Johns's canvas is more a lens, where we are guided by his eye as it travels, where the tide— somewhat different, somewhat the same—brings to mind Cage's dictum of 'imitating nature in the manner of its operation.' These paintings create, on one hand, the concreteness we associate with a patterned art and, on the other, an abstract poetry from not knowing its origins." [13]

Feldman thus reacts both to the process of perception in Johns, and to the painter's blend of concrete pattern and abstract poetry. In my view, it's significant that Feldman directly followed these remarks with a discussion of his own *Why Patterns?*, because this piece is the first of Feldman's to adopt the principles derived from Middle Eastern rugs and Jasper Johns's crosshatch paintings.

Feldman wrote *Why Patterns?* for flute, piano, and glockenspiel. All parts follow the same tempo and use traditional fixed notation, but the composer notated the parts in separate, unaligned staves and intended them to progress in an unsynchronized manner. All three parts divide into a series of different, though not dramatically contrasting, segments. In some places the segments are clearly partitioned; in other places one seg-

ment progresses in a seamless fashion into another. The segments are
irregular in length—one lasting about thirty seconds may follow one that
has lasted five minutes—and, with the exception of the synchronized con-
clusion of the work, no segments of one part coordinate with segments in
another part. Some segments gain their identity by relying on carefully
constructed musical systems; others coalesce gradually into segments by
following more intuitive kinds of organization. All segments assert their
identities by repeating some pattern or by adhering more or less strictly to
whatever set of materials defines them. The first two pages of score illus-
trate Feldman's method.

Methods of Segmentation

The first two pages of *Why Patterns?* constitute about three to five minutes
of the piece, depending upon which part and which performance one
attends to. (The whole piece usually takes about thirty minutes to per-
form.) In this opening music, the alto flute presents most of its first seg-
ment (the segment concludes in the middle of the third page); the piano
presents three full segments and about two-thirds of its fourth one; and
the glockenspiel presents three complete segments. (In figure 8.5 the
beginnings of the segments are marked with Roman numerals.)

A number of factors help the first flute segment cohere as an entity.
Throughout, the performer presents only single, isolated attacks; no group
of tones ever coagulates into a broader motive or gesture. The pace of the
musical action is especially consistent: the tones are roughly the same
duration and the silences, too, are similar in length, with the few variants
only serving to reinforce the overall consistency. Pitch structure plays a
prominent role. During the entire segment, the flute part progresses
almost invariably downward along the chromatic pitch-class scale. Only
occasionally does Feldman interrupt this pattern with other intervals.
Indeed, the listener will likely recognize the end of this segment when the
flute part abandons this pattern (see the third system on the third page) to
dwell on the repetition of a single pitch, D6. (The pitch pattern that gov-
erns this segment is an important element overall in *Why Patterns?* Thus,
we will return to the subject below.)

The piano part of figure 8.5 allows us to see not only the ways in which
a segment can cohere but also the ways in which one segment can differ
from another. In the first piano segment, the music consists of the same
kind of isolated, steady attacks that characterize the flute segment. The
segment also stands out because it consistently occupies a single high reg-
ister and it mostly relies on the steady reiteration of a single dyad (G and

WHY PATTERNS?

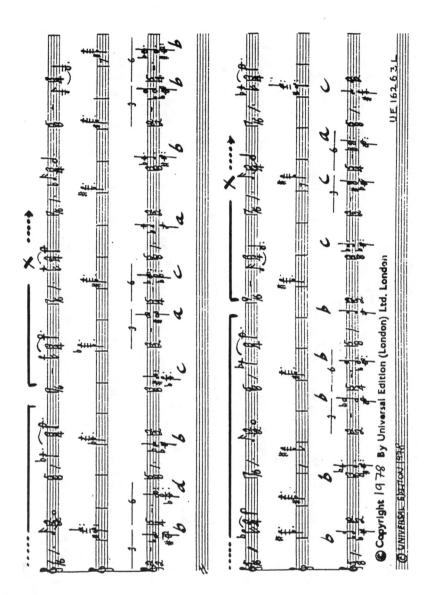

Figure 8.5 Feldman, *Why Patterns?* the first two pages of score. © 1978 Universal Edition (London) Ltd., London. All rights reserved. Used by permission of European American Music Distributors, LLC, Sole U.S. and Canadian agent for Universal Edition (London) Ltd. London.

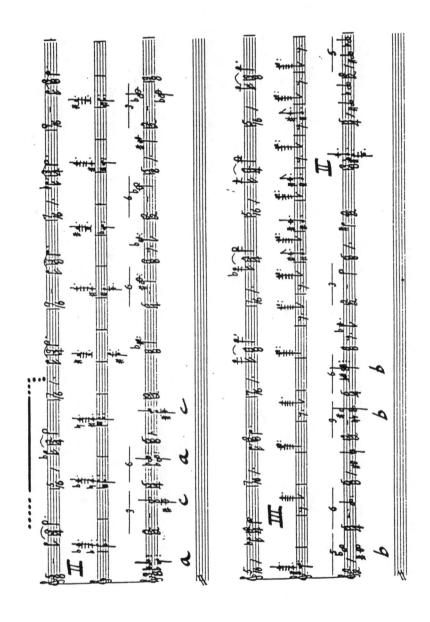

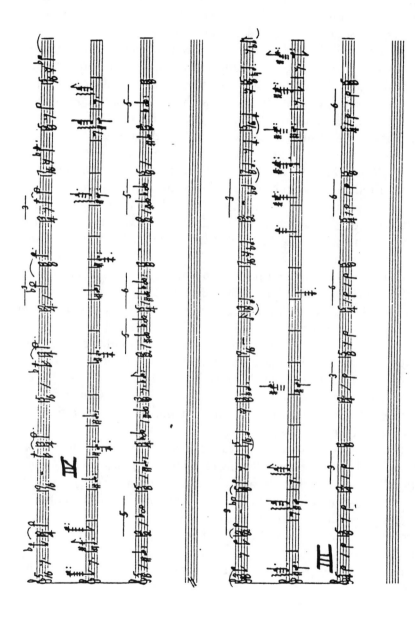

Figure 8.5 Feldman, *Why Patterns?* the first two pages of score (continued).

F♯). The only divergence from this pattern comes in the middle of the segment, when the chords grow more dense and the pitch-class content expands to include notes that lie adjacent (in pitch-class space) to the original dyad (see the bracketed section in figure 8.5).

While retaining the same general pace and character of the first segment, the second piano segment changes to a steadily thicker sound, deepened by the admission of the middle register. The passage includes a wider variety of chords and pitch classes; but perhaps most important is a new harmony—an all-adjacent set including A♭, A, B♭, and B—that loosely governs most of the chords in the segment. The third piano segment also introduces a new chord, but the alternation of one dyad (B/C) with the other (G♯/A♯) defines the music most distinctly. This alternation comes close to introducing an important new element into the music, because it admits—albeit faintly—the sense in which individual attacks are beginning to join together to form rudimentary motivic gestures. The fourth piano segment returns to the dyad that had defined the first segment (F♯/G). Feldman treats the dyad more flexibly in this passage, however, because it serves mainly as a point of departure for a number of other neighboring all-adjacent chords. (By "neighboring all-adjacent chords," I mean chords whose tones are adjacent in pitch-class space to either F# or G, such as E, F, F♯, G or F♯, G, A♭, A).

The three segments performed by the glockenspiel in figure 8.5 can be quickly summarized. The first segment presents a series of isolated atonal events—mostly four-note chords but with a few dyads as well—that seem to progress aimlessly from one to another. The second segment dwells exclusively on a single chord divided into alternating dyads, and the third segment simply repeats the pitch B4.

In figure 8.6, I've charted the overall scheme of the work, with horizontally deployed rectangles representing each individual segment. The chart is drawn roughly to scale, temporally speaking, so that the lengths of each segment correspond with the durations as determined by notated time. Of course, because the instruments proceed at their own chosen pace, the alignment of the segments will shift with each performance. The final section of the work, which Feldman added after the first performance and which is meant to be performed with the three players in synchronization, is also marked.[14]

Harmonic Uniformity

The music of *Why Patterns?* draws from the aesthetic world of Jasper Johns in a variety of ways. As we have remarked above, Johns's habit of

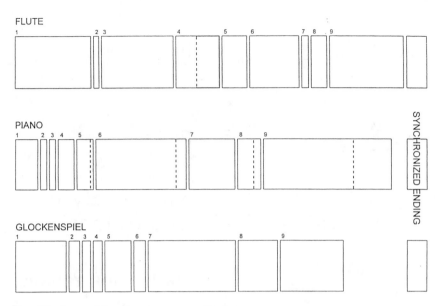

Figure 8.6 Diagram of the patterned segments in *Why Patterns?*

restricting himself to limited kinds of marks and colors suppresses contrast and thereby creates flat, uniform, and seemingly unordered fields. Feldman did much the same thing in most of his music. Indeed, he himself once described his primary style as one with a "flat surface,"[15] because most of the events sounded alike and avoided contrast with the other sounds. The flat surface of *Why Patterns?* derives, first, from the predominance of isolated, single-attack events of the kind we saw in figure 8.5; and second, from a limited palette of harmonic colors.

Feldman guarantees harmonic uniformity in this piece mostly by restricting the material in all the parts to a few simple chord types. *Why Patterns?* throughout is dominated by four different kinds of harmony: three kinds derive from semitone, the fourth from whole-tone, relations. Pure semitone chords (labeled A in figure 8.7) include chords built strictly of all-adjacent pitch classes. Two other chord types build their sonorities with semitones but apply the principle less strictly. For instance, many chords in the work combine pairs of nonadjacent semitone dyads (such as chord type B). Still other chords combine a single semitone dyad with a tritone (such as chord type C). The fourth chord type (D) is distinct from the other three chord types because it uses only relations derived from the whole-tone scale. When arranged as they are in figure 8.7, the reader may notice that there is a "stepped" relation between the four kinds of har-

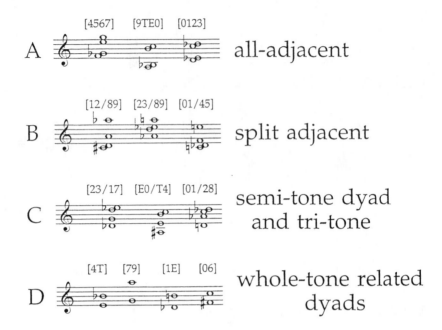

Figure 8.7 The four main types of chords in *Why Patterns?* The numbers above the notes designate pitch classes, with 0 = C, 1 = D♭, and with T and E representing 10 and 11 (i.e., B♭ and B).

monies: the outer chords (A and D) represent pure forms of semitone and whole-tone structures; the B chord represents a faintly diluted form of semitonal construction; and the C chord mixes semitone with whole-tone relations. One wonders if Feldman devised a kind of "color chart," if you will, with two distinctly different kinds of harmony at either end, and two mixed shades between.

Yet, as far as I can determine, the composer does not use these four chord types to create any kind of coherent overall design. At the global level, there appears to be no systematic treatment of the harmonies, no calculated plan. Locally, within segments, some passages focus exclusively on one or two chord types, others include all four types. For example, the first piano segment contains only all-adjacent chords and dyads (i.e., chord type A); but the first glockenspiel segment freely mixes together all four chord types and inserts a few that belong to none of the categories. (In the glockenspiel segment of figure 8.5, the letters indicate chord types, and the absence of a letter designates the chord as one outside of the four main categories. While the dyads are left unmarked, the reader will note that all but one are semitones.)

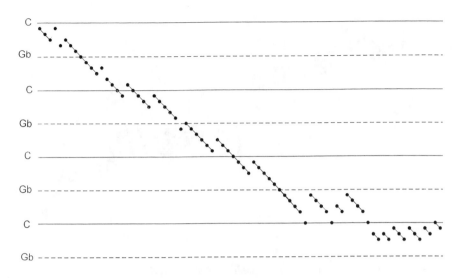

Figure 8.8 Diagonal pitch-class succession in the first flute segment.

Another element that unifies *Why Patterns?* and helps create its flat, uniform harmonic surface is the "diagonal" behavior of its pitches and pitch classes. Throughout the work, Feldman frequently connects strands of single pitches, dyads, trichords, or tetrachords that "descend" in pitch-class space. In a strand of single pitches, for example, the pitch class C would be followed by a B, then a B♭, then an A, and so forth. The opening flute segment exposes diagonal behavior in a straightforward, clearly audible manner. Figure 8.8 charts the pitch classes of the flute segment. To allow the diagonal pattern to unfold visually, I've mapped the pitch classes onto a grid expanded to three "registers." Of course, pitch-class space is a circular, not linear, construct; so the three registers in effect represent three revolutions around the pitch-class circle. Note that the music here consists almost entirely of skeins of descending diagonal lines. At first the skeins involve only two or three notes, but gradually they grow longer, to include, four, five, six, seven, and up to ten notes. Feldman periodically breaks these diagonal skeins with another type of interval; but following such an interruption a new skein begins. It's important to recognize that Feldman avoids creating regular, predictable shapes and he frequently displaces the register of the individual pitches to hide the pattern somewhat. Thus, it is the *principle* of the diagonal—not specific pitch or pitch-class patterns—that give the segment its identity. The coexistence of two such different, if not contradictory, ways of thinking—that is, the steadfast

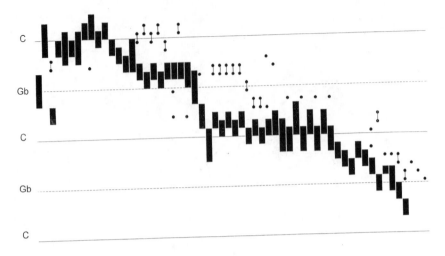

Figure 8.9 Diagonal pitch-class succession in the first glockenspiel segment.

avoidance of concrete motifs combined with an adherence to a straight-forward governing principle—constitutes a chief link between Feldman's late music and Johns's work of the 1970s.

Skeins of diagonally related pitch classes occur throughout the work, even though few of the other segments exhibit the pattern as conspicuously or at such length as does the first flute segment. In other segments, surrounding pitches veil the diagonal patterns. In the first glockenspiel segment, for example, diagonally moving cells link the chords together, but the patterns are mainly hidden within more complex harmonies. As we've already seen in figure 8.5, the glockenspiel presents a series of isolated verticals and some single notes. Figure 8.9 charts the pitch-class succession of the glockenspiel segment onto a grid expanded to two "registers." Filled-in black squares identify the main string of diagonally moving pitch classes. Beginning with the second chord, diagonal relations govern the majority of the pitch classes in the segment and link every chord to the next. Pitch classes that do not participate in the main diagonal skein appear as smaller dots. As the reader may note, in several instances these "dotted" pitches also move diagonally.

Passages at or near the conclusion of *Why Patterns?* appear to drive home the thematic importance of the diagonal principle. The piano music just before the added ending—that is, the passage that Feldman originally intended to conclude with—begins with four all-adjacent tetrachords that

slide downwards chromatically (see figure 8.10). The passage proceeds with the left-hand dyads continuing their chromatic assent while the right-hand twice repeats the four dyads that begin the passage. In the newly added conclusion to the work, the glockenspiel presents several skeins of chromatically descending pitches in a manner reminiscent of the first flute segment.

I can't prove that this "diagonal" harmonic behavior relates to any visual source. But certainly Feldman would have noticed the many diagonal patterns in his carpets; in fact, in his "Crippled Symmetry" article he specifically mentioned being impressed by a diagonal pattern in one particular Turkish rug.[16] Nor can I prove that Feldman's diagonals derive from Jasper Johns.[17] But it is worth remembering that Johns's *Usuyuki*—created at the same time as *Why Patterns?*—featured a diagonally descending space. Regardless of whether that painting or any other of Johns's served as a direct source, we can at least acknowledge the structural affinity between it and Feldman's piece.

Several other aspects of *Why Patterns?* evoke a Jasper Johns–like spirit. At the beginning of the work, for instance, Feldman uses isorhythm to organize both the flute and glockenspiel segments, thereby implanting hidden order to seemingly random materials. In the first flute segment an extended isorhythmic pattern occurs three times, although the last talea is left incomplete. (The three isorhythmic talea are marked with an x in figure 8.5.) The three talea present identical patterns of meter, surface rhythm, and pitch-class succession; the only thing that differentiates them is the fact that, when most of the pitch classes return in subsequent talea, they sound in different registers.

Another isorhythm governs most of the first glockenspiel segment. The segment begins with eleven statements of a talea that handles pitch freely but repeats the same five-bar metric and surface-rhythm pattern. (In figure 8.5 brackets show the first five talea.) Characteristically, Feldman never yields entirely to any regulated pattern. Thus, the first and third talea vary the pattern slightly: the first one begins with a 2/4 instead of 2/2 bar; the third one eliminates the 5/8 bar. At the end of the segment, Feldman abandons the isorhythm to treat the individual sections of the talea in a freer, modularly reordered manner. As in Johns, then, what appears to be random turns out to be orderly.

Serial Dyads and Whole-Tone Fields

The most regulated music in *Why Patterns?*—indeed, perhaps in all of Feldman—appears in what I've labeled the sixth piano segment.

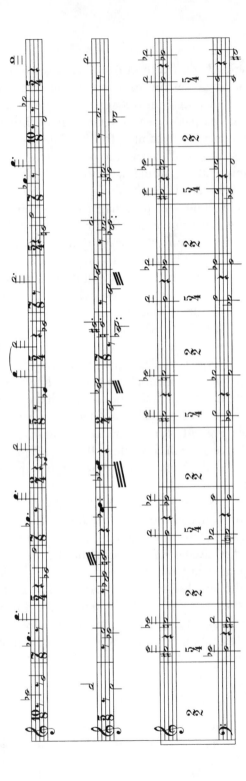

Figure 8.10 Diagonally descending all-adjacent chords (in the piano), near the end of *Why Patterns?* © 1978 Universal Edition (London) Ltd., London. All rights reserved. Used by permission of European American Music Distributors, LLC, Sole U.S. and Canadian agent for Universal Edition (London) Ltd., London.

Throughout this very long segment, the composer presents a steady stream of isolated dyads. Like the crosshatch bundles in Johns, these dyads create an inordinately uniform field, because they use only interval-class two or six relations (i.e., minor sevenths, major tenths, and tritones). And, again like Johns's work, the dyads participate in a simple serial process.

Feldman based the music of the segment on a row of six dyads that altogether contains all twelve pitch classes. The segment as a whole divides into seven sections, followed by a brief concluding passage. (See figure 8.11, which shows the music of the piano without the other parts.) Each section follows the same pattern: the first begins with the original row; each succeeding section begins with a transposition of this row. (In figure 8.11, the row is marked with an *R*.) In each section, Feldman follows the row with two reordered versions of the row's six dyads. (In figure 8.11, the two reordered versions are marked *x* and *y*.) The reordering adheres to a strict system. If we label the six dyads of the row as A B C D E F, the first restatement (i.e., *x*) follows the pattern C F B A E D. The second restatement (i.e., *y*) reshuffles the reordering just given by *x*. Indeed, *y* presents *x* backwards in two stages, with the first three dyads appearing in the order B F C, the second three following thereafter with D E A. Only twice does Feldman depart from this scheme. The seventh section modifies the scheme simply by giving each restatement of the row twice: thus, R–x–y becomes R–x–x–y–y. At the beginning of the second section, the opening row omits its final dyad, which would have been C/G♭. The two restatements (i.e., *x* and *y*) adopt a reordering modified from the one already described.

If we examine the pitch organization of the piano segment more broadly, we see that Feldman has combined this serial scheme with the diagonal principle. As we've already discussed, each section begins with the dyad row, then continues with reordered versions of that row. Note now that each row begins a semitone lower than the previous one. Thus, the first section begins with the dyad E♭/A (reading from top to bottom), the second with D/G♯, the third with D♭/G, and so forth. In broad terms, then, the piano segment combines its rigorous serial structure with the same kind of chromatic descent found in the first flute segment and in many other segments throughout the work. Note, too, how scrupulously Feldman follows his scheme. As dictated by the pattern, the dyad that begins the seventh section returns to the same two pitch classes of the first dyad from the first row (E♭ and A). As mandated by the scheme, however, the two pitch classes must be turned upside down, and Feldman spaces the dyad accordingly.

As I already mentioned, the dyads in this piano segment belong exclusively to interval-classes two and six. This constraint creates an unusually high

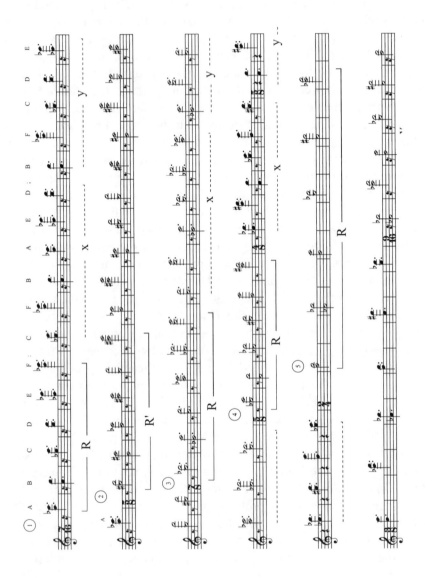

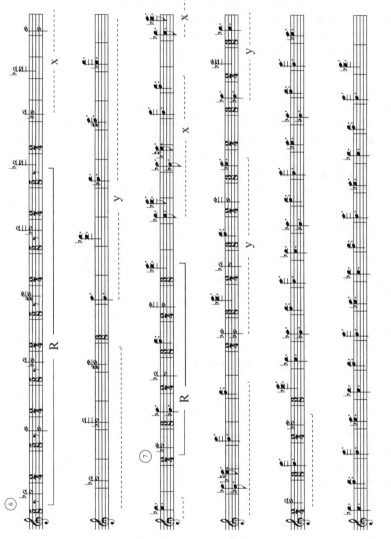

Figure 8.11 The sixth piano segment. © 1978 Universal Edition (London) Ltd., London. All rights reserved. Used by permission of European American Music Distributors, LLC, Sole U.S. and Canadian agent for Universal Edition (London) Ltd., London.

degree of harmonic uniformity, of course, but it also permits a complicated set of patterns within patterns to arise. (Figure 8.12 diagrams the pitch-class content of the seven dyad rows. To help clarify the patterns, I've used numbers to represent pitches: thus, $0 = C$, $1 = D\flat$, and so on, with T and E standing for 10 and 11.) First, note that each row contains the following property: every interval-class-two dyad in a row belongs to one whole-tone scale; whereas every interval-class-six dyad belongs to the other. Second, all rows operate according to a systematic rotational scheme. The same scheme applies to all seven rows, but if we want to trace the rotation of identical dyads we must compare every other row form. As figure 8.12 illustrates, rows 1, 3, 5, and 7 contain the same tritone dyads, but these shift their position from row to row in a predictable, systematic manner (as shown in the example by arrows). In contrast, the interval-class-two dyads *keep* their position in the row (as shown by lines without arrows). Exhibiting what I would call a "whole-tone" diagonal pattern, when a dyad returns in the row below, it discards the "upper" pitch class, keeps the "lower" one, and adds another below. Notice the evolution of the dyad 2/0 (i.e., C/D) from the first row: in the third row, it becomes 0/T (or C/B\flat); in the fifth row 0/T becomes T/8, and so forth.

In my view, this is the most Jasper Johns–like stretch of music in *Why Patterns?* Like Johns, Feldman repeats simple and similar elements in a rigorously ordered scheme. And, as in Johns, the extreme uniformity of the elements paradoxically inhibits the listener's ability to recognize pattern. The diagonal semitone descent, the rotational schemes within the rows, and indeed, even the serial structure itself represent the same kind of hidden system that one finds in works such as Johns's *Usuyuki.*

A Progression of Gestures Generates Global Shape

As mentioned several times already, *Why Patterns?* exhibits a mostly "flat" surface, possessing a sameness that mainly prevents the listener from distinguishing one event from another and sometimes one instrument from another. This uniformity largely stifles a listener's sense of goal-directed movement. However, there are different moments in the piece that poke above this surface, and thus seem to constitute, however faintly, points of orientation. Indeed, after careful and repeated listening, some may hear these moments collectively as forming a kind of abstract teleological progression. Again, this is significant because Feldman has been known for avoiding such things in his music.

Although *Why Patterns?* is dominated by sounds produced by single attacks, occasionally the players will interject other, more complex kinds

Section

1 3 0 4 5 T 7
 9 2 6 E 8 1

2

3 1 0 2 3 8 E
 7 T 4 9 6 5

4

5 E T 0 1 6 9
 5 8 2 7 4 3

6

7 3 8 T E 4 7
 9 6 0 5 2 1

2 1 3 4 9 [0]
8 E 5 T 7 [6]

0 E 1 2 7 T
6 9 3 8 5 4

T 9 E 0 5 8
4 7 1 6 3 2

Figure 8.12 The pitch-class content of the sixth piano segment.

of gesture. Indeed, I hear at least six different kinds of gesture coexisting in this work. In figure 8.13, I give examples of these six types of gesture and arrange them in a sequence that progresses from the simplest, most disconnected events to the most complex, connected ones. Figure 8.13a, then, shows a passage containing the most familiar kind of gesture in *Why Patterns?*—a series of isolated attacks. About three minutes into the piece, the piano offers a passage of what could be heard as divided-chord gestures (page 3, system 3 of Feldman's score; see figure 8.13b). Because two different dyads join momentarily in close alternation, some listeners may hear the event as a compound gesture, one that at least sounds slightly more complex than the single attacks that have prevailed thus far. It's just as likely, however, that the listener will hear the two alternating dyads as a momentary sequence of juxtaposed single attacks, rather than one compound gesture. Thus, the distinction between single-attack gestures and divided-chord gestures is minimal, if it exists at all, and the listener certainly will not readily hear the latter gesture standing out audibly from the surrounding music.

A bit later in the piece, the bass flute introduces a series of pulsed tones (see figure 8.13c). This gesture goes only slightly further in expanding the dimensions of a single attack. Here the player elongates one pitch through straightforward repetition—very much like stretching a single syllable by stuttering its presentation. The gesture again is unobtrusive—the pulsing is muted because of the quiet dynamics and lowness of the pitch—yet it unquestionably sounds like a new kind of gesture, with its longer duration and slightly more complex rhythmic pattern. Elsewhere in the piece, Feldman creates a similar gesture with chords.

Neither the divided-chord gestures nor the pulsed pitches and chords disrupt the uniform flow of events in *Why Patterns?* About a third of the way into the piece, however, Feldman introduces another kind of gesture that stands out quite conspicuously. In the seventh glockenspiel segment, the player begins a string of short gestures characterized by agitated rhythmic motives (see figure 8.13d). The two-note motive that begins the segment—the first unequivocal compound gesture of the piece—at last breaks up the uniform flow of events. The glockenspiel then proceeds to unleash a steady stream of similar gestures throughout this long segment, as though intoxicated with its freedom to advance beyond the regimen of single attacks. Almost all of the gestures in this segment derive either from the initial short/long rhythmic pattern or from a pattern consisting of steady trill-like motion (an outgrowth, perhaps, of the pulsed-pitch gesture appearing earlier in the bass flute). Note, however, that, even though Feldman has given the glockenspiel gestures distinct rhythmic motives, he

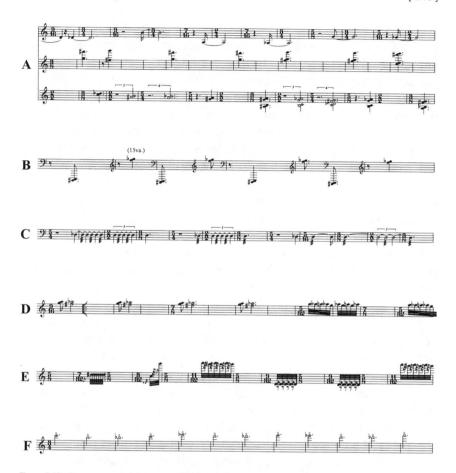

Figure 8.13 The seven gestural types in *Why Patterns?* © 1978 Universal Edition (London) Ltd., London. All rights reserved. Used by permission of European American Music Distributors, LLC, Sole U.S. and Canadian agent for Universal Edition (London) Ltd., London.

has kept the actual dimension of the gestures rather small: with few exceptions, they are contained within a 5/32 bar. The possibility of hearing traditional developmental relationships among the gestures—and thus the admission into the music, however vaguely, of a kind of left-to-right organicism—is enhanced by Feldman's modular method of construction. The fact that the gestures are united harmonically by their adherence to all-adjacent or nearly all-adjacent pitch-class structures may also help listeners hear organic development. At any rate, they will clearly recognize the frequent diagonal behavior within this segment.

After the glockenspiel segment, the players gradually introduce other gestures that are more distinctly motivic and/or much expanded in their dimensions. For example, about three minutes after the beginning of the glockenspiel segment, the flute begins its own sequence of compound gestures (see figure 8.13e). These sound more agitated than—and thus stand out more conspicuously from—the glockenspiel music. This is due, no doubt, to the breathy tone production, which in turn heightens the angularity of the musical contour and produces a greater expressivity. The frequent use of repeating pitches in this fourth flute segment connects this passage with the pulsed-pitch passage given earlier by the bass flute. However, the gestures now are far more intense in character and feature distinct rhythmic motives. Indeed, in my view, the character of this segment seems to have been sparked by the earlier glockenspiel music, as though the latter's break away from single-attack gestures has incited the other players to do the same. In most performances of this work, the flute gestures will enter in the midst of the seventh glockenspiel segment, thereby enhancing the listener's sense that the former has reacted to the latter.

The final stage in the evolution of gesture in *Why Patterns?* arrives when Feldman begins to introduce scalar gestures. This first happens in the fifth flute segment (see page 8 of Feldman's score, second system), which alternates between two main kinds of material. One kind features a series of pulsed pitches (using B_3); the other presents strings of chromatically related pitches connected in a conjunct and legato manner (see figure 8.13f). These latter passages constitute the first melody-like entities in the entire piece. Ultimately, the abstract, featureless nature of these gestures will likely dissuade listeners from hearing them as melodies in any traditional sense, but their linear natures and greatly enlarged dimensions help them stand out sharply from the surrounding isolated attacks. A few minutes later the piano responds with its own scalar gestures (beginning on page 10 of Feldman's score, third system), presented in several different registers.

Feldman seemed to believe that no hierarchical structure exists in this work. He wrote that the "most interesting aspect for me, composing exclusively with patterns, is that there is not one organizational procedure more advantageous than another, perhaps because no one pattern ever takes precedence over the others. The compositional concentration is solely on which pattern would be reiterated, and for how long, and on the character of its inevitable change into something else."[18]

To my ears, the six gestures supply the piece with a faint, abstractly rendered teleology. By arranging the various types to "advance" from isolated attacks, divided chords, and pulsed pitches through short but rhythmically

distinct motives to expansive scalar lines, the composer has embedded within the music a barely perceptible left-to-right progression. The listener must pay close attention to hear this process, just as Johns's viewers must gaze intently in order to see his spatial progressions.

The parallels between this late work of Feldman's and the crosshatch paintings of Johns run deep, though inevitably they are inexact. In these paintings, Johns seems to have fused contrasting aesthetic concerns from very different movements in modernist art. In *Scent*, for example, Johns adopted an abstract, nonobjective subject for the first time in his career. The simple, repetitive motif reminds us of minimalism's manufactured regularity; yet the artist created the marks in a handmade, painterly manner. The result produced an ostensibly flat, all-over surface reminiscent of abstract expressionist works. The choice of *Scent* as a title—also the title of Pollock's last painting—perhaps confirms this new direction, though Johns himself has denied any such intention. At the same time, the strict use of one kind of mark, along with the existence of a whole set of a priori rules and secret structures, hardly match the improvisational spirit of a Pollock or a de Kooning. What is more, the controlled exploration of space, in which an apparently flat surface turns out to be cylindrical, points toward the intellectual preoccupations of analytical cubism.

In *Why Patterns?* Feldman likewise joined together a variety of modernist approaches. The character of the sounds themselves shows a continued allegiance to his abstract expressionist roots. The events in the piece, all abstract and mostly solitary, stand disconnected from conventional organic rhetoric; their musical significance depends instead on their physical, *sonic* properties. The unsynchronized method of performance reinforces Feldman's embrace of abstract-expressionist chance and improvisation. The frequent use of repetition reveals Feldman's own awareness of 1960s minimalism, yet, like Johns, he uses such techniques in a "handmade" as opposed to mechanical manner. Indeed, the principle of "facture" is fundamental both to Feldman and Johns, for both want their audiences to sense the hand of the artist, to connect in a visceral, physical way with the actual process of making the work of art.

Perhaps most extraordinary is Feldman's adoption of serial procedures for some of the music, because it was just such procedures that he denounced bitterly for so many years. It would be wrong, I think, to consider the serial passages in *Why Patterns?* a capitulation to a rival aesthetic. It seems more likely that, maturing as an artist, Feldman eventually learned to appreciate such methods as valid parts of the modernist argument. The serial dyads in the piano segment, then, may best be understood as a medi-

tative exploration of what such techniques can—and cannot—accomplish. As did Johns with analytic cubism, then, Feldman appropriated an early modernist language and offered a new interpretation.

As a whole, *Why Patterns?* presents structural contradictions similar to those in Johns. The music adheres to a carefully managed spectrum of harmonies, but does not use this spectrum to determine middle or global-level shape. The harmonies instead insure uniformity, a flat "all-over" surface of the kind Johns achieved with his repeated bundles of hatchmarks. Rhythmic and pitch patterns often operate in carefully regulated ways, but the materials usually are too homogenous to permit apprehension. As in Johns, hidden systems of order abound, but the meaning of these systems is enigmatic. Perhaps Feldman is simply asking, "Why Patterns?"

Notes

1. John Updike, "The Rumor," in *The Afterlife and Other Stories* (New York: Knopf, 1994), 213.

2. Paul Griffiths, *Modern Music: The Avant Garde since 1945* (New York: George Braziller, 1981), 72.

3. Jonathan Kramer, *The Time of Music: New Meanings, New Temporalities, New Listening Strategies* (New York: Schirmer Books, 1988), 386.

4. Morton Feldman, "Between Categories," in *Contemporary Music Review* 2 (1988): 3. This article was originally published in *The Composer* 1, no. 2 (1969): 73–77.

5. Gavin Bryars and Fred Orton, "Morton Feldman: Interview," *Studio International* 192, no. 984 (November–December 1976): 246.

6. Morton Feldman, "Crippled Symmetry," in *Morton Feldman Essays*, ed. Walter Zimmermann (Kerpen, West Germany: Beginner Press, 1985), 124–29.

7. Mark Rosenthal, *Jasper Johns: Work since 1974* (London: Thames and Hudson, in association with the Philadelphia Museum of Art), 17.

8. Jasper Johns, statement in *Sixteen Americans* (exhibition catalog), ed. Dorothy C. Miller (New York: Museum of Modern Art, 1959), 22, quoted in Roberta Bernstein, *Jasper Johns' Paintings and Sculptures: "The Changing Focus of the Eye"* (Ann Arbor, Mich.: UMI Research Press, 1985), xv.

9. Michael Crichton, *Jasper Johns* (New York: Harry N. Abrams, in association with the Whitney Museum of American Art, 1994), 58–60. The charts appearing as figures 8.2, 8.4a, and 8.4b derive from those presented by Crichton.

10. Ibid., 60–61.

11. Rosenthal, *Jasper Johns*, 34.

12. Feldman, "Crippled Symmetry," 128.

13. Ibid. In 1976—two years before he completed *Why Patterns?* and during the height of Johns's crosshatch period—Feldman told two interviewers that he felt "very, very close to Jasper Johns" and his recent paintings and that the painter's work was closer to his own than to John Cage's. See Bryars and Orton, "Morton Feldman: Interview," 247.

14. Therefore, even though in notated time the flute is the longest and the glockenspiel the short part, in three recorded performances—all of which last about a half hour—the shape of the piece changes significantly. In a December 1978 recording (with Feldman at the piano), the flute finishes first (at 26:10), the glockenspiel second (at 26:40), and the piano last (at 28:52). In a September 1990 recording the glockenspiel finishes first (at 25:29), the flute second (at 28:22), the piano last (30:02). In an October 1990 recording, the three performers end virtually together. After the first performance of *Why Patterns?* Feldman added a new conclusion, which, unlike the main portion of the work, is to be played synchronously.

15. Feldman, "For Frank O'Hara," in Zimmermann, ed., *Morton Feldman Essays*, 142. These remarks were originally liner notes for a recording of Feldman's work entitled *For Frank O'Hara*.

16. Feldman, "Crippled Symmetry," 127.

17. I wrote to Johns, hoping that he would tell me there was some direct influence. He responded that he "saw very little of Morty during his last years and have no information about his interest in my work. I did have the good fortune that he called me a few days before he died to say good bye."

18. Feldman, "Crippled Symmetry," 129.

[About the Contributors]

David Nicholls is Professor of Music at the University of Southampton. Author of *American Experimental Music, 1890–1940* (1990) and a number of articles on topics in American music, he has also acted as contributing editor to *The Whole World of Music: A Henry Cowell Symposium* (1997) and *The Cambridge History of American Music* (1998). He is a contributing editor of the forthcoming *Cambridge Companion to John Cage*, and is the editor of the journal *American Music*.

Olivia Mattis is a musicologist specializing in twentieth-century music. She obtained her Ph.D. from Stanford University and has served on the faculties of the Eastman School of Music and the University of New Hampshire. She has published articles in *The Musical Quarterly, The New Grove Dictionary of Music and Musicians, Keyboard Magazine*, and elsewhere. One of her articles won the prestigious ASCAP–Deems Taylor Award.

Austin Clarkson is Professor Emeritus of Music at York University, Toronto, and general editor of the music and writings of Stefan Wolpe for the Stefan Wolpe Society Inc. His critical editions of the music appear under the imprint of Peer. He edited *On the Music of Stefan Wolpe: Essays and Recollections* (forthcoming) and is co-editor with Dr. Thomas Phelps of Wolpe's German writings. Recent publications include the catalog of the music of Mordecai Sandberg and essays on John Cage, Istvan Anhalt, and Wolpe.

David W. Bernstein is Professor of Music and head of the music department at Mills College. He has published and lectured on topics such as Arnold Schoenberg's tonal theories, the history of music theory, John Cage,

Fluxus, and avant-garde aesthetic theories. He organized the conference/ festival "Here Comes Everybody: The Music, Poetry, and Art of John Cage," which took place at Mills College in November 1995. He co-edited (with Christopher Hatch) and contributed to a book of essays titled *Writings through John Cage's Music, Poetry, and Art* (2001) stemming from this event.

Thomas DeLio is a composer and theorist. His compositions are published by Smith Publications/Sonic Art Editions (Baltimore) and Editore Semar (Rome), and his works are recorded on the labels Wergo, Neuma, Spectrum, 3D Classics (Paris), and Capstone. Articles about his music have appeared in *Perspectives of New Music, Interface,* and *Leonardo.* As a theorist, DeLio has published several books, most notably *Circumscribing the Open Universe, Contiguous Lines: Issues and Ideas in the Music of the '60s and '70s, The Music of Morton Feldman,* and numerous essays in such journals as *The Musical Quarterly, MusikTexte, Interface, Perspectives of New Music, The Journal of Music Theory,* and *The Contemporary Music.*

John Holzaepfel received his Ph.D. in historical musicology from the City University of New York, where he wrote his dissertation "David Tudor and the Performance of American Experimental Music, 1950–1959." He is currently preparing a biography of David Tudor.

Jonathan W. Bernard is Professor of Music Theory at the School of Music, University of Washington. His articles and chapters on the music of Varèse, Carter, Messiaen, Ligeti, Zappa, minimalism, the history of theory, and the history of twentieth-century compositional practice have appeared in numerous scholarly journals and books. He is the author of *The Music of Edgard Varèse,* the editor of *Elliot Carter: Collected Essays and Lectures, 1937–1995,* and a contributing editor to *Music Theory in Concept and Practice.*

Steven Johnson is Professor of Music at Brigham Young University. He has written on Gustav Mahler, Henry Cowell, Ralph Shapey, and Morton Feldman for such journals as *American Music, Perspectives of New Music,* and *The New Groves Dictionary of Music and Musicians.*

[Index]